SoulStyle

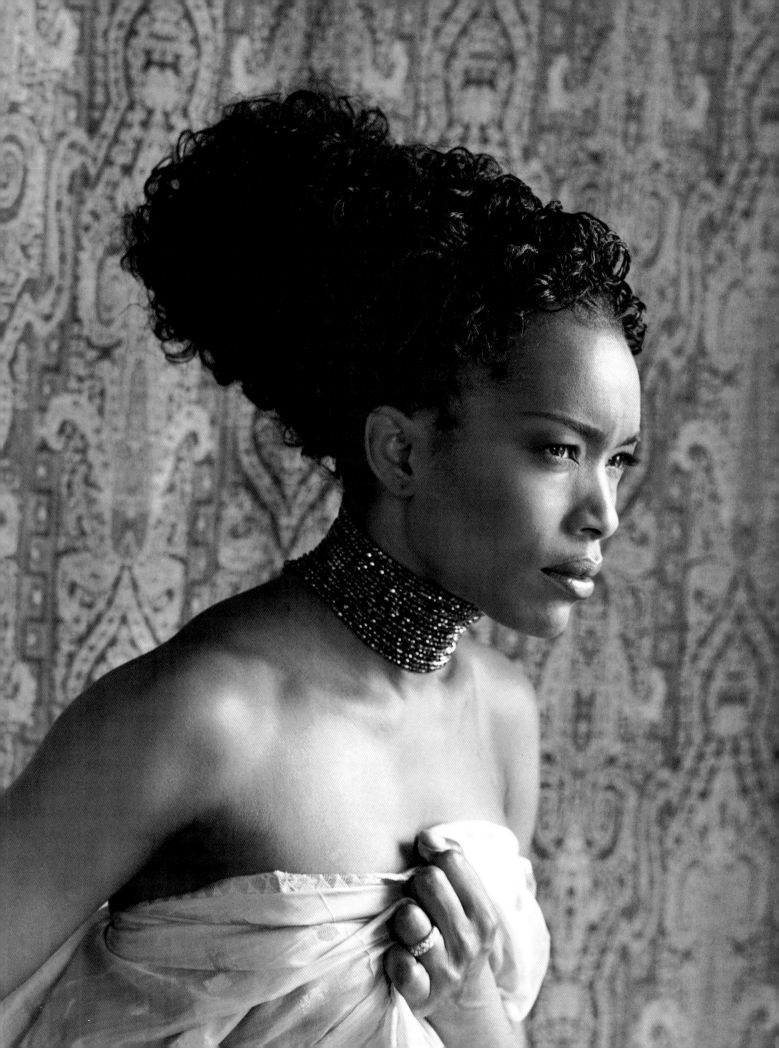

SoulStyle
Black Women Redefining
the Color of Fashion

Duane Thomas
Universe

First published in the United States of America
in 2000 by UNIVERSE PUBLISHING
A Division of Rizzoli International Publications, Inc.
300 Park Avenue South, New York, NY 10010

2000 2001 2002 2003 / 10 9 8 7 6 5 4 3 2 1

Library of Congress Cataloging-in-Publication Data
Thomas, Duane
SoulStyle: Black Women Redefining the Color of Fashion
p. cm.
ISBN (PB): 0-7893-0465-1
ISBN (HC): 0-7893-0466-X

Printed in Singapore

This book is dedicated to my parents Yvonne and Jerome, sisters Nikki and Daisy, and nephews Bosie and Jeremy.

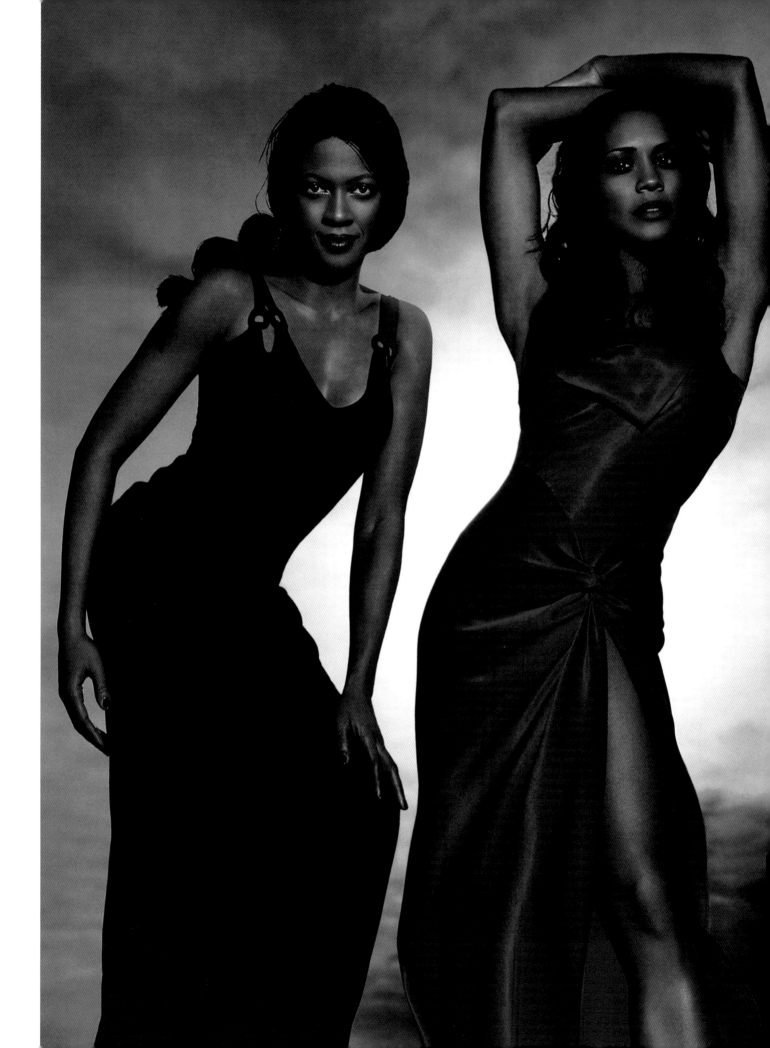

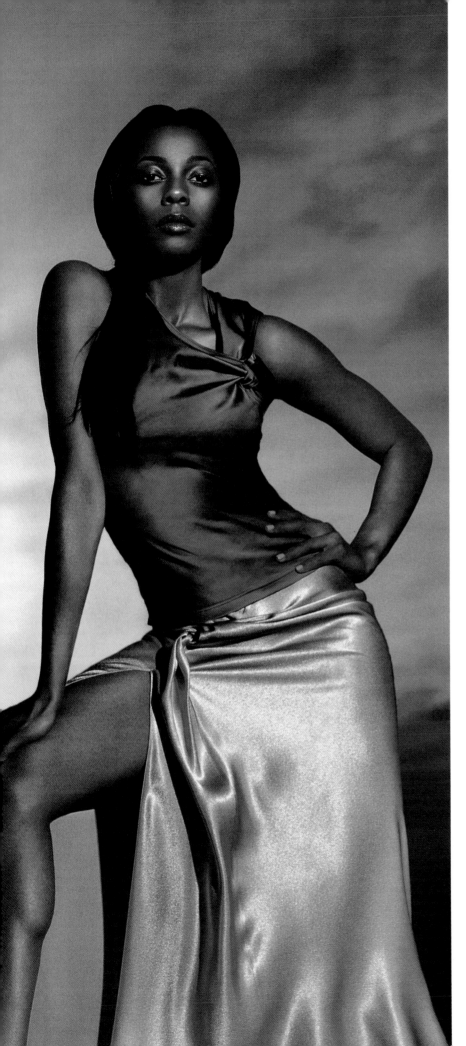

En Vogue
photographed by
Markus Klinko

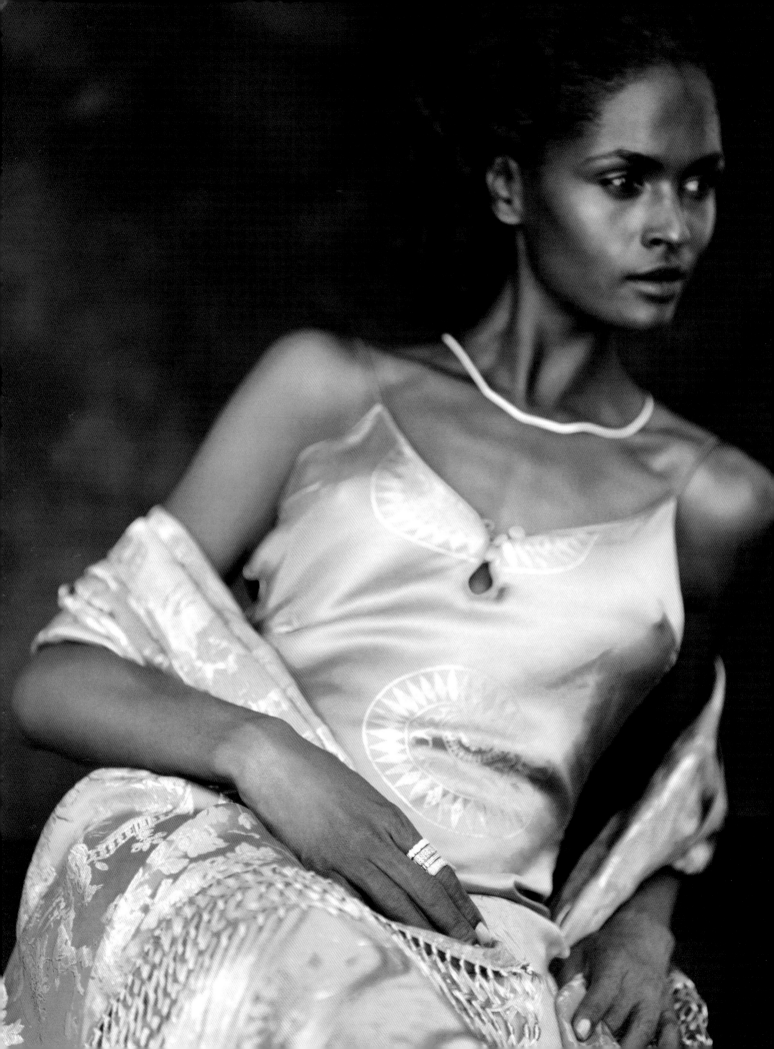

Karen Alexander
photographed by
Carlton Davis

contents

Foreword
Duane Thomas

I've long had a love affair with fashion, fashion magazines, and photography books. I became interested in them at about age fourteen. Johnson Publishing launched *EM: Ebony Man* for Black men, and I ordered my first magazine subscription. I was giddy with excitement each month when the magazine would arrive in the mailbox. My family lived in the country in Florida so the magazine was my only connection to "high society." As I grew older, women's fashion suddenly replaced men's fashion as a source of excitement for me. It wasn't the clothing that interested me the most; it was the models, the photography, the art direction, and the magazines themselves. In 1987 when I entered the Fashion Institute of Technology, *Elle* was making a splash in America. For a class assignment, I was thrilled to interview the man who would become my idol, Régis Pagniez, *Elle*'s founding publication director. He'd made *Elle* the talk of town and I was in awe of him, his success, and his magazine. At the same time, the original supermodel trio of Naomi Campbell, Linda Evangelista, and Christy Turlington emerged. Fashion was hot and I wanted to be a part of it. My dream from then on was to create a fashion and beauty magazine for Black women.

Since F.I.T., I've worked at all the major style magazines: *Vogue, Elle, Harper's Bazaar, Essence, Esquire,* and *Details.* While at *Esquire* I got the idea to do a Black men's photo book. I was tired of flipping through photography books in bookstores and seeing only one or two Black men in them. My first photo book, *Body&Soul: The Black Male Book,* was published in 1998. (Thank you, Universe!) The book featured supersexy singer D'Angelo on its cover and received rave reviews. Both women and men loved it. Now, you hold my latest fashion dream: *SoulStyle: Black Women Redefining the Color of Fashion.* It's a celebration of Black women's style and beauty. You'll revisit the Legends who were among the first to bear their color with elegance. You'll meet the modern-day Hollywood starlets who are carrying on that tradition. You'll also meet the outrageous hot girls and hip-hop divas who've broken fashion standards to write their own book. I hope you enjoy it as much as my team and I enjoyed putting it together.

**Tyra Banks
photographed by
Jonathan Mannion**

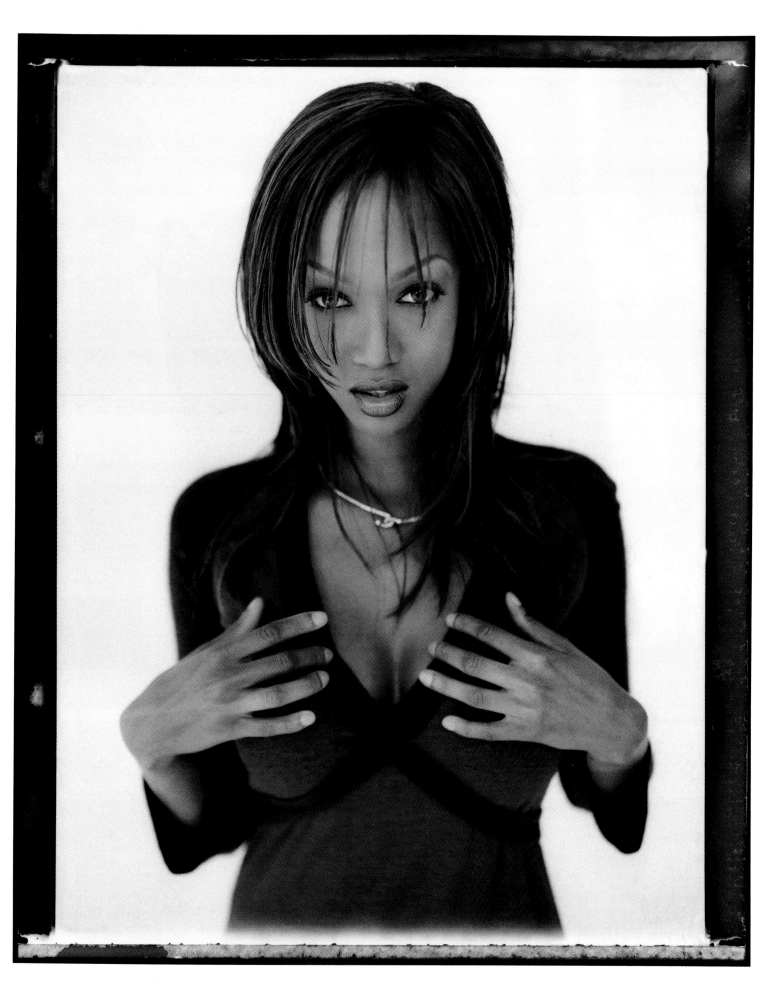

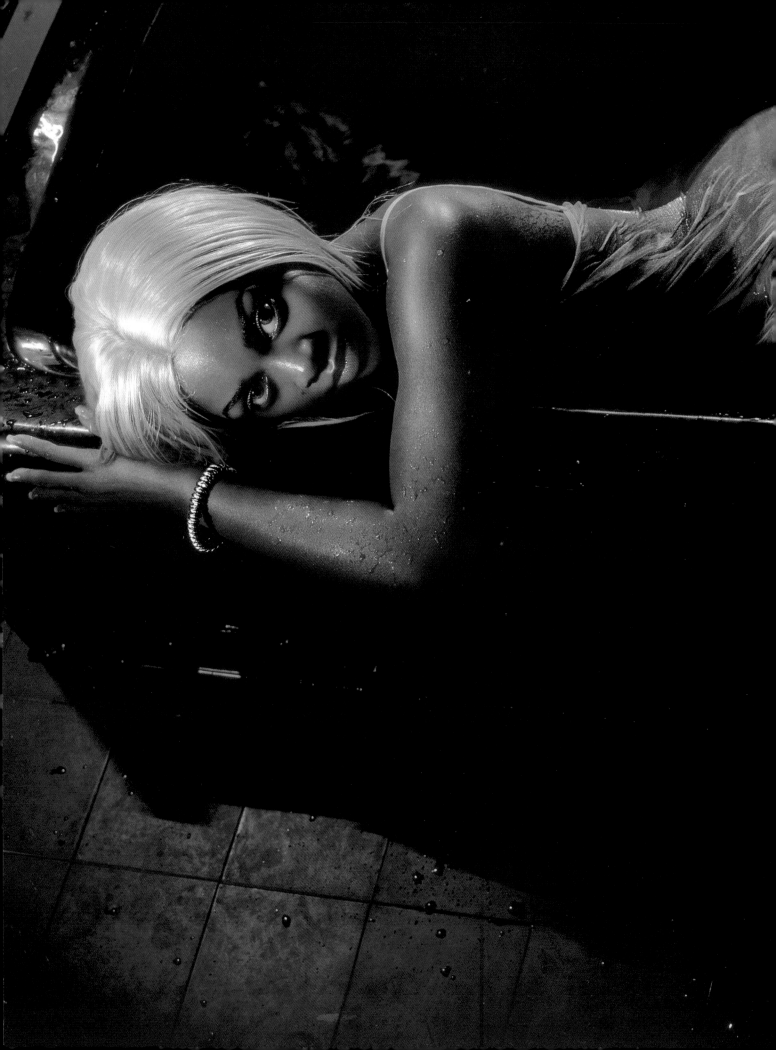

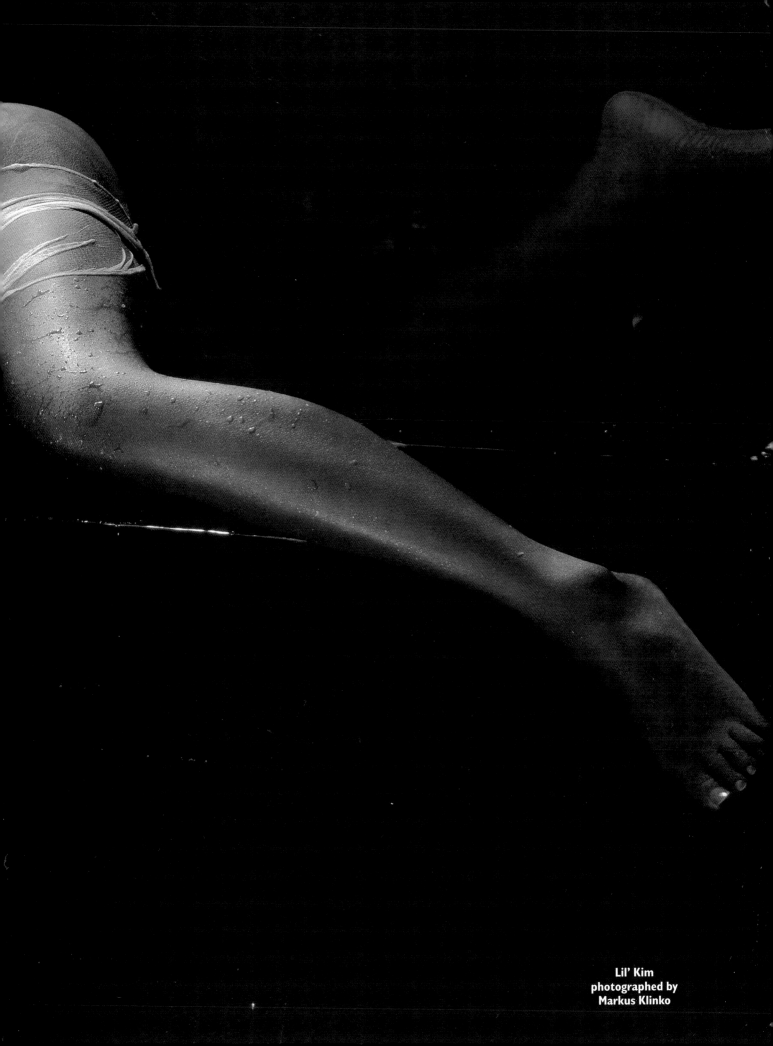

Lil' Kim
photographed by
Markus Klinko

Glamour Girls

Halle Berry
photographed by
Steven Meisel

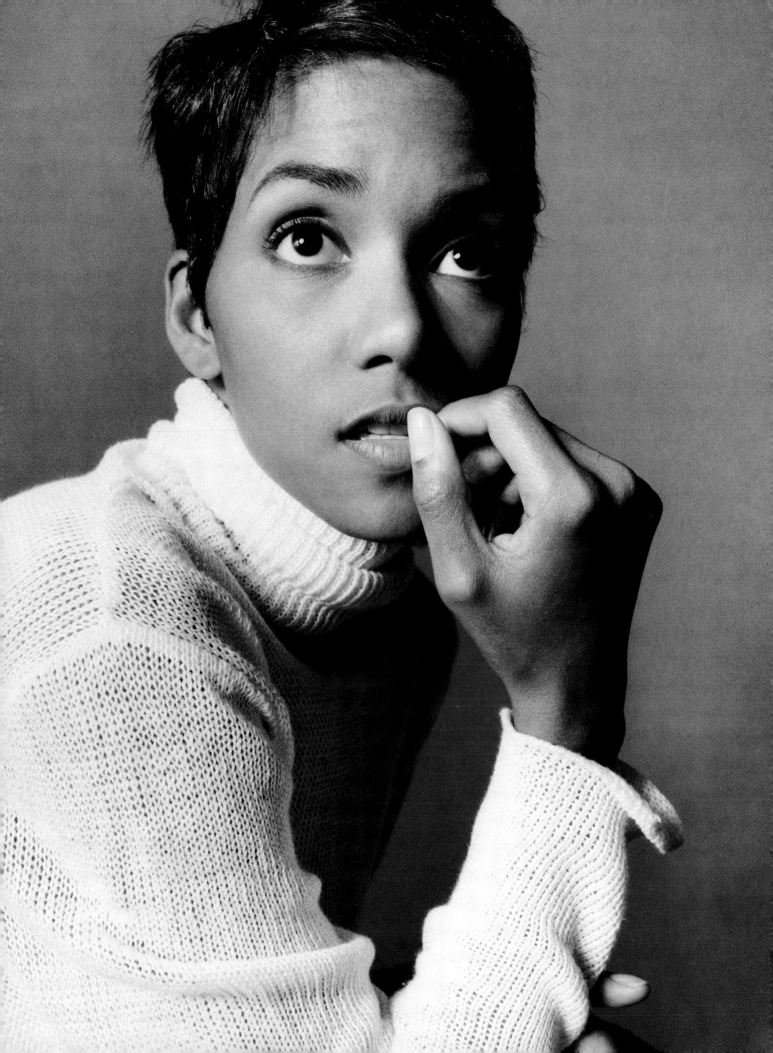

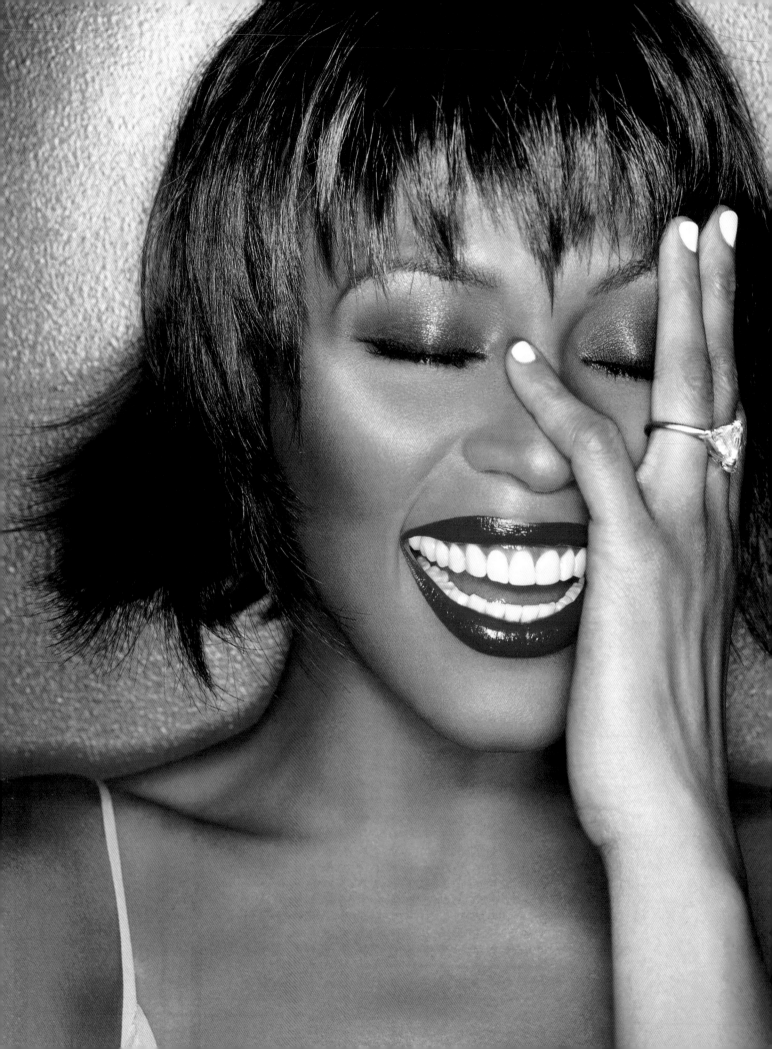

On Grammy night, I, most probably like you, pressed the button on my remote control, settled into the pillows on my bed, and watched the parade of fashions with as much interest as I watched who got what awards. A few weeks later I did it again. This time it was the stars hitting the red carpet at the Oscars. Though Black actresses were as scarce as dodo birds—and to think, this is billed as Hollywood's biggest party—those who were present shone. Garcelle Beauvais in a shimmering gown she must have been sewn into, Vanessa Williams in demure black skimming her lovely pregnant belly, and Angela Bassett, her pumped-up arms a riveting contrast to the romantic strapless beaded evening gown she wore.

As we move from the last decade of one millennium into the first of another, our insatiable interest in style is among the most important pop culture developments. And soul style—as exuded by celebrities like Angela Bassett, Garcelle Beauvais, Whitney Houston, Oprah Winfrey, and Star Jones—has had a major impact on the definition of style. These women are fashion role models for a host of Black girls and women who flip on television sets and thumb through the latest magazines. Always impeccable, down to the well-manicured fingernail, these are the glamour girls. The stars for whom looking slick and beautifully put together is as important as their work. Glamour girls don't step out of the house looking shady.

These stars exude the glamour, the chic attention to detail in fashion and beauty that has long been associated with both Hollywood, and with Black women in general. In the mainstream spotlight, these stars project a style that is glamorous yet accessible, a sensible and tasteful interpretation of high fashion that is consistent with their careers and their crossover audience.

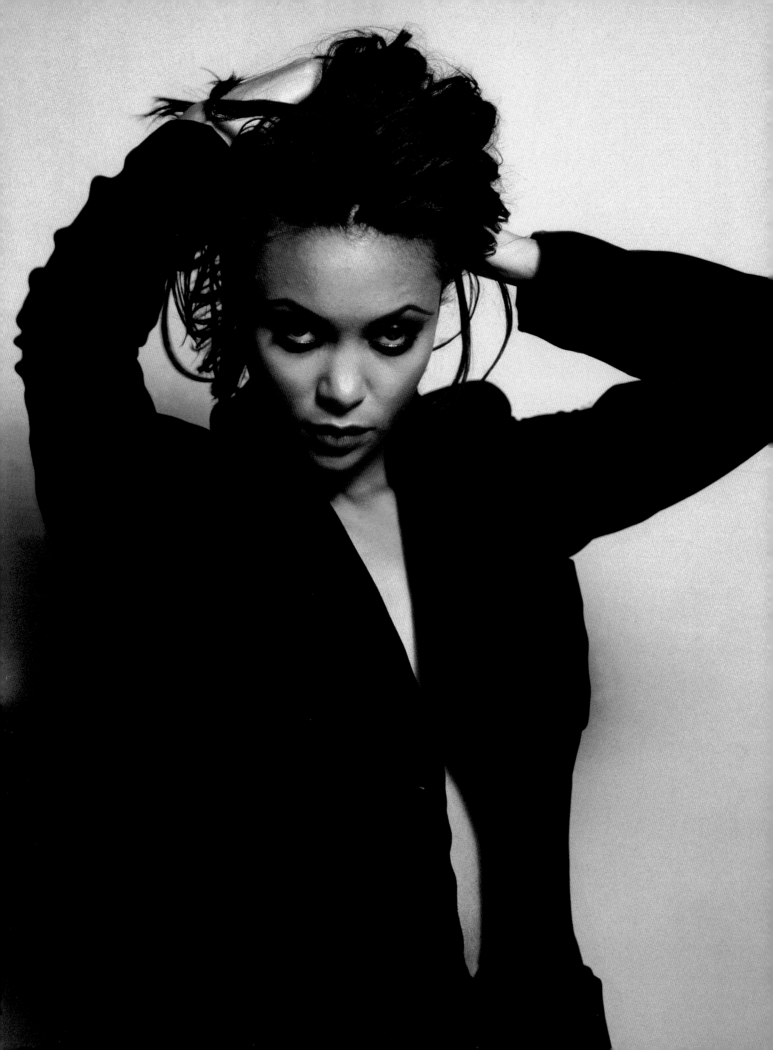

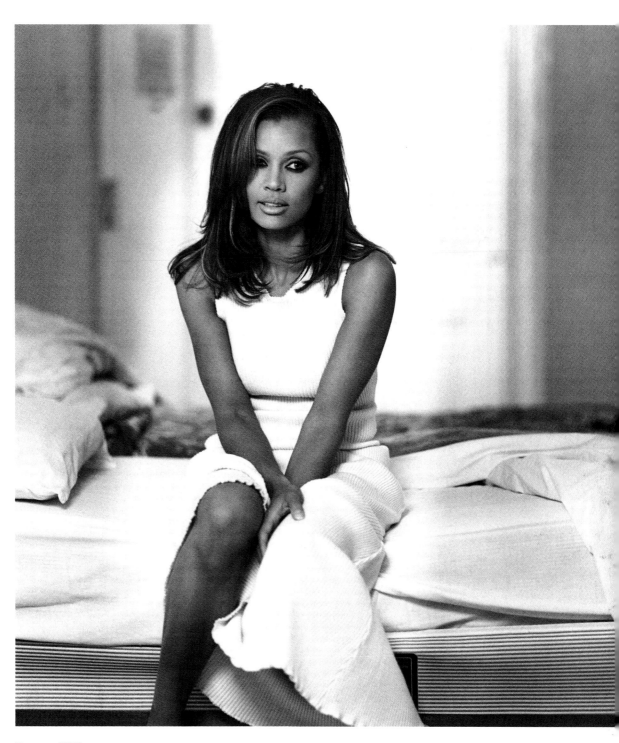

Vanessa Williams
photographed by
Bob Frame;
Opposite:
Thandie Newton
photographed by
Firooz Zahedi

Angela Bassett
photographed by
Bob Frame

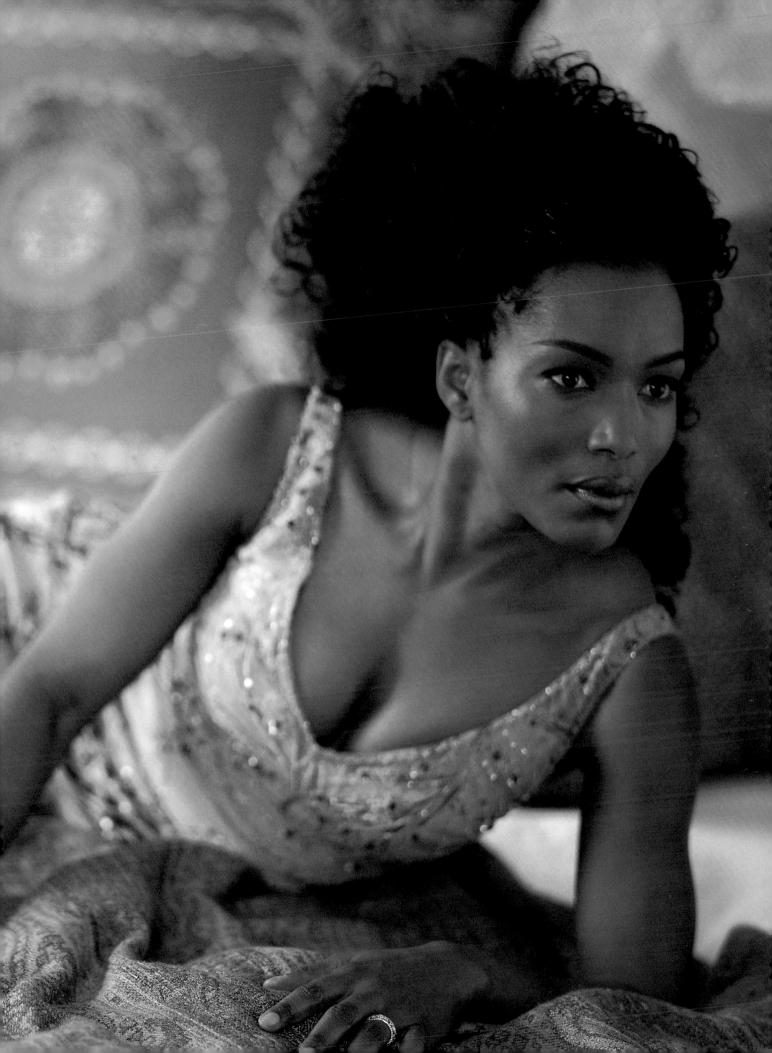

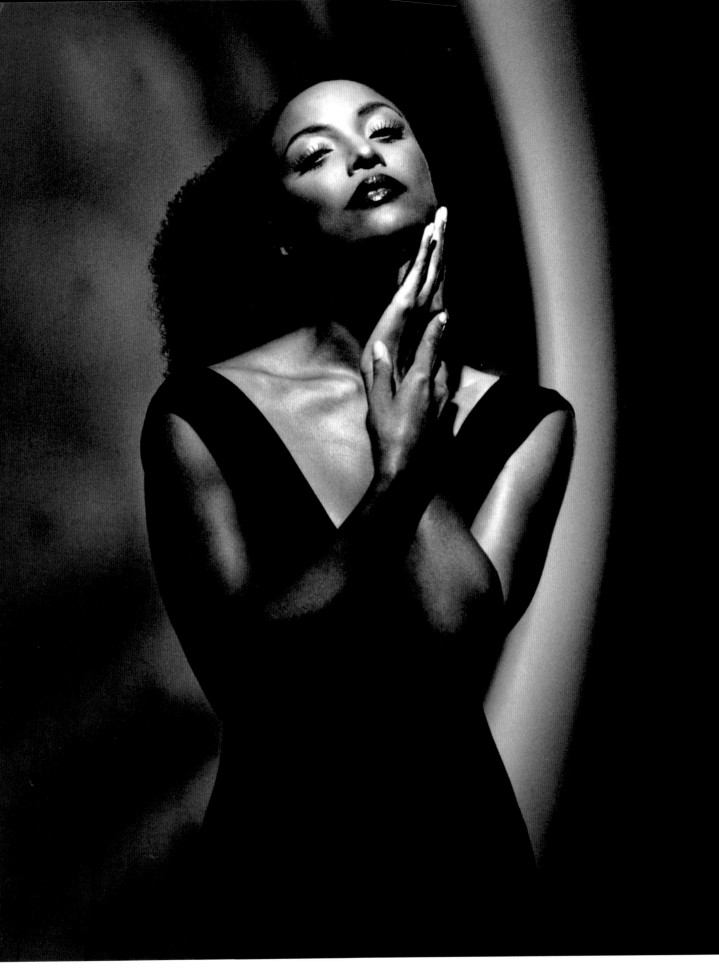

The two most influential glamour gals are Star and Oprah. The first needs no intro-
duction. Star, a lawyer, burst onto the scene as a legal reporter on television. She has
now fulfilled the destiny of her name as one of five rambunctious hosts of ABC's *The
View*. Both Star and Oprah have a daily audience of millions and they've made an impact
as large-size women who ain't afraid to dress up. This, of course, is a very soulful tradi-
tion—big Black women who don't give a second thought to wearing vibrant colors,
flashy jewelry, a parade of different hairstyles, and sexy, bold shoes. As full-figured celebri-
ties, their influence has no racial boundaries. Sure, years ago, Oprah was the famous
dieter, making news when one of her weight-loss programs got her into size-eight Calvin
Klein jeans. But what has really been part of the Oprah legacy is seeing a large-size Black
woman on TV every day, a woman who is attractive and style-conscious.

You have to hand it to Oprah for always staying abreast of fashion. The effort has
never seemed overwrought. From the baroque look of the eighties, when she shot to
stardom, to the more dressed-down minimalist style of the nineties, she has evolved
nicely into a sleek model of mainstream style. These days Oprah is likely to be in the
kind of ethereal comfort clothes that mark the new millennium: luxurious knitted
twinsets, long white skirts, tactile shoes, and skinny knitted tunic tops with matching
pants. Her trademark makeup—smoky eyes and bright, wet lips for daytime—is
always impeccable. And Oprah's hair is truly her crowning glory. She has worn it, plus
a few wigs, in a variety of styles over the years, from Afros to shags to a smooth
glossy shoulder-length bob.

Perhaps more than any other star, Black or white, Oprah is everywoman and like
every woman she loves to dress up and play the drop-dead glamour card on occasion.

Stylewise, Star might easily have been pegged as another Oprah, but when Star
came along she ratcheted up the style quotient for all women on TV, all celebrities, and
all women of a certain size. Star always looks fabulous. It may be 11 AM when *The View*
is broadcast, but Star looks like she's about to take to the stage at the *Soul Train* awards.
Her look is Ladies' Auxiliary Second Baptist Sunday luncheon meets trés chic Paris
haute couture. This means stilettos, preferably Manolo Blahnik, color-coordinated out-
fits, and a bank vault worth of makeup, diamonds, and a revolving selection of wigs
(which she also sells under her name).

Looking the part of a star has become a high-stakes, three-way play between the
star, the designer, and the stylist. The designers and stylists chase the stars, and the stars
are just as intent on bagging the most fantastic dress, because looking right has once
again become crucial to one's career. Not only can it catapult a star onto the pages of
numerous magazines and enhance their visibility, it can lead to valuable contracts from
advertisers. Style power equals star power. Hollywood insiders like Angela Bassett, Halle
Berry, Jada Pinkett Smith, Lynn Whitfield, Vivica Fox, and Stacey Dash have become
experts at the game.

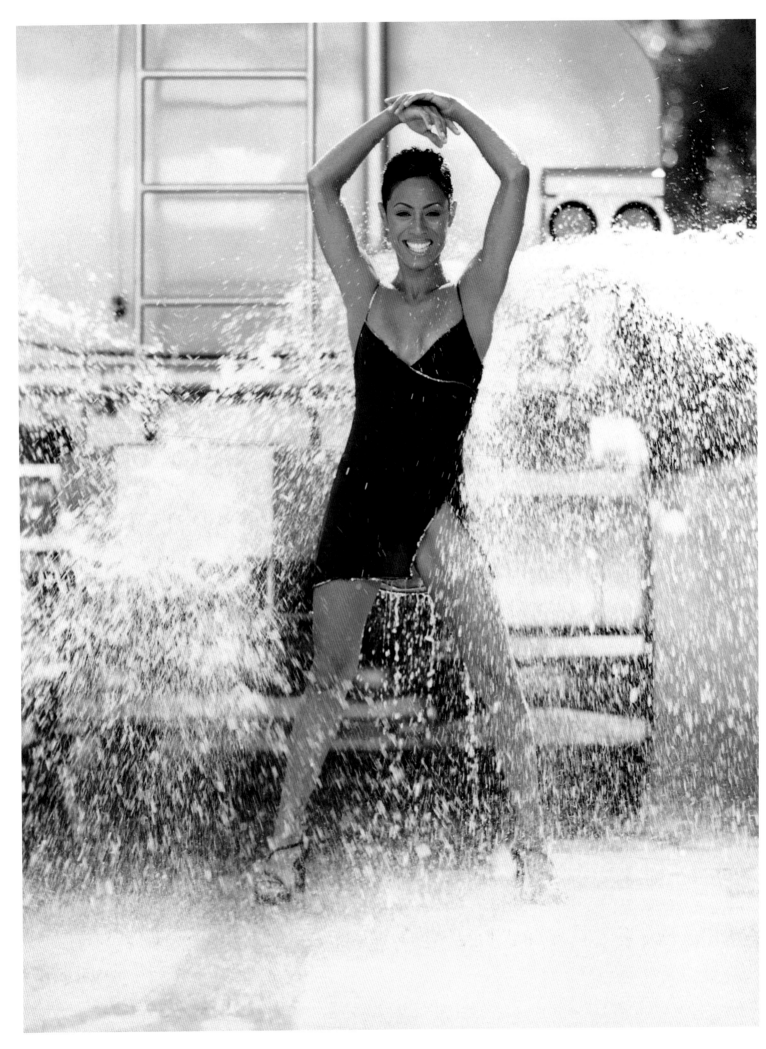

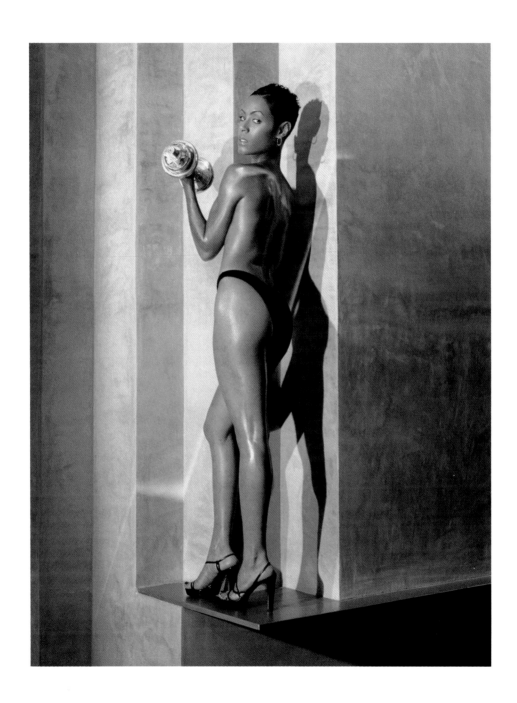

Jada Pinkett Smith
photographed by
George Holz

Jada has pulled off a look on her own terms. She is sought after by high-fashion designers who want to see the beautiful star outfitted in one of their gowns when she hits the red carpet with her prominent husband, Will Smith. Like Star and Oprah, Jada has true soul style, though it's of a different kind. She is just as likely to give a hip-hop spin to her appearance, with her close-cropped, wavy hair or baggy pants baring her midriff. As an actress her audience is the hip-hop generation, Black and white. In contrast, Angela Bassett's older, more wide-ranging following seems to demand that she dress more elegantly and conservatively. Always impeccably turned out, Angela's a top "get" among designers. She chooses romantic, glamorous looks from designers like Badgley Mischka and Escada. Another favorite glamour girl of European designers like Valentino and American designers like Ralph Lauren is Halle Berry. Halle's beautiful, glossy style helped her land the role of Dorothy Dandridge in the television film, which she coproduced for HBO. So strongly associated with beauty and glamour was Dandridge and the era in which she emerged, it's hard to imagine any star without a strong style image being given the green light to play her.

Music stars show a greater range of style and, in fairness to the stars of stage and screen, our musical sisters have more of a legacy and more leeway in expressing their style. The music industry is much broader in its vision of what is and isn't acceptable style. Hip-hop and R&B have had such an influence on culture and on record companies' bottom lines that the door is open wider to Black shapers of style. More of the influential stylists in music are Black, whereas in Hollywood most are white. A freer expression of style is encouraged in music simply because for the most part music stars have a hand in how they want to present themselves on stage and in videos. In a movie, the actor must dress in character, in clothes and makeup provided by a costume designer and a director. Stylish sirens like Whitney, Toni Braxton, Deborah Cox, and Sade have a long, colorful legacy of glamorous singers who came before them. Paving the way were Aretha, Diana, Dionne, Patti, Nina, British chanteuse Shirley Bassey, Billie Holiday, and Bessie Smith.

Black artists had a hard time breaking into music videos, one of the primary ways the religion of style is preached today. We still don't find our stars featured as often in the style annals as their white counterparts, but amazingly their effect is as potent as that of their white peers. Black culture's pervasive influence over the last ten years is one reason. Another is that we have always had our own vehicles of communication. Black Entertainment Television, god bless—it tries—promotes videos with Black entertainers. Our magazines have always been strong on star style, from bourgeois-Black publications like *Essence*, *Ebony*, and *Vibe* to the Black "hair salon" magazines—we may not all buy them but we all read them when we're under the dryer at the salon. Magazines like *Black Hair*, *Sisters In Style*, *Sophisticated Hair*, and on and on are indispensable sources of exposure for our stars, and style information for the reader.

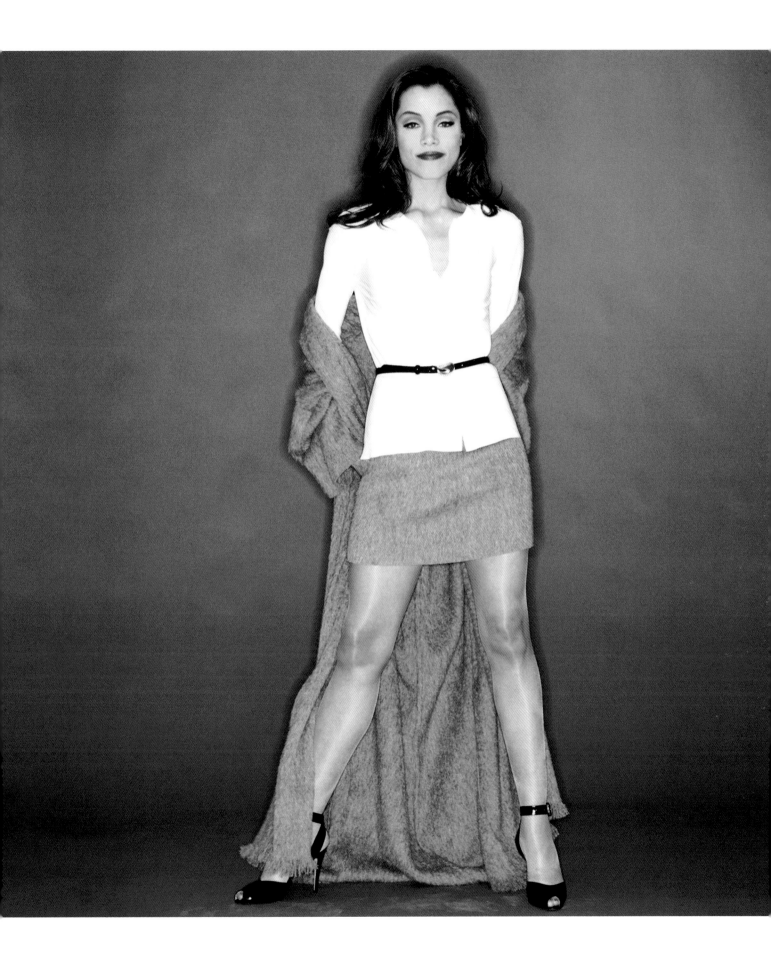

Halle Berry
photographed by
Kate Garner;
Opposite:
Lela Rochon
photographed by
David Jensen

**Deborah Cox
photographed by
Christian Lantry;
Opposite:
Theresa Randall
photographed by
David Jensen**

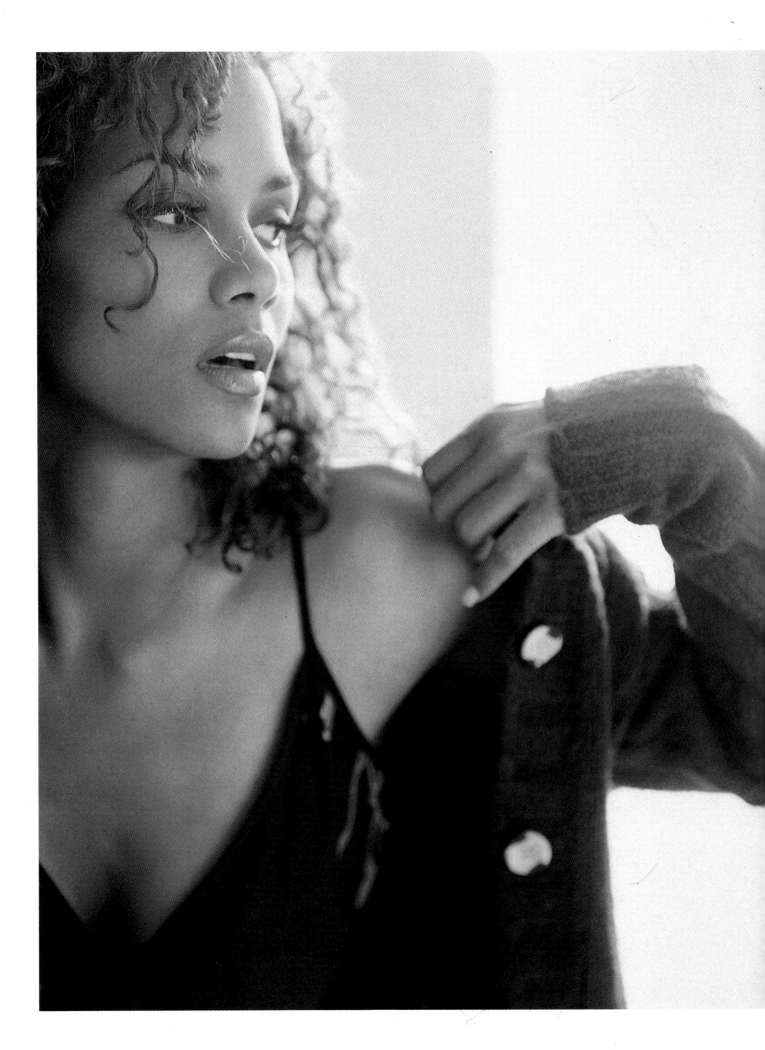

Model tall, model beautiful: Whitney Houston is a walking billboard for style. Devastating. Influential. Impressive. She was all this—and "all that"—when she chose Italian designers Dolce & Gabbana to outfit her for her 1999 world tour. Prior to the tour, Whitney visited Milan to sit front row at the designers' show. She looked gorgeous. The paparazzi went crazy as they had two years before, when La Whitney swept into the Versace show in a floor-length Versace gown and with an entourage as big as the president's trailing behind her. The Italians love Whitney for her style as much as her voice. She wears clothes so well, and because she is one of the top international female vocalists in the world with such a large following, all designers want to dress her.

Designers appreciate stars who exude glamour. In a purely callous vein, they help them sell their clothes. But youth and glamour haven't often gone hand in hand in our generation until recently. There's Whitney, and then there's Toni Braxton, the first of the new, young singers to establish herself as much for her singing as for her look. In 1994 when I was the executive fashion editor of *Elle* magazine, I interviewed Toni in my celebrity style column. In describing her approach to style, Toni said, "I wouldn't pay $70 for a tee shirt, but I would pay over a thousand dollars for a Barry Kieselstein-Cord belt." Recognizing an invaluable endorsement when he heard one, Mr. Kieselstein-Cord promptly sent Ms. Braxton a luxurious belt.

Toni went on to win a VH1 style award. Designer-driven, her look is sophisticated and sultry with sexy cut-out gowns, Kohl-ringed eyes, and always, always ready for the camera whether she is in jeans or high fashion. Designer Marc Bouwer's trademark is steamy, stop-the-party gowns for celebrities like Pamela Anderson Lee and Patti Labelle. But he chose sultry Toni to vamp her way down his runway as his ultimate celebrity client when he staged his show in New York in 1997.

In the grand manner of Madonna, soul stylists like Vanessa Williams and Deborah Cox have used their style to catapult them into lucrative endorsements for designers. Vanessa's cool, ultra-glam look landed her in ads playing up her severe hair combined with voluptuously red lips. They're notes in her style repertoire. Like her singing, Vanessa's look hints at erotic passions brewing beneath a clean, mellow surface.

Soul style is more than a Black body in a white dress. Glamour has always been a definitive part of soul style or Black style. Transcending any particular era or place, we have a disposition—who can say if it's genetic or cultural—to glam ourselves. It's partly the reason we spend so much money on fashion and beauty products.

The most notable of stars are those who bring something of themselves to the clothes they wear; the way they put on their makeup, how they do their hair. Still more special are those who manage to express something of our unique culture in how they look as they go about the business of being stars. —*Constance C.R. White*

supermodels

Naomi Campbell
photographed by
Steven Meisel

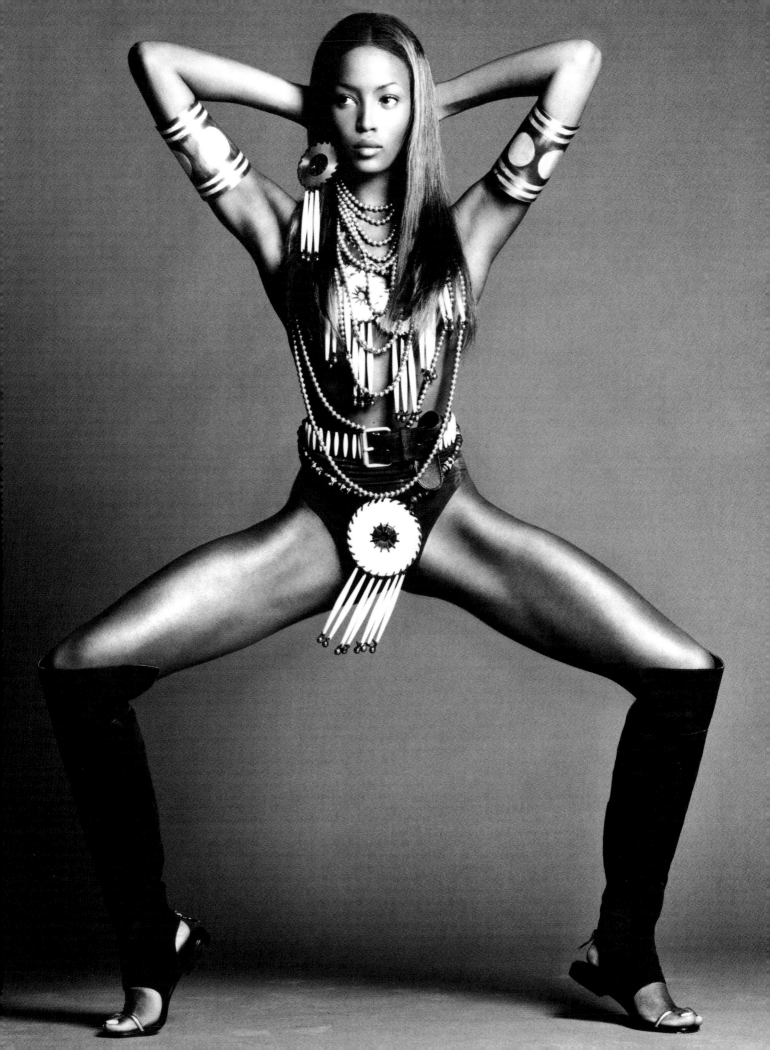

A lek Wek is regally African. Her skin is shiny and smooth like so much black marble. Her hair is scalp-short and oh so gloriously nappy. Her lips are voluptuously full. Her nose is prominent and flat. Her hips are wide and round. Her lithe legs are elongated, made for the long-distance strut that sets hips to swaying as only a Black woman can.

She is far from the European idea of beauty. Yet, in 1997, out of nowhere, this Sudanese refugee-turned-model suddenly found her kind of beauty cele-brated almost everywhere. Alek proudly conquered the catwalks for designers as diverse as Yves Saint Laurent and Ralph Lauren, brilliantly starred in dozens of beauty and fashion spreads, and culminated the year flashing her exuberant smile on the cover of *Elle* magazine.

A supermodel was born.

Supermodel, a word coined in the mid-1980s to describe the new breed of models whose power to fascinate the public allowed their careers to soar far beyond the catwalk or the printed page. These top-tier members of the beauty elite came to be known by name and face the world over. Their celebrity status granted the mega-models huge sums of money and queenly perks to add their faces and fame to promote movies, commer-cials, restaurants, night clubs, music videos, albums, clothing lines, books, and much more.

Like the biggest female movie stars of old Hollywood, the supermodels were the sought-after glamour queens of their times, showing up at all the right parties, pre-miers, and places, their lives and loves suddenly fodder for the gossip sheets.

And among the select few to climb to the top and lay claim to the title "supermodel" were some of our own breathtaking beauties: Iman, the legendary one, an exotic regal queen; Naomi Campbell, the chameleon-like temptress and ultimate fashion diva; Tyra

Banks, the body-beautiful All-American girl who turned lust into lucre; Veronica Webb, the class act with the brains to match the beauty; Beverly Peele, the gorgeous Lolita of her day; Roshumba, the hip-swinging downtown girl; Kiara, the elegant patrician princess; and, last, Alek Wek.

These women are icons not just of Black beauty, but of beauty in general. Their impact on society cannot be underestimated. More than mere status symbols of the billion-dollar fashion industry, more than just objects to project our fantasies upon, the supermodels we call our own are high-profile symbols of the enduring struggles of our race and our ultimate triumphs.

Some things that would seem trivial to some, such as Tyra Banks becoming the first Black model to capture the cover of the popular *Sports Illustrated* "Swimsuit" issue or Veronica Webb signing a multimedia Revlon ad campaign contract, does much to advance the cause of racial equality. Such milestones reveal us as a multidimensional people who are on equal footing with whites. Tyra typifies those models who in their efforts to integrate an industry made a visible difference. Told she would never make it in the modeling industry by a Black modeling agency receptionist, Tyra pressed on, jump-starting her career in 1991 by marching down the Paris runways with an electrifying stage presence at age seventeen. Using her big light-brown eyes and enchanting smile to seduce the audience, and her bombshell body to sell the clothes, Tyra was literally an overnight sensation.

But she decided to aim even higher. She sashayed away from a successful career in fashion modeling to create a niche in the previously lily-white model sex symbol industry, where the right pose on a poster can translate to millions of dollars. With her mother, Carolyn London, as her manager, Tyra worked to prove that there was room for a Black dream girl.

"Throughout the years, America has appointed models like Cheryl Tiegs, Christie Brinkley, and Cindy Crawford to represent the American standard of beauty," says Tyra. "But where was the African American 'girl next door?' I set out to show people that a Black woman's image could indeed cross racial boundaries."

By age twenty-three, Tyra had opened those previously closed doors. There she was, in an itty-bitty bikini, the first Black model to appear on the cover of *GQ* magazine. There she was in commercials, ads, catalogs, and calendars. She was the first Black model to receive an exclusive contract with Victoria's Secret, starring in the sexy lingerie company's famous Angels campaign.

Like Tyra, most Black models who achieve superstar status are not content to just let their photographic images alone define them. Far from pampered pusses content to be merely adored and adorned, our supermodels are also role models. They speak out against injustice, raise millions for Black causes, form foundations, and dare to shine a spotlight away from the catwalk and into the dark crevices of the fashion world where racism and bigotry hide.

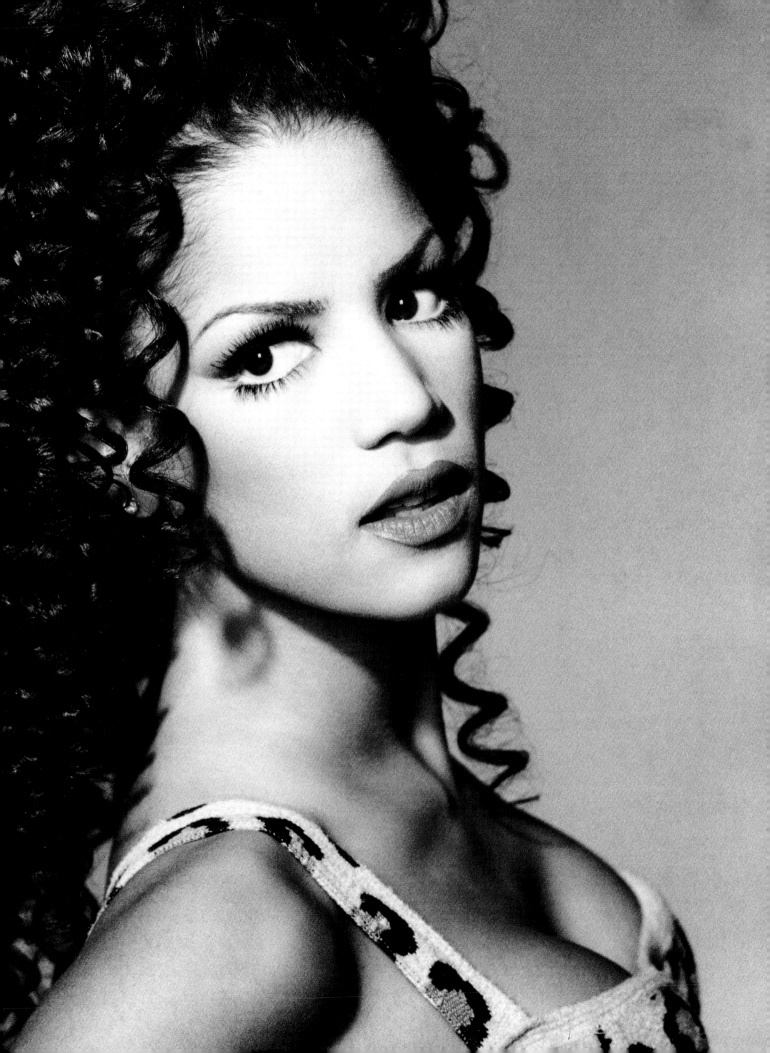

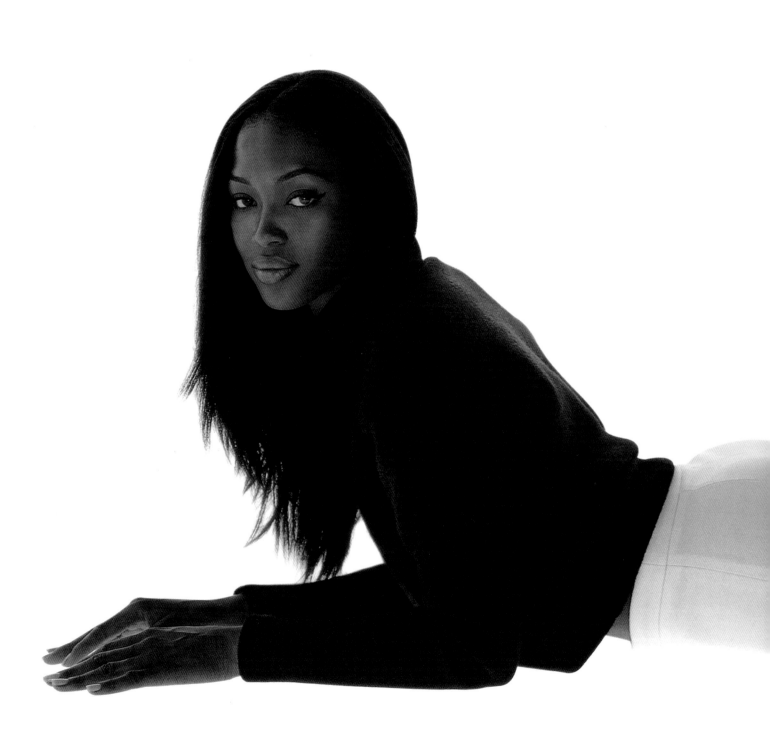

Naomi Campbell
photographed by
Gilles Bensimon

"They're more than just beautiful," says Sam Fine, celebrity makeup artist and author of *Fine Beauty*, "they do beautiful things."

Veronica Webb, for example, has written and published many articles scolding designers for all but banning Black models from the runway during some seasons. Roshumba, who moved from modeling to television and movies, raises money for the United Negro College Fund and has penned a book offering model aspirants a realistic look at the business.

Tyra endowed a scholarship for girls who wanted to attend her private Los Angeles high school alma mater but could not afford the tuition. She also started a foundation to establish a youth camp for young girls.

Similarly, Alek Wek works to raise awareness of the atrocities in her homeland. Discovered by quirky British magazines shortly after she fled to England to escape the civil war in her native Sudan, Alek's electrifying emergence did more than just further challenge white America's concept of beauty. Her success also held up a mirror to our own notions of what is beautiful. For, yes, there are some African Americans who look at Alek Wek and reject her Negroid features as "ugly."

Some call it "self-hatred," this shocking lack of appreciation of Alek's visage by some African Americans. But closer to the truth is that we African Americans, too, are heavily influenced by the values of the society we live in, which worships the European standard of beauty. To see Alek make it as a model, then a supermodel, is to see at last an acceptance of the real us, the kin of the motherland.

And that, finally, is why our supermodels and our mere models are more to us than just the personification of youth, style, and good looks. Our supermodels are reflections of our people, still emerging, still fighting, still proving ourselves, still breaking through barriers, still crying out to be seen and to be heard.

Their success is more than just about setting fashion and beauty trends. Black supermodels by their very visibility among the upper echelons of the fashion and beauty business have shown us again and again that if we press on, we cannot be held back.

It was not so very long ago that our aspirations to have our beauty and sense of style accepted by society at large stopped at some imaginary line that was, to us, as real as the signs that proclaimed some water fountains were "For Whites Only."

Until the 1970s, Black models were almost exclusively on the pages of Black publications in fashion spreads and ads for Black products. And if one wanted to see a Black model in a fashion show, well, it was in a show whipped up by your local church or a Black women's social organization.

Johnson Publication's traveling *Ebony* Fashion Fair, started in 1958, was the closest thing one could get to seeing live presentations of couture designs on Black models. And, oh, how we were thrilled year after year by the plethora of elegant Black women tipping down the runway swathed in a Dior or Chanel original. But that didn't stop us

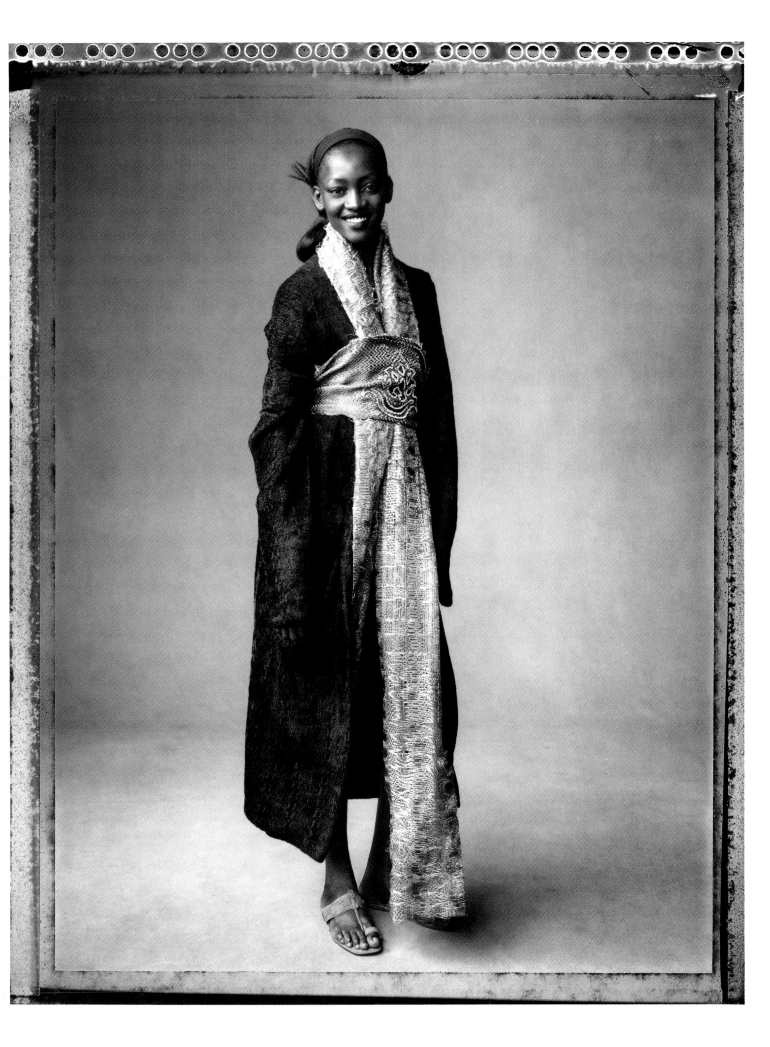

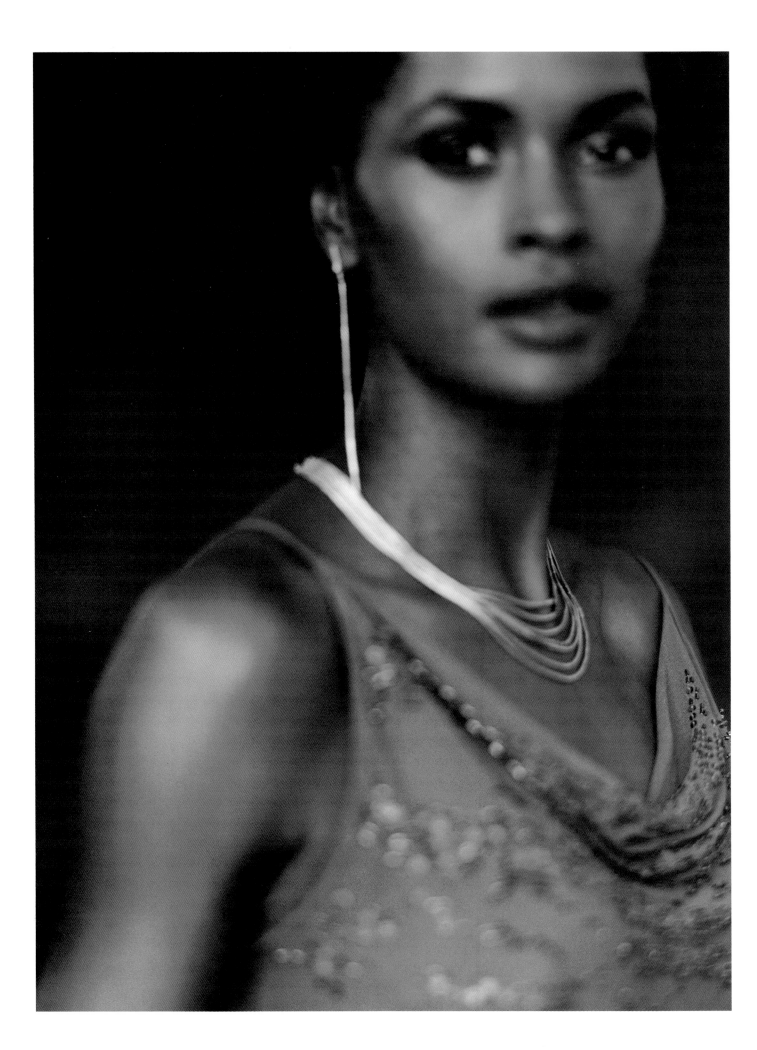

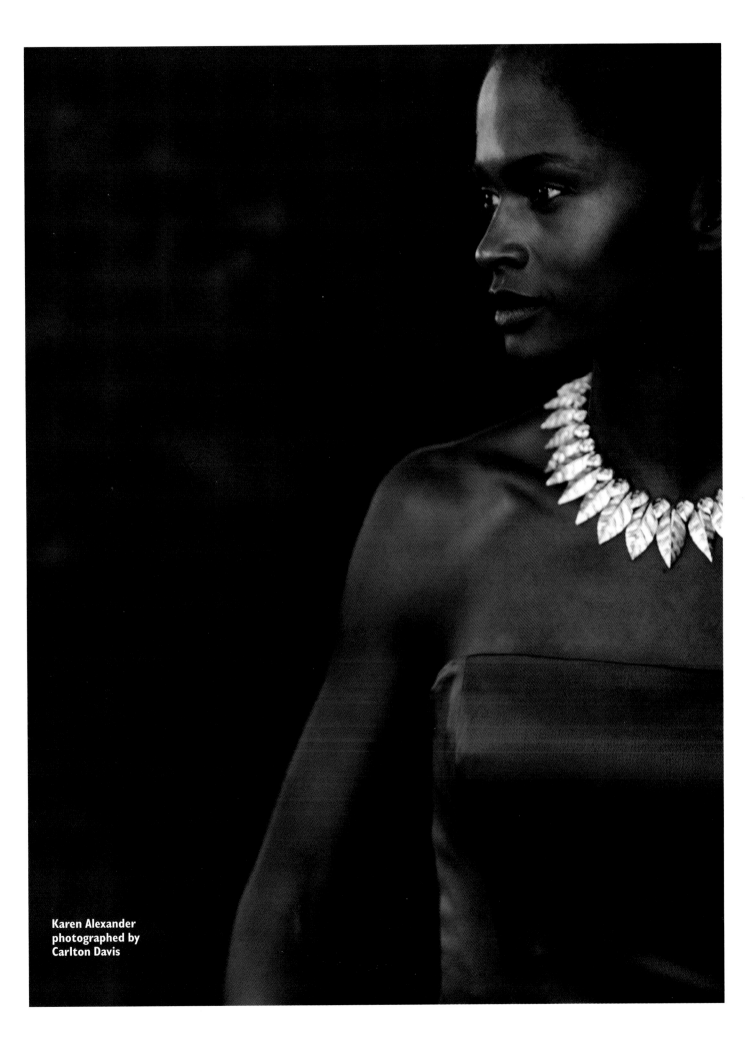

Karen Alexander
photographed by
Carlton Davis

Maureen Gallagher
photographed by
George Holz; oppo-
site: Adia
photographed by
Markus Klinko

from longing to see ourselves reflected in that great larger pool of beauty.

So when Beverly Johnson in 1974 obtained what had previously been unobtainable to Black models—the cover of *Vogue*—it was not so much a validation of our beauty, but a long-awaited acknowledgment. It didn't take *Vogue* to tell us Black was beautiful. We already knew that. But that racially groundbreaking cover told the world at large that we wouldn't be held down, held back, ignored, downplayed, or kept out any longer.

But truth to tell, any Black model that could keep on working in the face of the industry's rampant racism and bigotry had to indeed be super. Not only did she face rejection time and time again just because of the color of her skin, when she did find work she had to work harder, be nicer, act more grateful, and content herself with less pay than her white counterparts.

In the 1940s, 1950s, and early 1960s, when Blacks were segregated and mostly left out of the mainstream, Black models such as Ophelia DeVore, Helen Williams, and Ruth King inspired us only from the pages of *Ebony*, *Sepia,* and other Black publications, and made their mark in fashion shows produced by Black people for Black people. Though underground and unknown to most Americans, to us they reflected our dignity and beauty in a way that the Black supermodels would later do for the rest of the world.

In the late 1960s, as the civil rights movement took hold, Naomi Sims, a doe-eyed woman with skin the rich color of Caribbean coffee, broke the magazine color barrier. From the cover of *The New York Times Magazine*'s semi-annual "Fashion of the Times" issue to appearances in the so-called Seven Sisters' magazines—*McCall's*, *Ladies Home Journal,* and the like—to *Vogue*, Naomi Sims put Black models on the mainstream map.

The 1970s was the dawning of a new era. On the heels of the Black power movement and revolutionary focus on Black beauty, a cadre of Black models rose to the forefront of fashion.

These women, Bethann Hardison, Billie Blair, Alva Chinn, Toukie Smith, Pat Cleveland, and a few others, waged a revolution of their own. They took to the runways of leading fashion designers with such panache and style that their presence alone turned a fashion show into an exciting event. American designers fell in love with them. They achieved international acclaim when they were dispatched to Versailles, France, to show off American fashion in a show that pitted U.S. designers against their French competitors. Cleveland and her sisters of the catwalk prowled the stage with a grace and a sweeping style that brought down the house.

It was a watershed for the industry and at last gained Black models their long overdue respect. It also was the seed from which the Black supermodel would eventually sprout.

Cleveland personified that era and its Black models. Tall, straw-thin, with the face of an imp, the native New Yorker captivated audiences with her theatrical antics and her devil-may-care attitude.

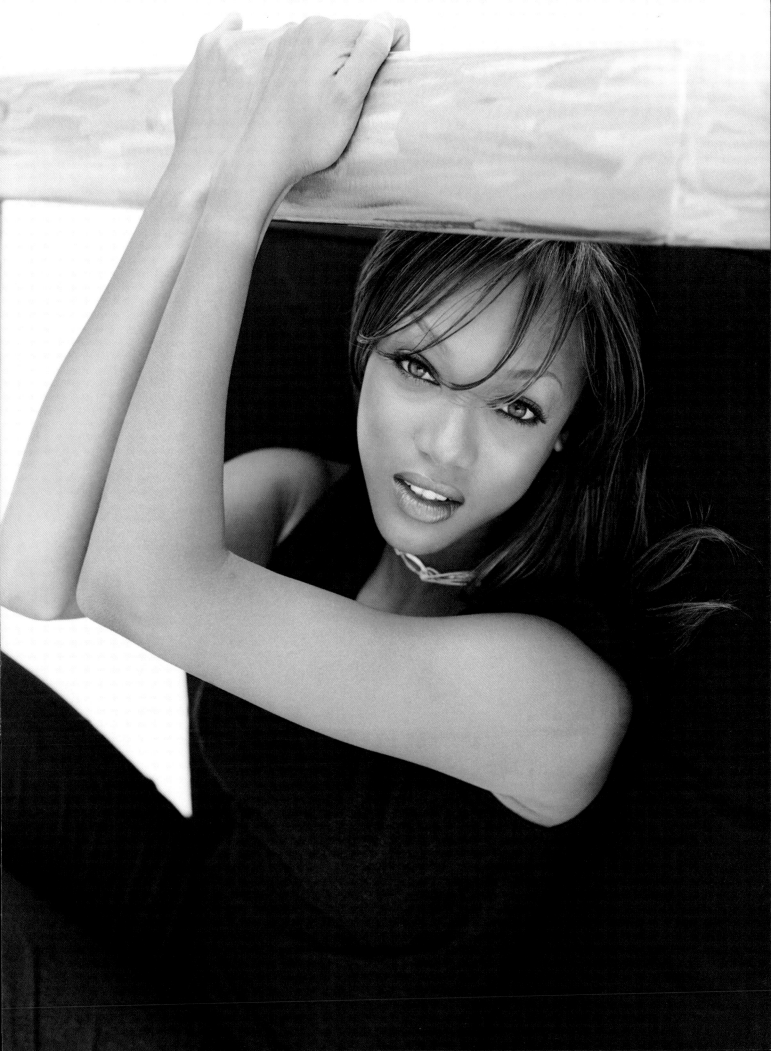

Chrystelle
photographed by
Pamela Hanson

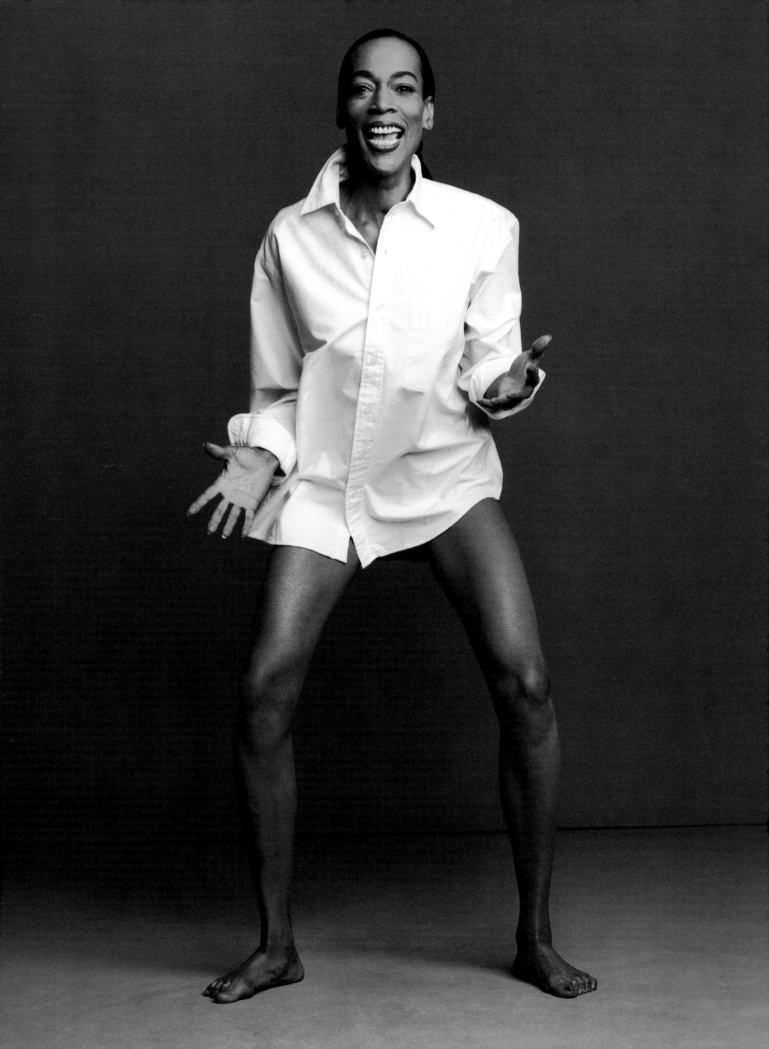

"No one could walk like her on the catwalks," recalls model turned fashion-mogul Audrey Smaltz. "She took Europe by storm in the early seventies."

That was a time when designers like Stephen Burrows, Paco Rabanne, Yves Saint Laurent, and Halston wanted models who could galvanize an audience, bring a crowd to its feet. Black models, held back for so long, filled the bill. Black designers such as Willi Smith and Patrick Kelly shot to fashion stardom, helped along the way by sending these bombastic Black models down the catwalk in their creations.

"They could take anything and put it on and make it look like a million dollars. They were just incredible," says Smaltz.

Indeed, their flamboyant style of modeling was to influence generations of professional and semiprofessional Black models.

Meanwhile, the magazines began sprinkling their pages with beautiful Black faces.

Beverly Johnson was the reigning Black queen of major magazines. On that famous *Vogue* cover of 1974, she was as American as any other model, her hair straight, her skin flawless, her jewelry discreet, a silk scarf wrapped about her neck inside a turtleneck sweater. The photo seemed to say to white America, I'm just like you. To Black America, the photo said, See, I've made it, even with the many obstacles in my path.

She broke through and gave lie to the widely held publishing belief that whites would not buy a fashion magazine with a Black model on the cover. Other print models, Barbara Summers and Peggy Dillard, to name a couple, also made historic appearances in mainstream magazines around this time.

In 1975, the woman who would become the first Black supermodel burst on the scene with a ream of fake publicity concocted by photographer Peter Beard, who claimed to have discovered "an exotic six-feet-tall beauty" in the "jungles" of Somalia.

"Somalia is flat, a desert, it doesn't even have a jungle," says Iman, who is two inches shy of six feet. She was college educated and amazed that the media swallowed the jungle story and ran with it. But the publicity launched her career.

Iman's ascension came just as African Americans were making strides in the professional ranks but encountering a glass ceiling. She realized that her path was made easier because she was an outsider.

"For white America, I was safe because I was foreign. They don't have a hard time dealing with Black people, they have a hard time dealing with Black Americans," Iman says. That she was out of Africa was a source of pride for people of color everywhere. What an exotic presence she was in U.S. and foreign fashion magazines, page after page filled with her image, those impossibly long limbs, the swan neck, and flawlessly symmetric features set in a head that is a perfect oval.

Three years after arriving in the United States, Iman made a move that set the stage for the emergence of the supermodel phenomenon. She crossed the then rigid boundary between print models and runway models and made her catwalk debut in a

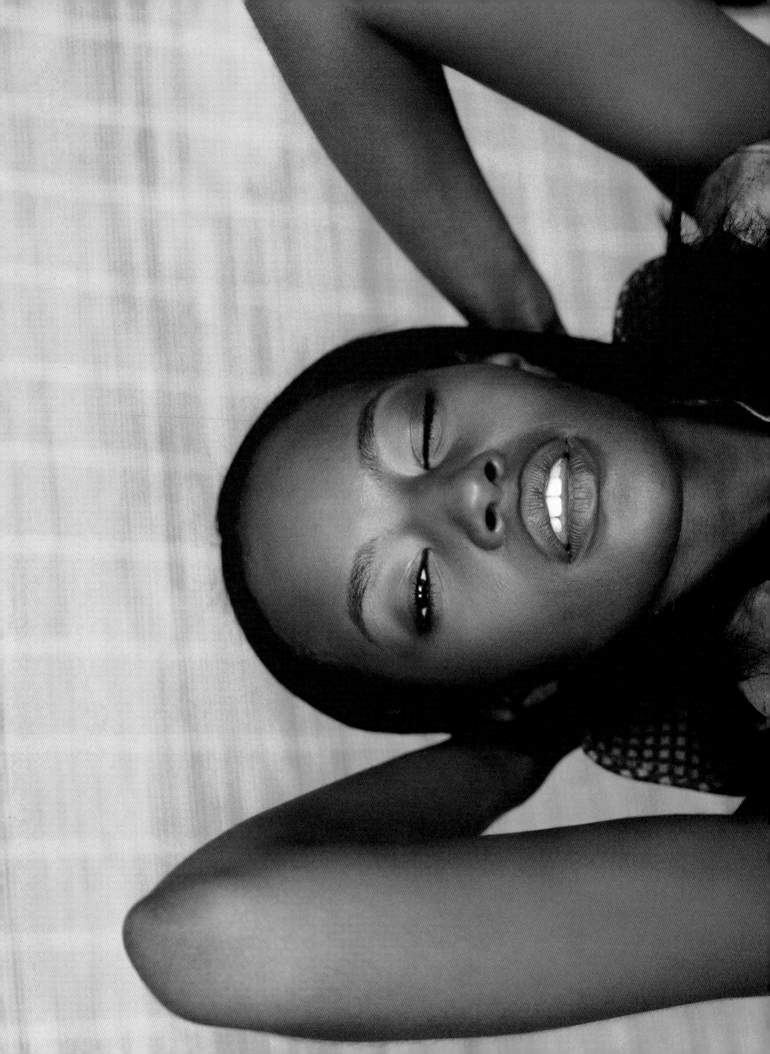

Kiara
photographed by
Jamil GS

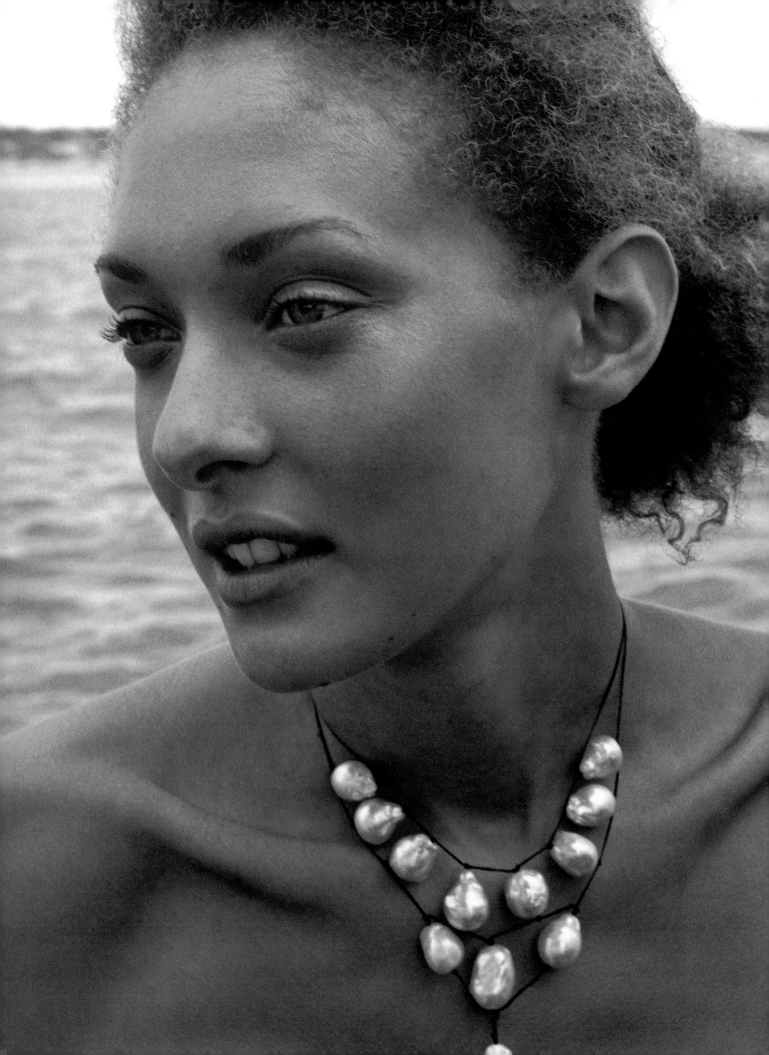

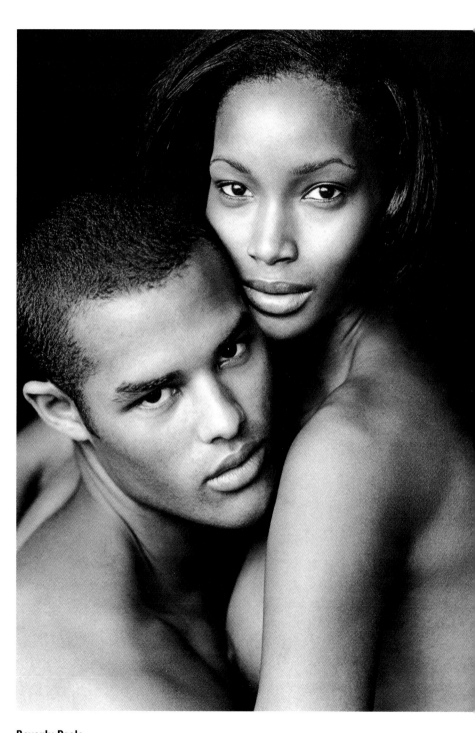

**Beverly Peele
with Jason Olive
photographed by
Calliope; opposite:
Chrystelle
photographed by
Gavin Bond**

Calvin Klein fashion show. She was a smash and never looked back.

Suddenly models could do print and runway work, doubling their earning power and multiplying their exposure. As the first Black celebrity model and ultimately the first Black supermodel, her name known around the globe, Iman says she was compelled to use her fame to help those less fortunate, especially in her suffering homeland.

"For starters, I believe in the saying that to those to whom much is given, much is required," says Iman. "One cannot live a life that is just about one's self, there is a lot to give. As a celebrity, you have a platform and it was natural for me to use it for Somalia."

Iman raised money to help alleviate famine in her country through fund-raisers and raised awareness by leading a BBC-produced documentary about the conditions there. The first Black supermodel, Iman proved to be an articulate spokeswoman, an efficient businesswoman, a gifted actress, an eternal beauty, and a champion of equal opportunity.

At the end of the 1980s, as Iman was preparing to retire from the catwalks for a career in movies and television, and African Americans were in a frenzy over designer goods, a new generation of gorgeous Black dream girls, some barely in their teens, entered the field.

These neophyte supermodels—Roshumba, Beverly Peele, Karen Alexander, Gail O'Neill, Aria, Georgiana, Brandi—were among a gang of gorgeous gals, prancing from photo shoot to runway presentation, from star-studded parties to exotic locations, all the while firing up our fantasies of the glamorous life.

"We did some really amazing stuff," says Roshumba, a wisp of a woman with a close-cropped Afro who went to Paris in 1987 after high school and a short stint as a medical technician. She was instantly the darling of the rag trade, courted by the houses of Yves Saint Laurent, Chanel, Armani, and many more.

"The opportunities were unbelievable. I know that I not only did every runway show for eight years, *Sports Illustrated* ["Swimsuit" issue] for four years, I also did basically every kind of advertising job from pantyhose to beauty products," says Roshumba, a Philadelphia native who grew up in Chicago.

Our models were now accepted in an endless variety of complexions and looks. Sam Fine observed that suddenly "the focus was on our beauty in so many different forms." There was Chrystelle, a fair-skinned beauty with a wild bush of dirty-blond hair who popped up on the Paris runways one season in the early 1990s. Discovered while studying at the Sorbonne, Chrystelle epitomized the new exotic global beauty and graced the runways of all the world's fashion capitals. There was Lana Ogilvie, a Canadian-born pixie with hazel eyes and a cocoa complexion, a popular magazine cover girl who captured a coveted cosmetics contract in 1992, the same year as Veronica Webb. And there was the sensuous beauty Maureen Gallagher; her killer body, sultry looks, and bronze skin made her a big hit in Europe and beyond.

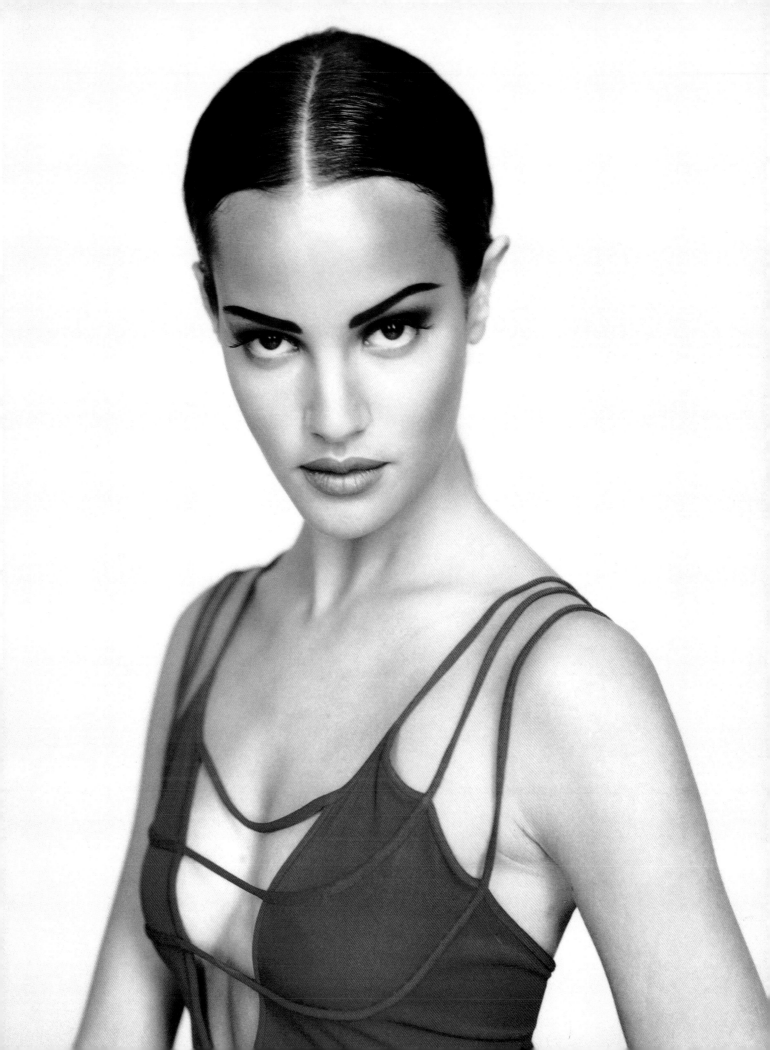

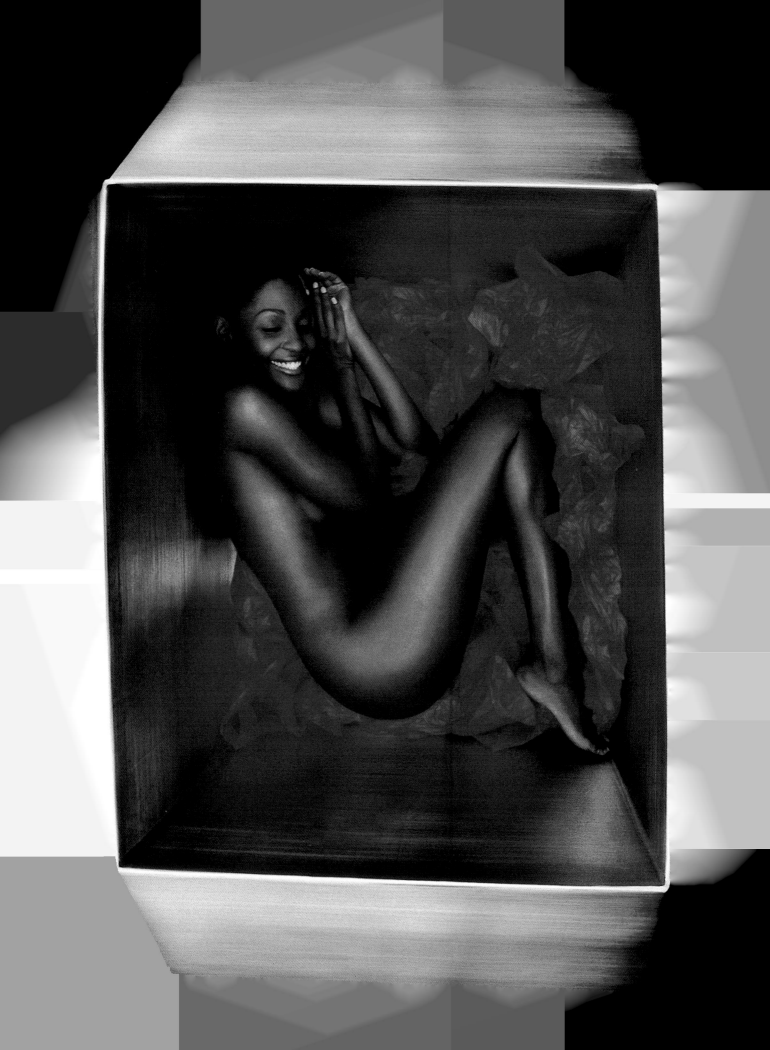

**Beverly Johnson
photographed by
Len Prince;
Opposite: Roshumba
photographed by
Kenneth Willardt**

One beauty would tower over them all. Discovered in 1985 at age fourteen by a London agency, the British-born Naomi Campbell was starring in *Elle* magazine by the time she was fifteen. Before long the world would be at her feet. She seemed born to be a model. But it is her chameleon-like ability to alter her appearance that made her a fashion icon. She changes hair color and length with ease; she can and does wear the most flamboyant wigs and makes them look natural. She adopts any persona from hellcat to innocent schoolgirl. In Naomi, Black women saw someone free to express herself in many different ways. She is widely credited with popularzing weaves and multicolored hair. And, like Pat Cleveland before her, Campbell's runway style has had a lasting influence on amateur and semiprofessional models.

She has worked with the world's top designers and fashion photographers, appeared in every major fashion magazine, recorded an album, penned a novel, appeared in movies, lent her name to the ill-fated Fashion Cafe chain, dated celebrities, and become intimates with the celebrated—from Gianni Versace to Tommy Hilfiger to Nelson Mandela. (She once staged a Versace fashion show in South Africa to raise money for Mandela's children's fund.) Naomi was truly Everywoman, the Black fashion star that shone the brightest. At last, someone to show the world that we didn't have to be nicer, quieter, meeker than whites for the privilege of earning our money. She even dared to bite the hands that fed her, criticizing magazines for still rarely using Black models on the cover. Naomi slammed the cosmetics and fashion powers who rarely gave Black models lucrative exclusive advertising contracts. And she even boycotted a few American designers one year, saying she was tired of being the only token Black model in their semiannual catwalk collections.

Yes, even during the fifteen-year popularity of Naomi Campbell and the dozens of other Black models that rose and disappeared in her time, racism still held many back. Some Black models of light skin downplayed their racial heritage to find work. Claudia Mason, promoted as an exotic Latin beauty, came into the modeling field in the late 1980s. The child of a white mother and Black father, Mason says that because she looked white or vaguely Spanish, the industry pushed her as an exotic model, disguising her Black roots. "That's what the powers that be in the fashion industry wanted so I just went along with it," Mason says. After years of working for top designers, Mason came to regret her decision. "It's important to me now that people know who I am," she says. "I was just so young when I started, and so easily influenced." So it is that our supermodels have given a face to the pride, the beauty, and the perseverance of a people.

With the arrival of the new millennium another generation of Black models are carrying the torch, led by the rising one-name starlets: Kiara, Adia, and Oluchi. This new generation can dare to aim for the highest heights thanks to the Black models before them who wouldn't take no for an answer.—*Roy H. Campbell*

Tyra Banks
photographed by
Kate Garner

Lege
nds

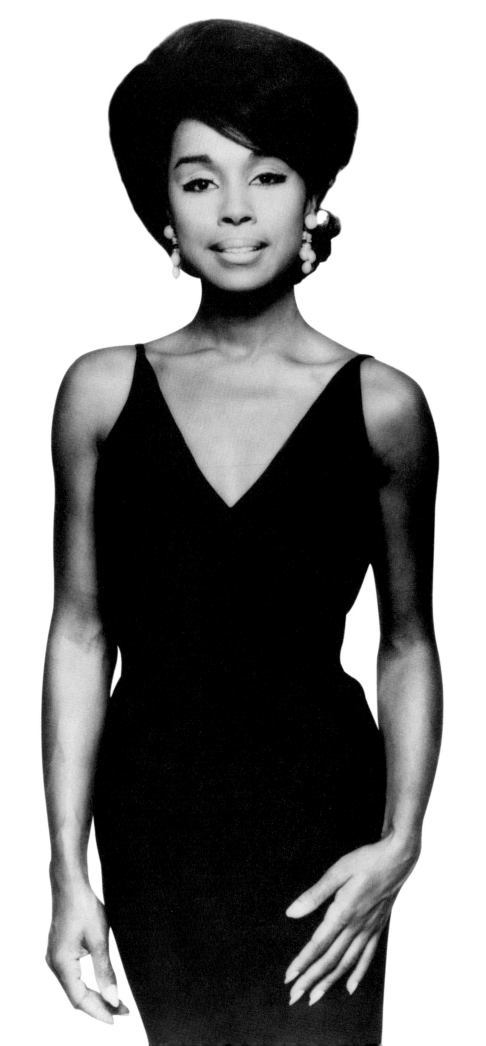

Voltaire once said about God: if He did not exist, we would have to invent Him. About Black women legends there is no doubt: They exist. With or without society's approval, they invent themselves. And with or without our knowledge, they continue to influence our lives.

Legends do what few can: outlive time. Ambidextrous, they write history with one hand and sketch the future with the other. As artists, they create masterworks, all the while trashing tired traditions with brash stances, regal restraint, sexual subversion, or any other means necessary.

That comes as no surprise. Black women have always been as complex in their individuality as the society from which they evolved. It is no wonder that the legends we claim are equally complex. Refusing to deny culture or color, they chose to enhance them with their choice of clothes and costumes, accessories and attitudes. And so they invented style along with themselves.

It is no coincidence that many of the legends we honor were performers. Their being required projecting. Trying to contain blues singer Bessie Smith to a juke joint, a pig's foot, and a bottle of beer was like trying to squeeze the genie back into Aladdin's lamp: impossible.

In the 1920s, she took her own hefty, round, brown figure, what was often portrayed as the stock Mammy in an apron and bandanna, and transformed herself into a red-hot mama bedecked in beaded gowns, furs, and jewels. She wore the bobbed wigs of contemporary flappers and the feathered turbans of mythical pashas. Fashion was the fun part of a serious business—show business.

As American women began to assert themselves in the political arena with their recently won right to vote, Bessie took charge in the personal realm. Ribald

lyrics and gutsy delivery characterized her songs of sex and desire, love and loss. When she sang of needing "a little sugar in my bowl" or "a little hot dog on my roll," she wasn't making a grocery list. And her audiences knew it. Her daring encouraged other women to enjoy their bodies, acknowledge their real feelings, and express their true selves.

It was her good fortune to be the first singer in tune not only with the times but with the technology of the day. Without the commercial recording techniques new to the mid-1920s, Bessie Smith would be just a silent footnote like so many of her predecessors. With her early blues recordings selling an unprecedented million copies in one year and her vital performance in the 1929 movie *St. Louis Blues*, she would never be forgotten.

The Harlem Renaissance also reached its peak in the twenties. Writers, musicians, painters, along with millions of just plain folks thronged to the northern cities, hoping to leave servile conditions far behind. Women hiked up their skirts, discarded their work boots, took a fearless look at their hair, and went to work on change. They wore shorter dresses, often cut on the bias, over undergarments that fit more comfortably than the boned corsets of previous generations. When they could, they chose delicate shoes with buckled straps worn with luxuriously sheer stockings. Furs and fur-collared coats became a sign of status as well as a concession to colder temperatures. Heeding the advice of Madam C. J. Walker and a legion of hair specialists, Black women heated metal combs on stove burners and straightened out their hair. Then, neatly coiffed, dressed, and shod, they went out looking for jobs.

This modern mass migration, up north, represented the most significant transformation of Blacks since the end of enslavement. And Black style, inventive and courageous, quickly became a component in the search for freedom and fairness.

It could not come too soon, and for Bessie Smith it came too late. After she died from a car crash in 1937, rumors spread that a white hospital's refusal to treat her caused her to bleed to death in Mississippi at age forty-two.

The story seemed all too credible, and the legend of Bessie Smith seemed to script martyrdom as the last chapter. But her death did not close the book. Bessie's indomitable attitude provided a legacy. A mere generation later but a world away, such diverse performers as Ruth Brown, Eartha Kitt, Nina Simone, and Dinah Washington, intriguing legends in their own right, could trace their roots back to her.

At the other end of the galaxy was the classical singer Marian Anderson. A near contemporary of Bessie Smith, she was the complete opposite in temperament, style, and appeal, but her influence was no less epic. Quiet and formal, she embodied the highest cultural accomplishments that white America respected, but could not bring itself to accept in a person of color.

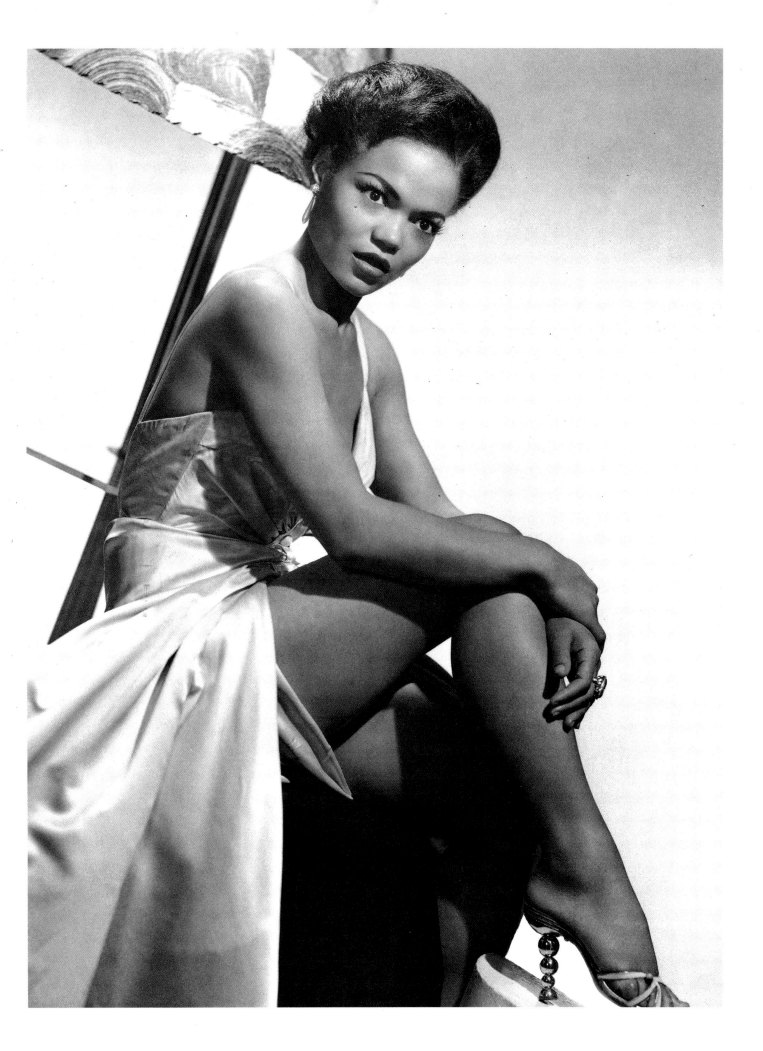

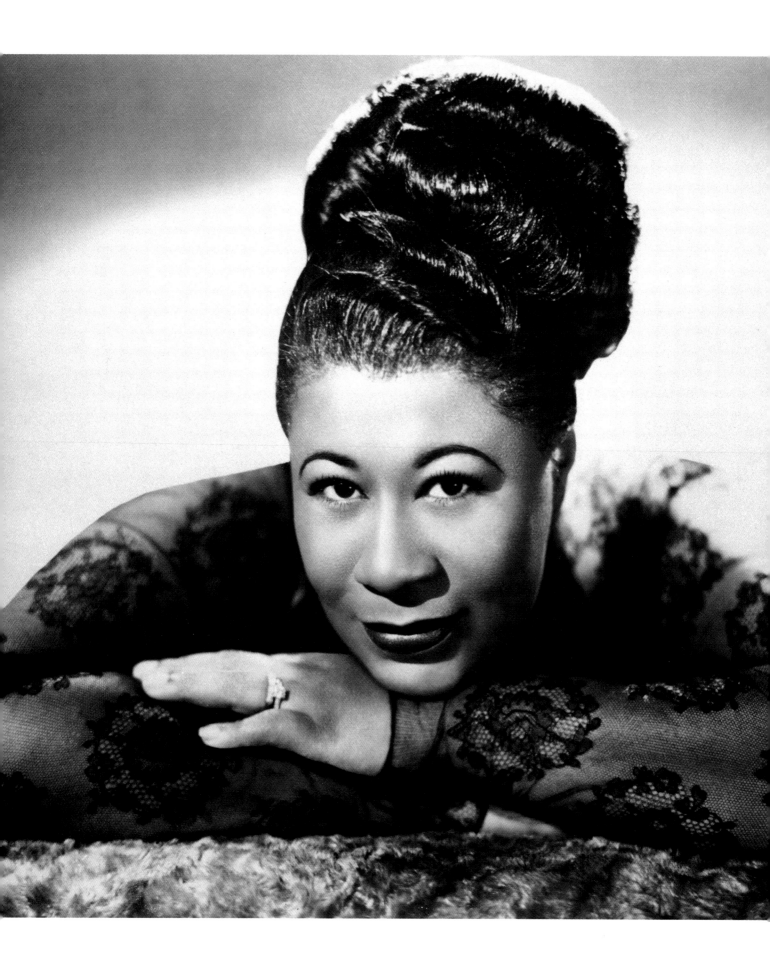

Trained in the European classics, Marian Anderson sang them along with Negro spirituals in major American recital halls. As a matter of race pride, if not complete cultural affinity, Blacks flocked to hear her, and also to see her. They scrutinized her gowns, slim and decorous with elegant trains. They admired her dazzling brooches, her perfectly waved pageboy, and her superb carriage. She was upheld as the very model of proper Negro ladyhood when that term still seemed an oxymoron to many Americans.

Despite severe economic depression at home and war looming on the eastern horizon, Marian Anderson toured Europe several times and performed in Japan, Africa, and Central and South America to great acclaim. But homegrown segregation kept her locked out of her own nation's capital until one unforgettable day, Easter Sunday 1939.

When the Daughters of the American Revolution closed the door of Constitution Hall to Marian Anderson because of her race, they ignited a national scandal. The outcome, resolved only by the swift intervention of First Lady Eleanor Roosevelt, high government officials, and the firebrand NAACP, provided a spectacular, free outdoor concert at the Lincoln Memorial, held on a day sacred to millions. When she sang that day there was no doubt that another legend, one of carefully cultivated, restrained resistance was born. Dressed in a soberly luxurious, full-length mink coat over a long, dark gown, she stood in serene triumph before the microphones at the foot of the Great Emmancipator. Then her marvelous contralto began to warm a chilled, record-breaking crowd of seventy-five thousand. As she trilled the lyrics of "America," "Nobody Knows the Trouble I've Seen," and "The Lord's Prayer," everyone in attendance—and the countless numbers listening to the radio broadcast—understood their poignant irony. Henceforward, the singer was hailed as a new kind of revolutionary and one of the most famous women in the world.

Two decades later the mantle of queen of classical music passed to a radically different diva in a radically different era.

A native of Mississippi, Leontyne Price was the opera world's first prima donna *assoluta* of color. Uncompromising in artistry and ambition, she boldly staked her claim to fame. On stage she was electrifying, gorgeous, and lushly sensuous. Off stage she often wore a curly Afro, a public signal of race pride. Her voice and her passionately assured performances insured that the doors to the Met, first opened by Marian Anderson in 1955, would never again be closed.

A legend in gospel music, Mahalia Jackson united the sacred and profane and, in the process, brought the dynamic sounds of the Black church to a worldwide audience. Born in 1912 in a shotgun shack in New Orleans and later based in Chicago, she sang with the ecstatic, foot-stomping power of blues vocalists. The lyrics,

however, were always hymns, spirituals, or songs testifying to her Baptist beliefs. Her performances shocked traditionalists, at first. Hair shook loose from the bee-hives and upsweeps she wore. Floor-length gowns swirled around her heavyset body as she moved with unrestrained vitality. Mahalia Jackson became a vocal supporter of the Civil Rights Movement and took the biblical dictate literally, dedicating her life to making a joyful noise unto the Lord.

Possessed of a brilliant, artful voice, Sarah Vaughan could have made her mark in any style of music. Her talents at the organ and piano were well known in her hometown of Newark, New Jersey, becoming wider after she won—as a singer—first prize in Harlem's renowned Apollo Theater Amateur Hour. Hired by some of the most popular jazz bands of the forties Sarah Vaughan embodied her nickname, Sassy. She could hang out all night long with the fellas and still hold her own when it came time to perform again.

Petite and self-conscious about her looks, she learned from her dapper male colleagues—including the suave Billy Eckstein and bereted bopper Dizzy Gillespie—how to dress and style herself for greatest effect. She capped the gap in her front teeth, found the correct makeup for her chocolate complexion, and kept short wigs handy for bad hair days. An avid seamstress early in her career, she employed a dressmaker to create the strapless, full-skirted gowns she favored. Her flamboyantly lush voice had found a suitable package.

Like Ella Fitzgerald and Billie Holiday, Sarah Vaughan started as the girl singer brought out in front of an all-male band to provide a little visual relief and sing a couple of songs. But that supporting role would soon change. Ten years after her first Apollo success, Sarah Vaughan was the star, earning upwards of $150,000 a year, topping the jazz polls, and able to hire the choicest musicians to accompany her around the world.

In the jazz pantheon only Ella Fitzgerald would be considered a greater musician than Sarah Vaughan. Although Ella Fitzgerald suffered a brutal, dehumanizing childhood, her voice belied any deep sorrow. It was effortlessly clear, sunny, and agile. She won the Apollo contest as a teenager, a few years before Sarah Vaughan. Fitzgerald went on to became known as a singer who helped people forget, or at least not feel, the problems of the outside world. She had a playful musical style, able to scat-sing and improvise on a dime.

A full-figured woman even at a youthful age, Ella wore her share of sequins and glittering beads to perform, but it was her voice that provided the genuine sparkle. She proved that the glorious art of song did not depend on sexual allure. Audiences around the world loved her.

The most revered stylist among the leading ladies of jazz was known for wearing two significant accessories: a gardenia in her hair and her heart on her sleeve.

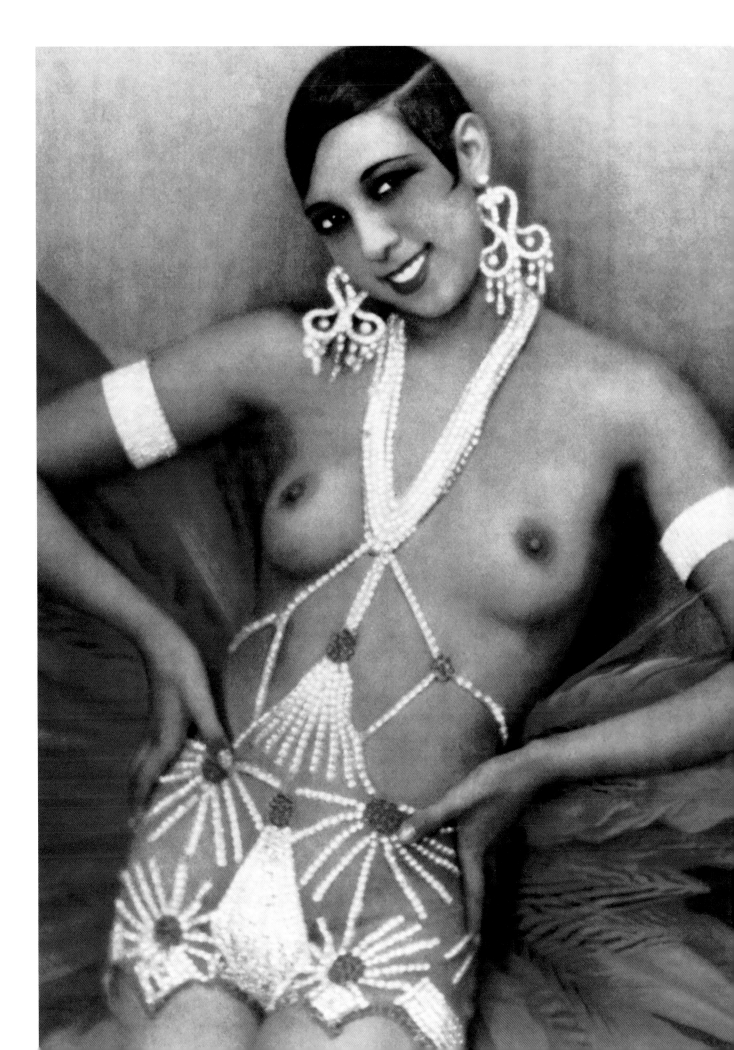

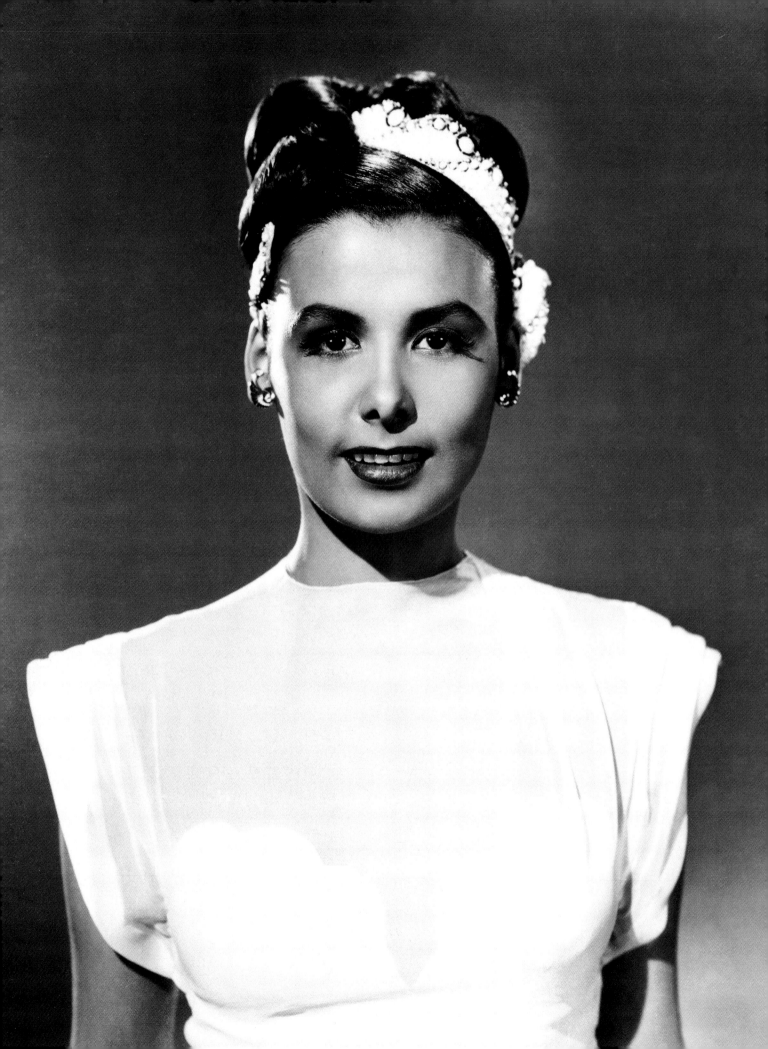

Eleanora Fagan was an abused, restless child hardened by the mean streets of Baltimore and New York City before she became the legendary musical innovator known as Billie Holiday. Billie brought an exquisitely vulnerable intensity and emotional depth to her repertoire of love songs.

The essence of Black cool, as Duke Ellington described her, Billie was an oddly mesmerizing artist who struggled to keep her life under control. Her sleek chignons, tailored suits, and platform shoes often lent her a deceptively benign and matronly air. And while the denizens of café society saw her dressed in expensive gowns and furs, they sensed from her smoky, world-weary voice and independent attitudes that the trappings of success could never contain her. She never forgot the humiliations of segregation she and most Black people were forced to endure nor the sheer disrespect she experienced in carving out a career.

Instead, Billie Holiday showed women, Black women in particular, how to value originality, how to focus ambition, and how to raise a ruckus creatively. So impressive was Billie's style, however, that after her death at age forty-four, in 1959, the tragedy of her short life was transmuted into legend.

In contrast, survival was an integral element of another legend and could well be considered Lena Horne's middle name. An age-proof beauty and performer, Lena Horne turned eighty-three in 2000. She was born into the politically active Black bourgeoisie of Brooklyn. From Cotton Club chorus girl in the thirties to the toast of Broadway fifty years later, Lena Horne was as much an image as a singer. Her flawless tan complexion, keen features, and straight hair made her the Negro GI's pinup of choice during World War II. Although she conveyed a smiling, hip-swinging tease of sensuality, it was just warm enough to invite, not involve. Slim and fluid, she wore midriff-baring halters and revealing gowns with aplomb. Glamorous and intelligent, she never played servile roles in movies or in life. Throughout her long life Lena Horne has demanded respect, and received it.

Music would not be the only field to claim legends—heroic or tragic—among Black women in America. When Pearl Bailey, Diahann Carroll, and Dorothy Dandridge gallivanted in the 1954 movie *Carmen Jones*, three intriguing performers in various stages of metamorphosis flashed across the screen bidding for more attention.

The most polished actress and the great beauty of the three, Dorothy Dandridge, started singing and dancing as a child. She grew up in show business determined to break through to color-free stardom. It seemed as though the time had finally come. America's postwar prosperity was emerging from Senator John McCarthy's hunt for Communists, and some progressive policies—school desegregation, for example—had even become law. Although Hollywood had traditionally offered Black actresses, even the most attractive and talented, only clichéd, one-dimensional roles, Dorothy Dandridge strove to be ready whenever opportunity knocked.

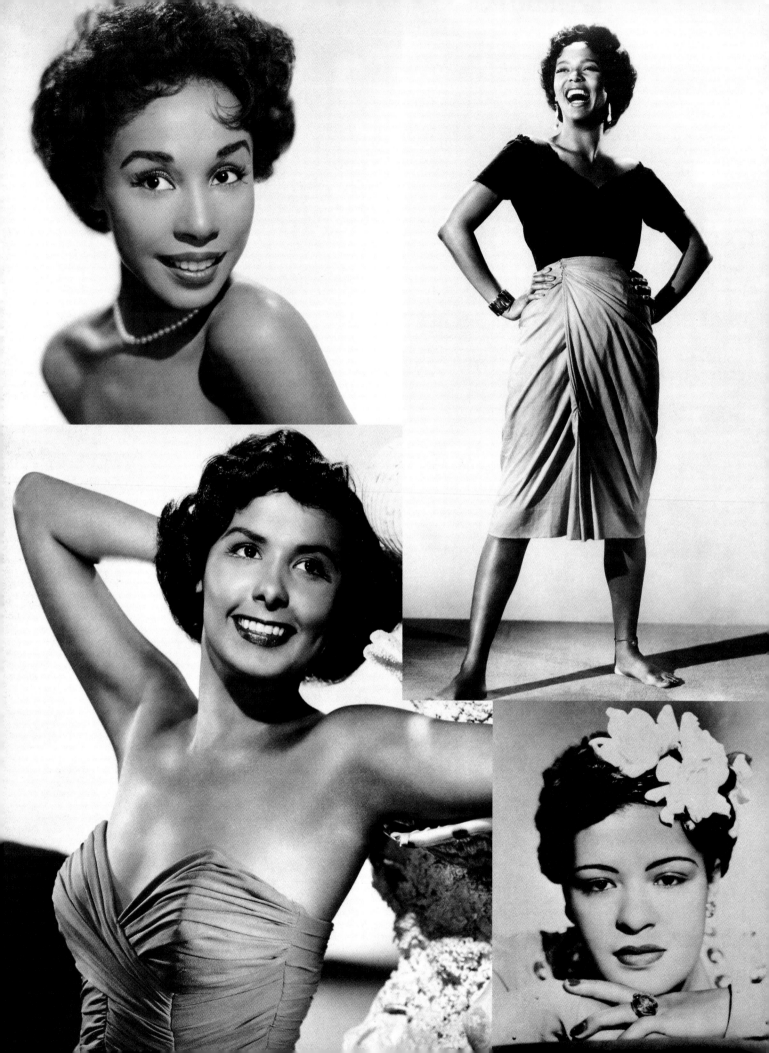

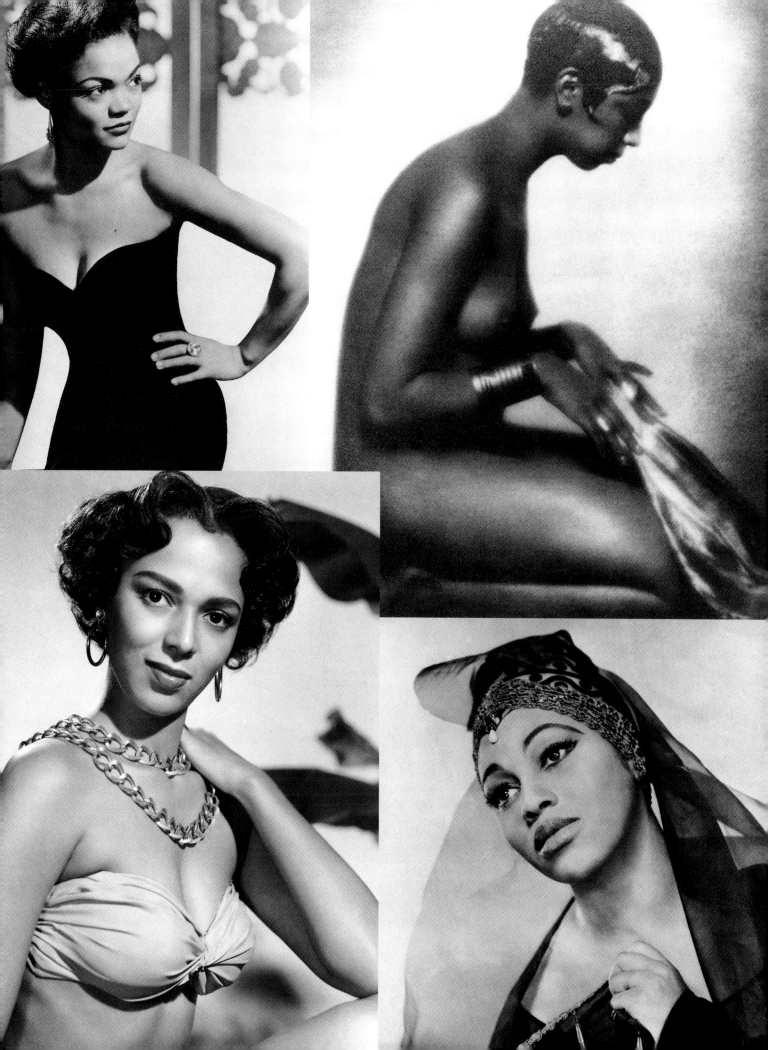

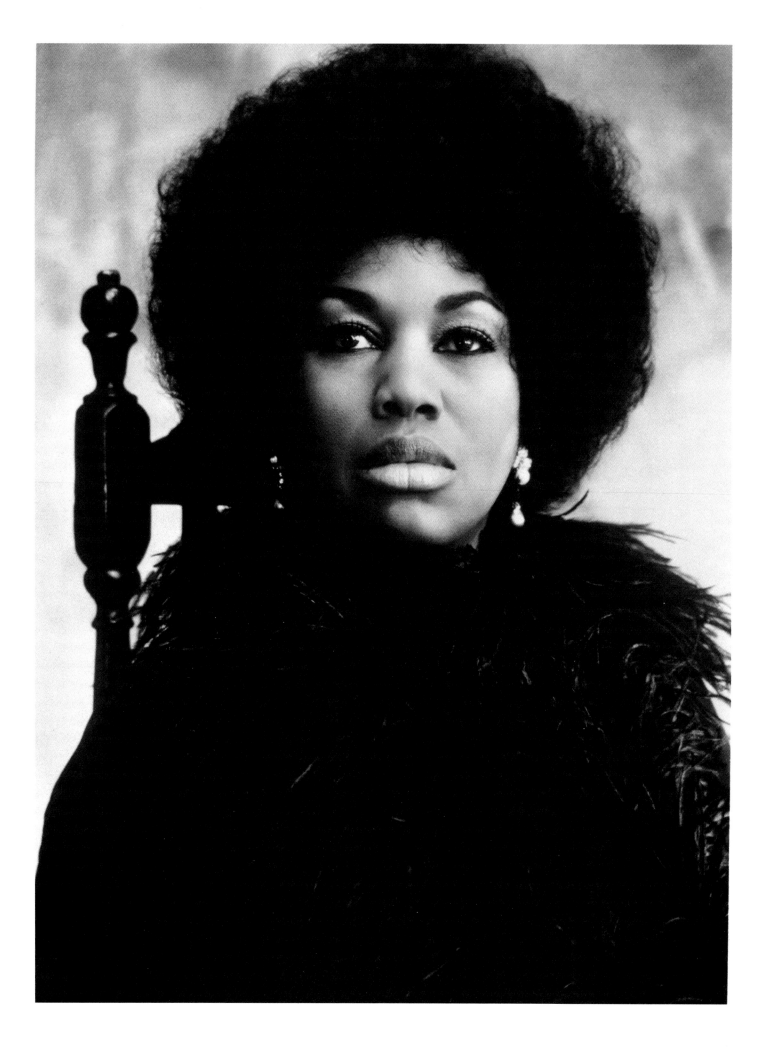

When it did, director Otto Preminger was holding auditions for *Carmen Jones.* Considered too refined for the fiery femme fatale, she was rejected for the title role and invited to read for a lesser part. At this second interview a revamped Dorothy appeared in a tight skirt with a slit, a low-cut blouse, a tousled wig, and a come-hither attitude. Dorothy won the groundbreaking role. Clothes had, indeed, made the woman.

Dorothy Dandridge was the right person in the right place at the wrong time. Her bravura performance as Carmen Jones earned her a Best Actress nomination for an Academy Award, a first for a Black woman. But while her talents seemed larger than life, her future roles would prove smaller. It would take almost two decades before other Black women would be honored with this nomination.

One of those women was Diahann Carroll. A New York City model early in her career, Diahann Carroll came to fame in 1962 playing a high-fashion Paris model in the Broadway musical, *No Strings.* Accessibly pretty, she assumed many guises, from her lead in TV's groundbreaking middle-class series, *Julia,* in 1968, to her Oscar-nominated role as a welfare mother in the 1974 movie, *Claudine,* to a swanky dame in the 1980s television hit *Dynasty.* The fabulous faux couture outfits she wore in that show were a campy but welcome nod of recognition to the growing numbers of successful Black women professionals emerging in the real world.

Endurance was an indispensable element in the long-term success of many celebrated women like Lena Horne and Diahann Carroll. It also factored in the career of Pearl Bailey, who after *Carmen Jones* went on to develop an engagingly dry comic persona as an actress, singer, and pioneering television host. Yet, a kind of perverse logic often prevails regarding legends: the shorter the life, the longer the legend. The women at its source, including Bessie Smith, Billie Holiday, and Dorothy Dandridge, had a way of dying too young, too soon.

When pop diva Diana Ross played jazz innovator Billie Holiday in 1972's *Lady Sings the Blues;* Lynn Whitfield revived the flamboyant expatriate Josephine Baker; and Halle Berry paid homage to the nearly forgotten Dorothy Dandridge movies, a reciprocal revitalization was in effect here, working to everyone's advantage.

Dancers and choreographers shared a similar responsibility to portray the lives of Black women but in a different medium. Their challenge was to capture the essence of a people, not just an individual life, and tell myriad stories without a single word. Movement was their sole vocabulary.

In the 1930s and '40s Katherine Dunham redefined African American dance by incorporating folk traditions she had researched as a college student in Jamaica and Haiti. In the process, she did no less than redesign the entire art of modern dance. At a time when many Black people were ignorant of or conflicted about their African heritage, she placed it, literally, center stage. With her sensuously

81

uninhibited movements, she dared to educate as she entertained, aiming to make people feel pride. Her theatrical ballets, *Ballet Fedre*, *Biguine*, and *Tropics* and *Le Jazz Hot* were sensations. She and her troupe danced barefoot in tropical costumes to the rhythms of hypnotic percussion. The performances were so shocking that the doyenne of modern dance, Martha Graham, called her "the high priestess of the pelvic girdle." Whether that remark was outright insult or merely faint praise, the fact remained that Katherine Dunham changed the color and costumes, the music and meaning of dance.

No longer were Black dancers limited to the jazzy acrobatics of popular ballrooms or relegated to the European traditions of toe shoes and tutus. Katherine Dunham was the first to establish an authentic cultural basis for the serious appreciation of African-derived dance. She became an activist icon, spurring future dancers and choreographers, among them the dynamic Judith Jamison.

A standout performer with the trailblazing Alvin Ailey Company since 1965, Judith Jamison trained in classical ballet and modern dance. In the pastel, rarefied world of dance she was an unusual presence: strikingly tall, dark, and full-bodied. She wore her hair in a close-cropped natural. She seemed the very incarnation of the strong Black woman invoked during the turbulent '60s and '70s, when Black consciousness, women's rights, and protests against the war in Vietnam dominated the national conversation. Never before were the arts and politics so dynamically engaged.

Never before had a dark Black woman with such graceful, undisputed command danced onstage. Her sixteen-minute solo ballet, *Cry*, became perhaps the most famous single dance piece in the modern canon. As her turban's train streamed behind her, swirling skirts and sweeping emotions consumed the stage. In the finale, wisdom and strength triumphed over every obstacle. Unbeknownst to her, Ailey dedicated the piece "For all black women everywhere—especially our mothers." After the spectacular premiere Judith admitted that had she known what she was representing, had she understood the scope of her responsibility, she would have left the stage immediately.

The same might be said for all the legends we honor. Rarely do they seek election to the position. Most often they endeavor only to do their work: to sing their song, play their part, and dance their dreams.

To these women, blessed with extraordinary gifts and outsized personalities, style was never a superficial matter. Their freedom of expression depended on it. The way they achieved was almost as important as what they achieved. We knew that and listened, watched, and borrowed what we could. While we may not get to greatness with them, they taught us that we can always strive. —*Barbara Summers*

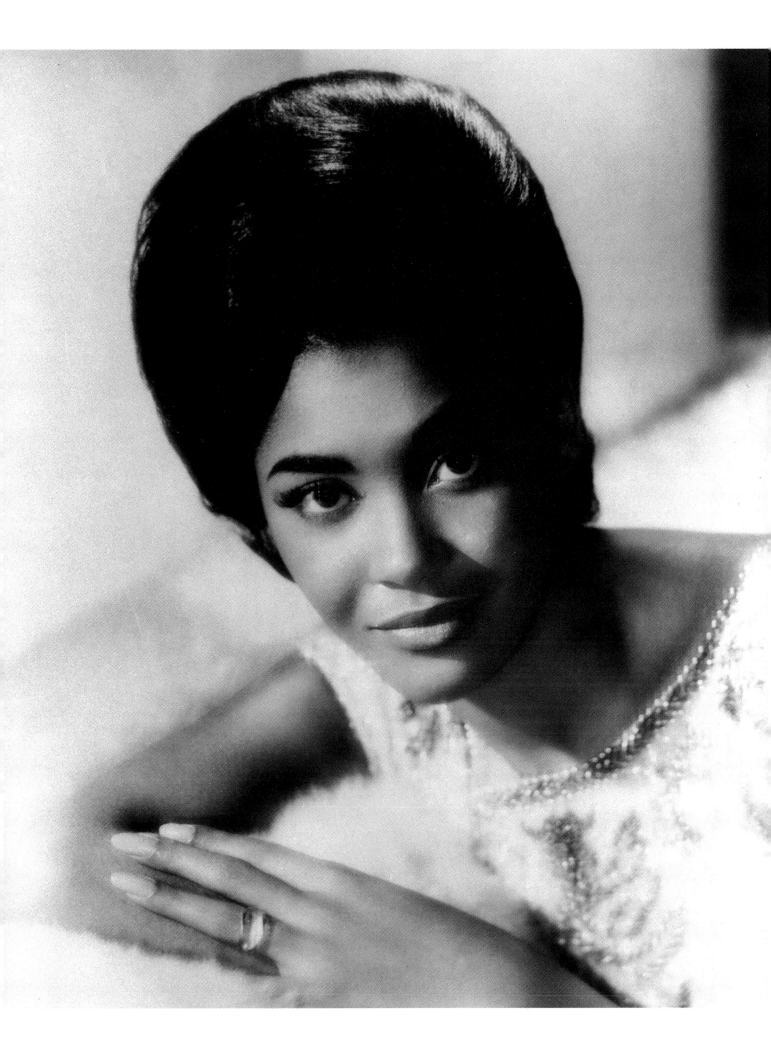

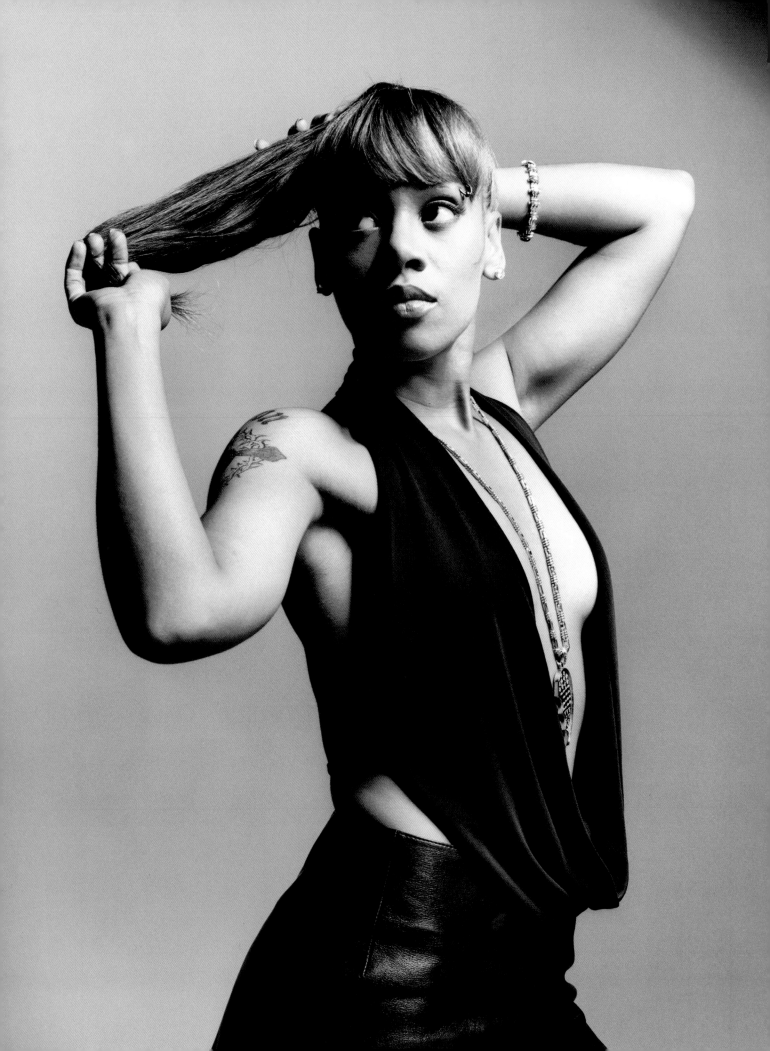

FunkyDivas

Lisa Lopes
photographed by
Piotr Sikora

e were starved. Before *the Ed Sullivan Show* and *Soul Train*, there was no showcase for "Negro glamour" on television. We were so delighted to catch a glimpse of our starlets that every sighting was cause for celebration. We practically inhaled their style. We loved to see our favorite performers looking the part—lots of wigs, yards of chiffon, pounds of sequins, and the big megawatt smiles.

It was one of the few times Black women could revel in their own beauty. Diana Ross and the Supremes offered the chocolate take on elegance. Chaka Khan's hippie antics of flying hair, fur, and fringe, and Donna Summer's postcoital, glossy red lips, wild curls, and sexy diaphanous gowns were cause for commentary and a chorus of oohs and aahs. We hung on to every glittery thread because these old-school dolls gave up the sepia goddess vibe: larger-than-life and untouchable. And we loved it. Our divas looked and acted like divas.

The advent of MTV in the eighties put an end to the famine. Videos set to music required a storyline, a stylist to create the look, and an attractive artist. Michael Jackson set a standard, proving how video could be used to an entertainer's advantage. And little sister Janet was taking notes.

Ms. Jackson took control of our imagination from day one. Fast-forward past her cute days as Penny on *Good Times* or Charlene on *Different Strokes*. The adorable little girl gave way to a lovely teenager.

When baby Janet whirled onto the scene in 1986 with her second album, *Control*, all hell broke loose. She stormed the scene full of attitude, flashing doe eyes, button nose, shoulder-length hair, and that bit of homegirl heft, that on 125th Street was a banging figure. She played it off in the first two videos by wearing the boxy jacket and dressing in

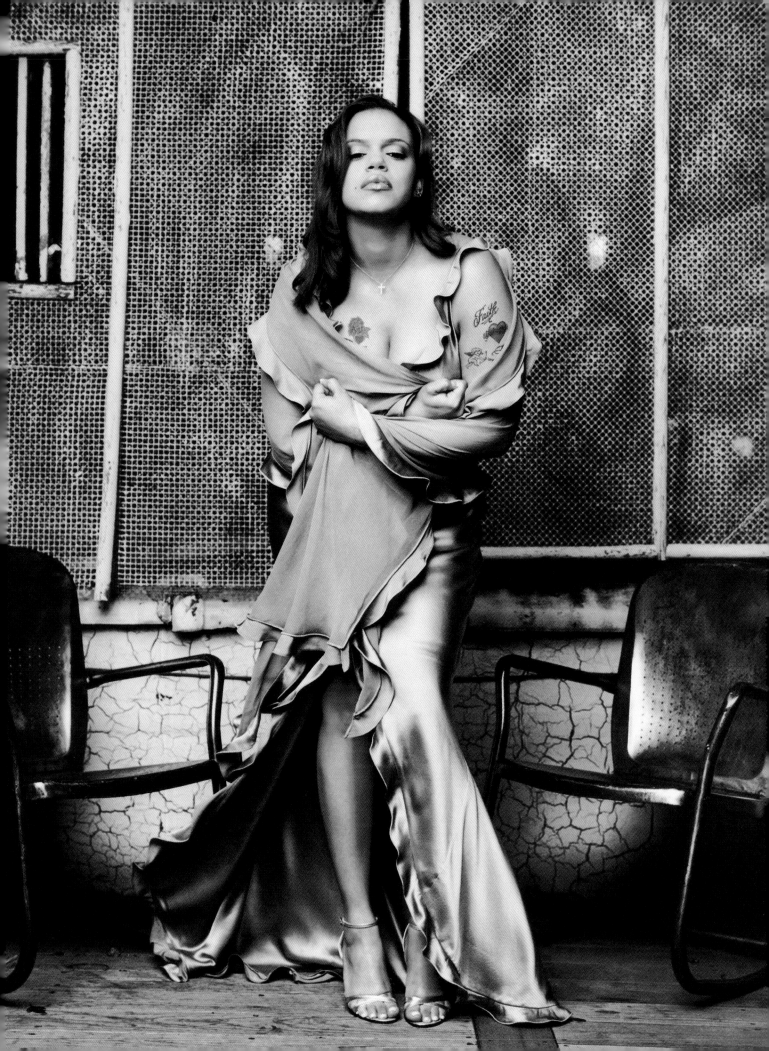

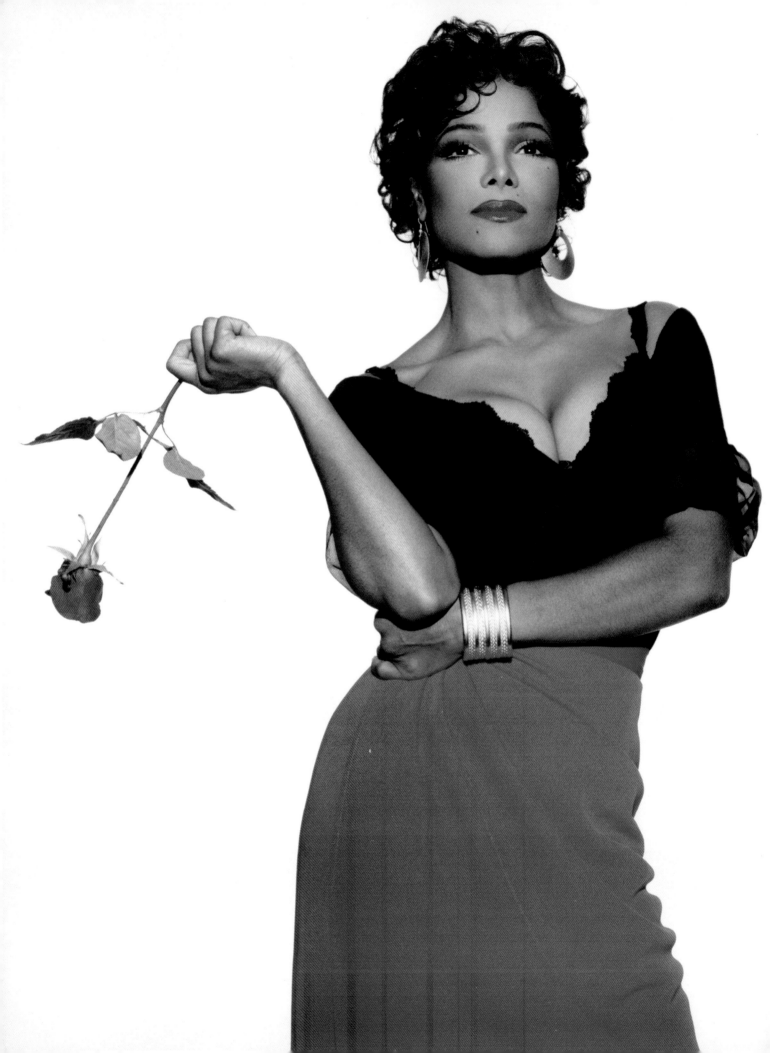

black from head to toe. It wasn't until she busted out, literally, in her video "The Pleasure Principle" that we collectively gagged and gaped.

Clad in a simple tee shirt knotted in the front to expose a bit of midriff, Janet packed a pair of black jeans that accentuated a small waist and the classic Black-girl butt. The long shag cut was rocking, the makeup appeared minimal, and the whole effect was out-and-out fly. Thanks to the power of music videos, girls from everywhere were simultaneously clamoring for that look. The hair, in particular, hit during the emergence of weaves and extensions. Every hairstylist was trying to re-create that silky moveable mane. The outfit? Genius. Didn't everyone have a tee and tight jeans? Shoot, we all learned a new way to work a casual look. Janet was one of the first Black stars to break the Black glam rule for entertainers: she didn't get dressed up. These were street clothes. Ironic, huh, that the baby girl of the Jackson dynasty, our ruling princess of pop and pedigree, was the one who was bringing a bit of the street to music videos.

She stomped right into her third album, *Rhythm Nation*, and kept feeding our passion for long hair with the black cap and ponytail coming out the back. The brothers were still glued to the glorious booty. In 1990, a collective sigh went out again in response to "Love Will Never Do without You." Celebrated lensman Herb Ritts captured and unveiled the new Janet—again. Her mane was caught up in a sexy blondish upsweep. Janet was all sparkle and lashes, and the body was seriously sculpted. The top was brimming with bosom, the waist was whittled to nothing, the abs were tight, and the jeans were tighter.

All of these changes led to fever-pitch conversations on working with what you were born with versus enhancements. Janet was the lightening rod because of her spectacular metamorphosis, and we also speculated about her alleged plastic surgery. It was a given she'd had a nose job, but was it true she had a rib removed for that whittled waist look? Was that really her hair or was she dependent on wigs and weaves? Did she have a boob job? The questions were troubling, because if the epitome of Black beauty and femininity had been carved by a skilled surgeon's knife, we had to ask ourselves what, are we celebrating? Whose aesthetic are we embracing? What is Black beauty? We pondered that for a minute and concluded that there was no debate: Janet was still fine.

Spawned by the video age and fueled by the eminence of hip-hop, the funky diva was born. She is the Black girl who gives it to us her way. With a stylistic nod to the old dolls, she's learned to serve up drama but she doesn't manufacture it; she mines her own pain and insecurities.

The funky diva's whole look and artistry is informed by her culture. She pushes boundaries and charts new ground on the Black woman's experience, as evidenced by Janet's departure from swingy manes to auburn box braids in her 1994 homegirl turn in

Nia Long
photographed by
Diego Uchitel

Poetic Justice. The funky diva takes risks with her look, always pushing for the next level of fierceness that will mirror her growth. She's cool with the knowledge that sometimes the look clicks, and sometimes it's just plain crazy. But our diva doesn't apologize; she just keeps on exploring—and at the same time staying true to who she is.

Janet and other founding funkettes Jody Watley and the quartet En Vogue ruled the late eighties to the mid-nineties with a series of sexy, playful looks that always said lady, never tramp.

Jody Watley is still a thrill. We discovered her dancing and showboating in the late seventies on *Soul Train* and then snapped our fingers as she eased on down the R&B/pop road with her *Soul Train* partner Jeffrey Daniels in the trio Shalimar. All the while we were captivated by her exotic looks and unique sense of style. Stepping out on her own in 1987 with "Looking for a New Love," Jody was high glamour to Janet's accessible beauty, and she was the master of her image. She remembers, "Both Madonna and Janet Jackson had been making a big impact but they were more street-oriented than me. I brought a high quality to what I was doing and people responded." Indeed, Jody's large, expressive almond eyes, full brows, and razor-sharp cheekbones gave her face a regal hauteur.

The long hair, frequently curled for a wild tousled gypsy look, softened and sexed up the look a bit. Her slim build and height made it easy for Jody to wriggle into anything and make it look runway worthy. Jody was the clotheshorse, game to try anything, and able to wear it with grace. She mined the vintage shops and would put together pieces from various eras, like a fifties crinoline skirt and a sleeveless denim jacket. She would go panther sleek in slinky sheaths where her only accessories were red lips and large gold hoops. Or then again she might be feeling the old-school Hollywood glamour of the white shirred halter bathing suit with large movie star glasses and turban. A classic beauty, her groomed, full, dark brows and full rouged lips were her trademarks. Most of all, Jody was the style chameleon who went her own way and did it boldly and beautifully.

En Vogue started out cute and went couture. The four songbirds hit the scene trilling "Hold on to Your Love" in 1990 draped in shimmery sequin mini slip dresses and high heels. It worked because in the midst of bohemian looks and random ensembles, the unified glamour look actually did deliver a punch. In the 1992 follow-up, *Funky Divas* Maxine Jones, Terry Ellis, Cindy Herron, and Dawn Robinson took it all the way there. The CD cover heralded the change in Thierry Mugler pinstripe suits and bustiers. They freed minds and libidos in skintight gowns and bustiers from the hautest designers, Franco Moschino, Rifat Ozbek, Christian Lacroix. En Vogue took high-concept fashion and wore it with the sensual casualness of a pair of beloved Levi's.

The biggest girl group of all time, TLC, caused seismic shock waves when they appeared in 1992. They were the total opposite of the high-glam, high-maintenance look

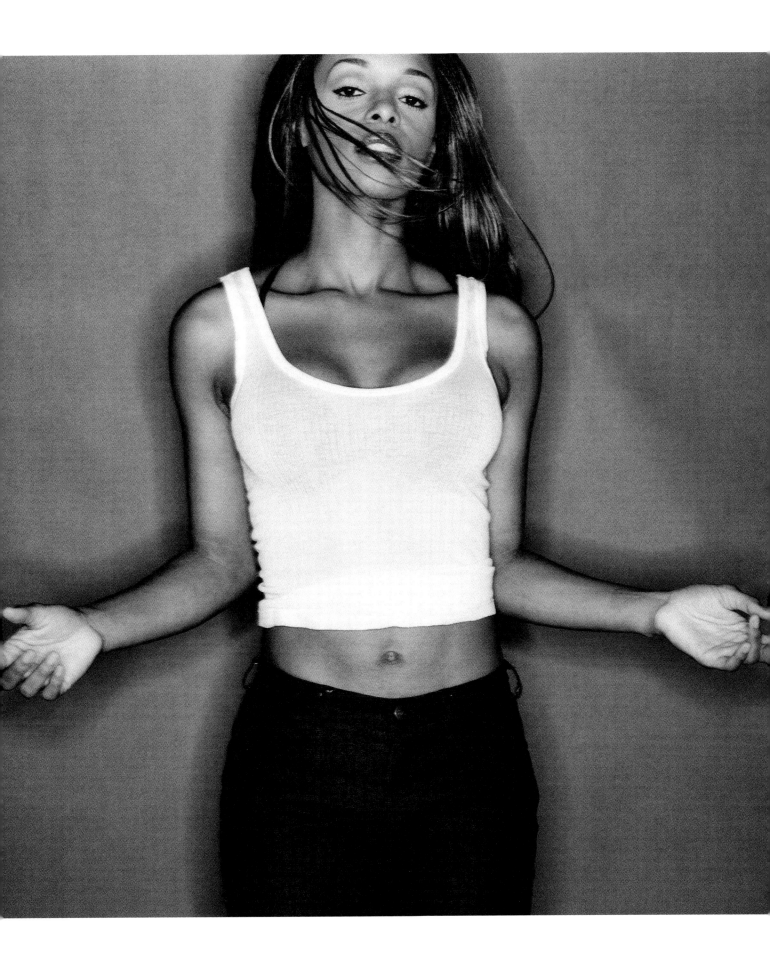

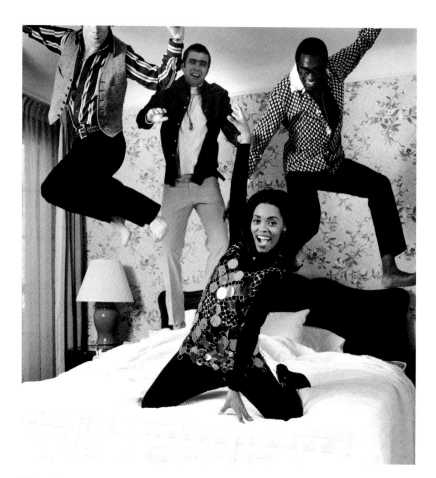

N'Dea Davenport
with The Brand
New Heavies
photographed by
David Jensen;
Opposite: SWV
photographed by
Stephanie Pfriender

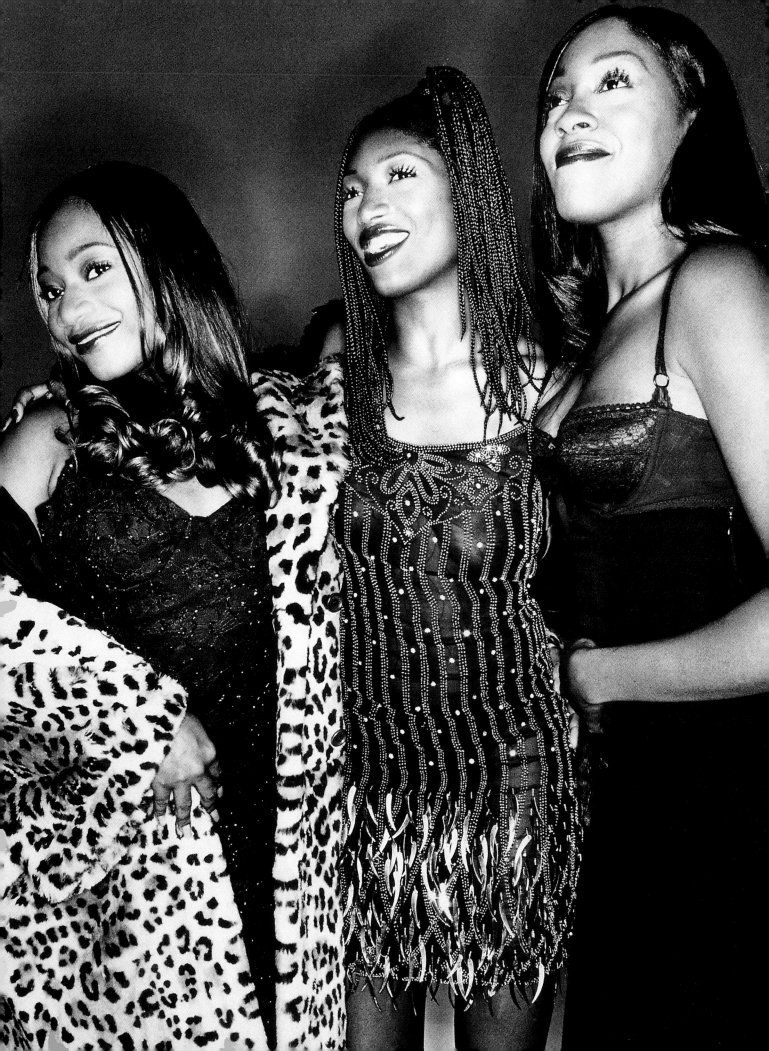

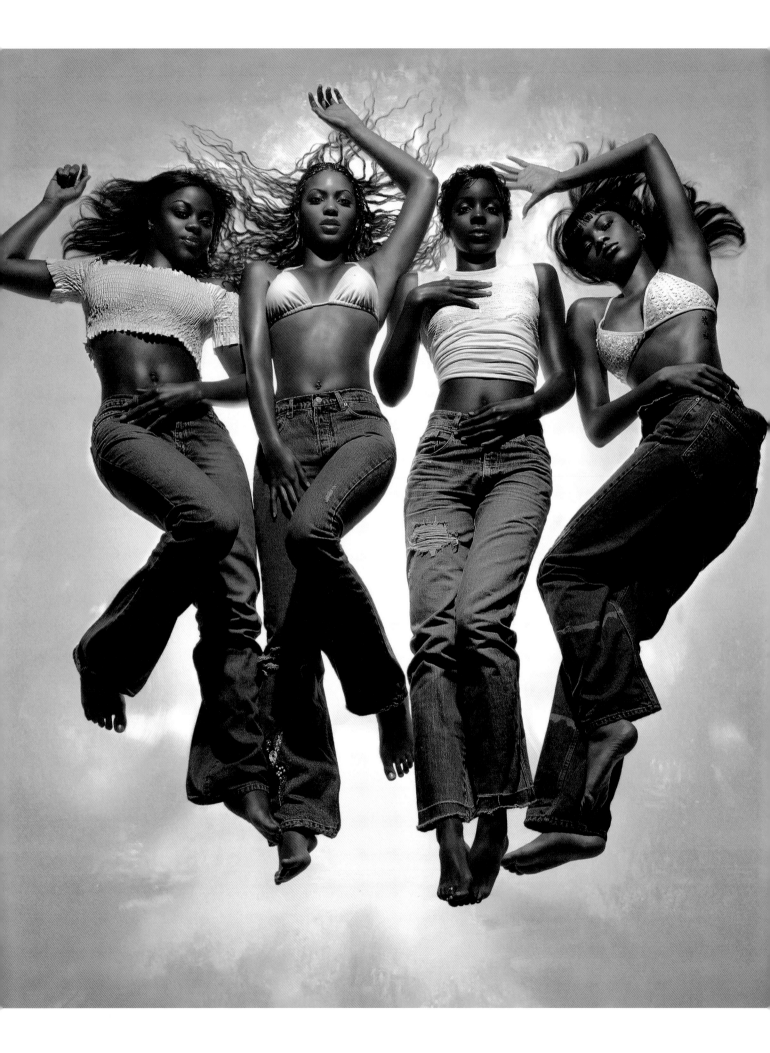

of En Vogue. Togged out in oversized tops and baggy shorts coolly accessorized with condoms, Tionne "T-Boz" Watkins, Lisa "Left-Eye" Lopes, and Rozonda "Chilli" Thomas were tomboys.

This trio was about girl power and safe sex. You don't have to wear short skirts and tight tops to strut your assets. Needless to say, TLC caught on like wildfire. As the CrazySexyCool trio has evolved emotionally, they've maintained their style edge by exploring futuristic looks that, yes, celebrate the body with cut outs and cropped tops. But with all their edge and agitato, it's T-Boz's buttery blond precision cut that goes down in the annals of Black style.

While groups like Destiny's Child melded En Vogue's unified glamour with a bit of the street, En Vogue's real stylistic successors are a pair of dewy-eyed ingenues. Brandy and Monica eschewed the trend toward ghetto-fabulous looks for hip-haute. Like En Vogue, both bring a middle-class sensibility of chic with an injection of fun to their look.

The multimedia phenom known as Brandy is a one-woman corporation, and her braids and winning grin are her tradekmarks. Her wide-eyed regular teen look netted her contracts with cosmetics giant CoverGirl and fashion doyenne Donna Karan's younger DKNY line. Her style sense landed her smack dab on the cover of *People*'s "Best Dressed" in 1998. Atlanta native Monica blossomed into a beautiful young woman, and her innate elegance caught Chanel designer Karl Lagerfeld's attention. Sisters were struck by the classic shoulder-length blunt cut.

Actress beauty, Nia Long also serves up a middle class sensiblitliy. She works the simplicity factor; it's all about her great face and figure. Nia's gift to Black style is her hair. She, long after Toni and Halle abandoned their famed short crops, still waves the banner for sexy short 'dos. The 'dos are often simple affairs; a wispy pixie cut, or even saucy Afrocentric Bantu knots, but Nia knows in a sea of weaves and fussy hair, she stands out.

A true style iconoclast was N'Dea Davenport of the funk group the Brand New Heavies. While she did not reach the level of fame and visibility that Janet and Jody did, N'Dea was known as an artist's artist. And her bohemian pieces and glammed-out beauty made her stand out as the frontwoman for the seminal band. "N'Dea Davenport is an artist in every sense of the word. Not only will she take risks with her craft, but also with her makeup and style," remembers celeb makeup artist Roxanna Floyd.

Twenty-first-century bohemians include the luscious MTV hot girl Ananda Lewis, who flirts with the edge in kooky marabou jackets and leopard and python prints. But her Black dream girl looks—mocha skin, slim figure, long wavy tresses that are all hers—render her stunning. Actress N'Bushe Wright, gorgeous with her short natural and penchant for diaphanous flowing colorful fabrics and seventies Danskin bodysuits, gives a stylish nod to her dancer past. Actress Lisa Nicole Carson often makes us wonder what's up with her vintage pieces and makeup choices, but then again, the bosomy

Lisa Nichole Carson
photographed by
Diego Uchitel

diva is always an original.

Crack cocaine and hip-hop collided to create the beginnings of the "ghetto glam look," which exploded in the mid-eighties and peaked around 1995. Understand that crack fueled its own economy and created many project-dwelling "millionaires." Now it was easy to acquire the best of everything, designer clothes, lobster dinners, fly rides. For young women, the drug-dealer boyfriend was the benevolent daddy. She didn't have to do anything (well, almost anything) but look good and be there for him. Brother was paying for hair weaves, weekly manicures, and the freshest designer gear. There was a revelry in the excess—tons of gold jewelry, bright-colored clothing, multiple designer bags, designer everything.

Sisters with Voices brought the prevailing street look to the masses. Known as SWV, Coko, Taj, and Lelee were the around-the-way girls. Coko was the center of attention with her very long, airbrushed nails that looked like talons. Through the guiding vision of Sean Puffy Combs and his cohort, stylist Sybill Pennix, they captured and polished the ghetto-glam look for Total, his label's first girl group. They were rough, tough, and fly. But unlike Ronnie and the Ronnettes of the sixties, Total was the modern-day Bonnie without Clyde.

A few of today's chanteuses' styles are informed by archetypes of the past. Faith Evans, a prolific writer and gifted singer, seemed to wear her feelings as openly as her blond hair color. Recently married to the late rapper Notorious B.I.G., and celebrating the release of her first album *Faith* in 1995, the couple took on a look that harkened back to old urban player iconography.

Faith very much resembled the Harlem barmaid. Think the Red Rooster Lounge, circa 1963. Her look is lovely, yet fragile. It's the peroxide blond hair upswept into a sexy mess, café au lait skin, the heavily lined bedroom eyes, and pouty lips, hanging with her man, the fat, dark-skinned big daddy—let's call him Black—the big-time numbers man who owns the club. His wife is the light-skinned prize, the woman who was once a beauty and a talented singer, but drugs, Black, and life have worn her down. You know when they love, they love hard, and when they fight, well, you know who gets the bruises. All that's missing is her Chihuahua.

Faith stepped into the present after Biggie's death. The blond was deepened to a lovely red; the sixties makeup gave way to soft neutrals. Faith's look has matured, and her enduring contribution to style will always be her mercurial hair color coupled with her towering strength.

On the opposite end of Faith's uptown lounge look is Chante Moore as the classy chanteuse. Chante is a throwback to Dorothy Dandridge and Lena Horne performing high-society nightclubs like El Morocco.

The beautiful singer stepped out in 1992 with her first album, *Precious*, wearing old-school glamour like a cloak. The lush mane of hair, the perfectly arched brows, and soft

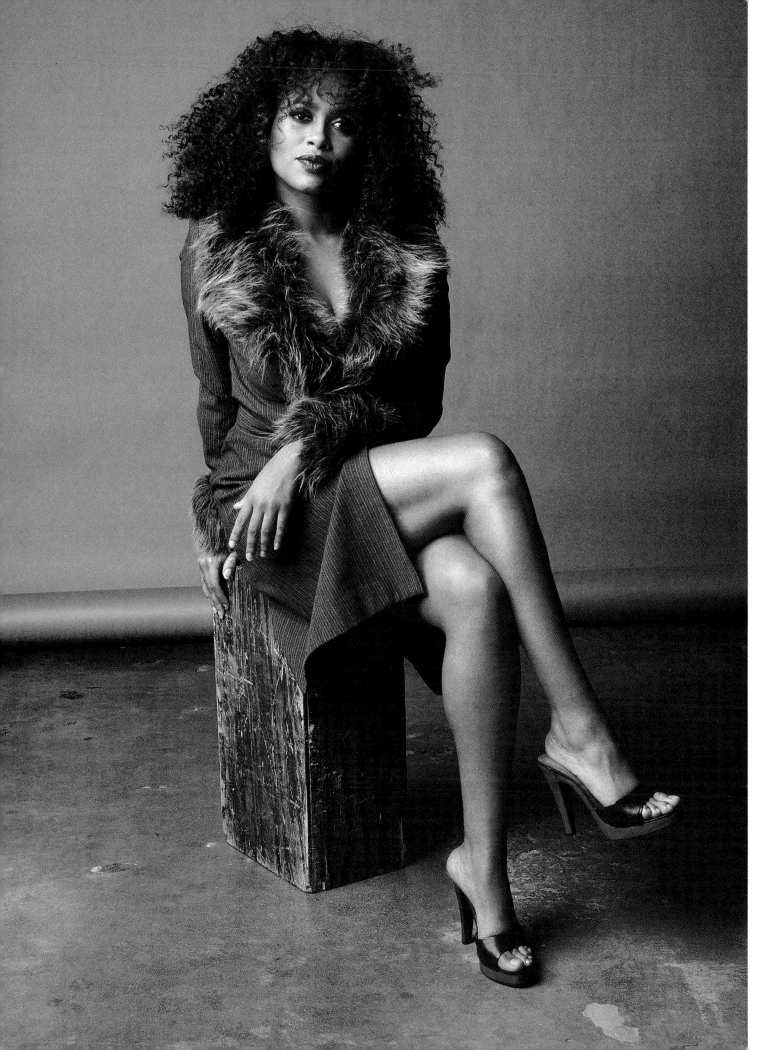

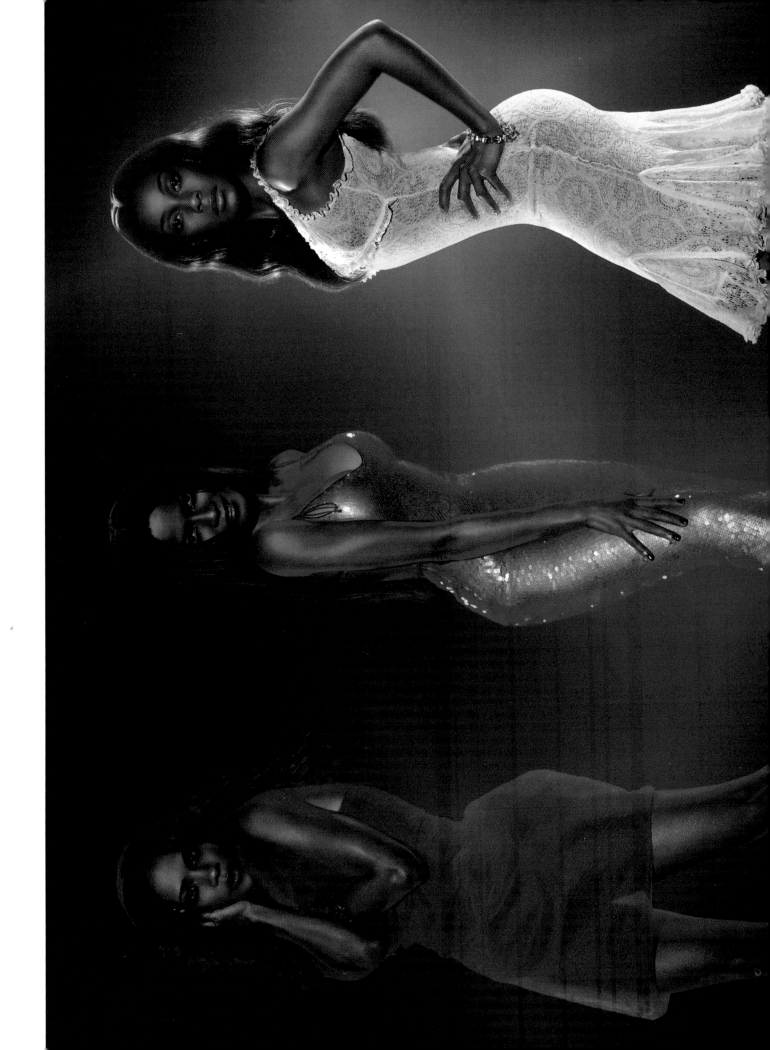

En Vogue
photographed by
Markus Klinko

red lips coupled with her sequin evening gowns, fell in line with the polished "Quiet Storm" period created by young Black professionals. Chante was the upwardly mobile boy's dream girl. Yet with the all of the Cotton Club trappings, Chante appeared real and totally likable, the kind of girl who could croon "Chante's Got a Man," and everyone's happy for her.

Mariah Carey takes on elements of the tragic mulatto, who morphs into the vamp. Mariah is problematic because although she is biracial and has always said as much, she doesn't quite feel or look like family. Fair enough, that probably happened because she grew up in a predominately white neighborhood and attended predominately white schools on Long Island. After she was discovered by, and then married to, her label's honcho, Tommy Mottola—it doesn't take a rocket scientist to know—her Blackness was downplayed in favor of a vaguely exotic pop princess image. But when the butterfly broke free of her gilded cocoon and Mottola, she went buck wild.

In 1997 she began to celebrate her freedom and a new album *Honey*, dressing hard-core skimpy. Gone was the mass of curls. Honey-streaked, iron straight locks ruled and ace bandage dresses with slits to there, from designers like Gucci and Victor Alfaro were the order of the day. And honey went nowhere without her trusty Manolo Blahnik or Gucci stilletos.

As time has gone on Mariah's outfits have gotten smaller and smaller and she is usually a mass of boobs and limbs at award shows. She has taken a critical drumming from the press, even ending as one of *People*'s "Worst Dressed" in 1999. But what makes this diva funky is she takes it in stride. One thing is for sure: the Rainbow girl is definitely enjoying herself. And that is what teenage girls love about her.

Kelly Price is set to kick the big-mama stereotype square in the face, and we will cheer her every step of the way. She's not about to play Mammy to the little pop tarts, and lend her soulful voice to the background vocals because of her weight. Sister not only took her rightful place as a solo singer but also as a glamorous figure.

The album cover was all hair, succulent lips, and cleavage. Videos have her styling and profiling. Size 2X rejoice. Her rise is concurrent with the slow but growing acceptance that beauty comes in all sizes. In fact, the rise of *Mode* magazine, a fashion magazine for voluptuous women, and an explosion of high-end retailers are finally creating fashionable frocks for our fuller sisters. Weight matters so much in the entertainment industry that several great singers died in the quest to be slim, including Mama Cass, Karen Carpenter, and Dinah Washington. But the question is, will we ever accept ourselves?

In the end the funky diva knows that her strength, fortitude, creativity, and intelligence are her best assets and the traits that really make her funky and diva. She is a kinetic thing, always in motion, checking for new ways to flip the sartorial script. The funky diva is decidedly one of us, only, as the beauty ad says, better. —*Jenyne Raines*

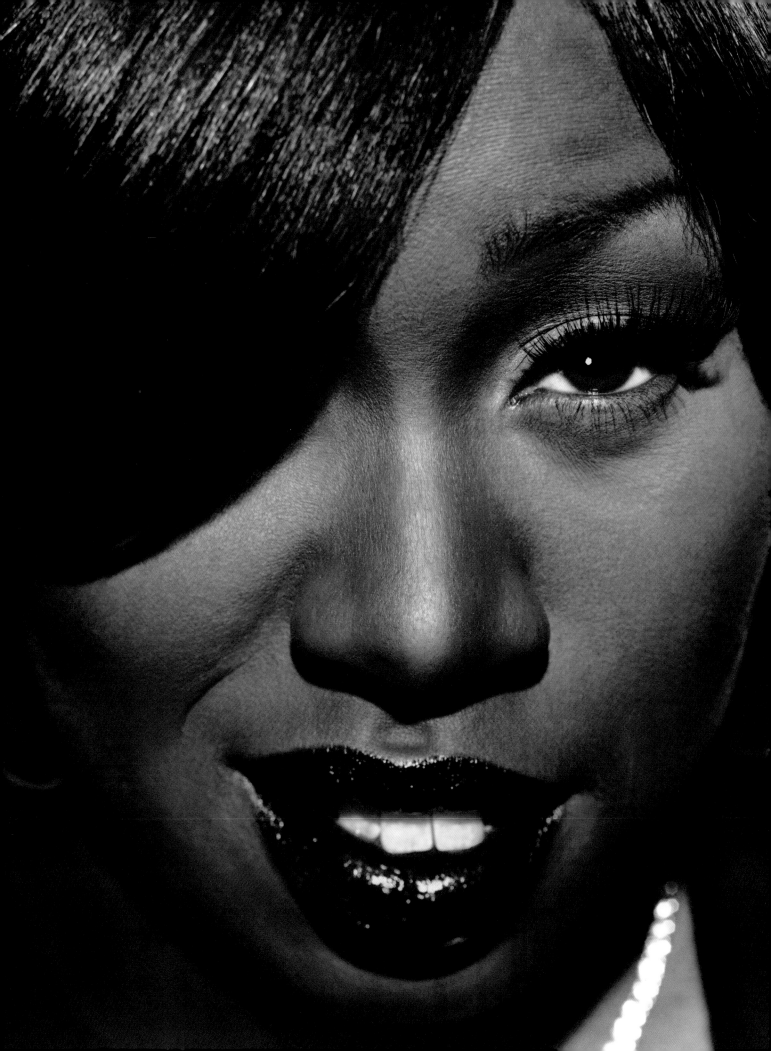

HipHo pchic

Missy Elliott
photographed by
Len Prince

Bamboo earrings, at least two pair. Extension nails, airbrushed and studded with rhinestones. Sergio Valente jeans. Belt buckle, with nickname spelled in brass, block letters. Plastic swatch watches, three to an arm. Layers of thin gold chain necklaces, each with its own charm. Biker shorts, in every color, under shredded jeans, or not. Reebok classics. Raw silk blouses, Guess jeans, red Gucci, knee-high boots. Hooded sweatshirt, baggy Girbaud jeans, timberland boots. Tennis skirts, halter tops, K-Swiss sneakers, cotton footies with pom-poms in the back. Tight leather pants, mint green furs, stacked Prada heels. Fendi baguettes, platinum watches and chokers. Three hundred dollar bags of ash blonde hair, four-karat studs, nothing less than H-class.

We've come a long way, homegirls.

Way back when, crowds gathered in New York playgrounds around the DJ bootlegging his electricity; b-boys and girls arrived in crews, dressed exactly alike so that their synchronized break-dancing was one fluid visual movement. Clothes were functional: Pants were loose and baggy, and fingerless gloves were used for the many floor movements this unique art form required. But when these gatherings were moved indoors—either because of police complaints about the violation of noise ordinances or simply because they'd outgrown neighborhood parks—a host of sorts was required to keep the crowd moving. The MC was born and battles moved from the dance floor to the microphone. The b-girl, an equal contender on the level playing field that were cardboard boxes (the breakdancers' stage), morphed into the "female MC" and was forced to compete in the testosterone ruled world of rap. And it's been tricky. Rhyming over beats, which has its roots in Jamaican toasting, was largely braggadocio and relied not only on wit, but on posturing. Posing became paramount in hip-hop.

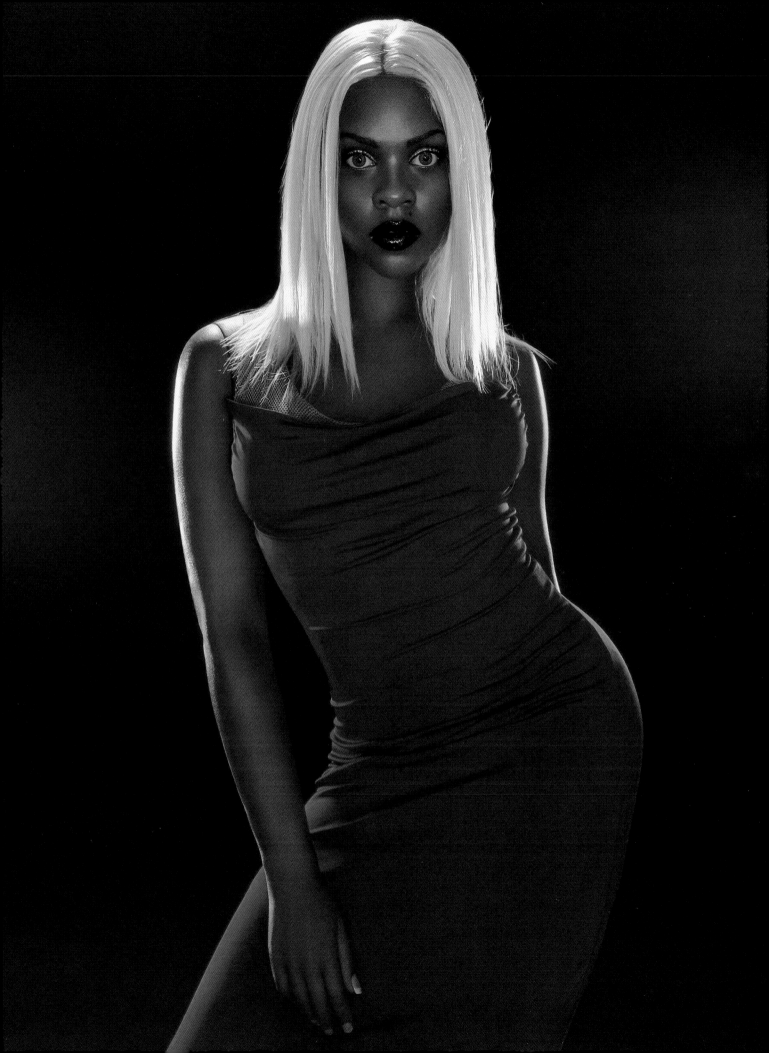

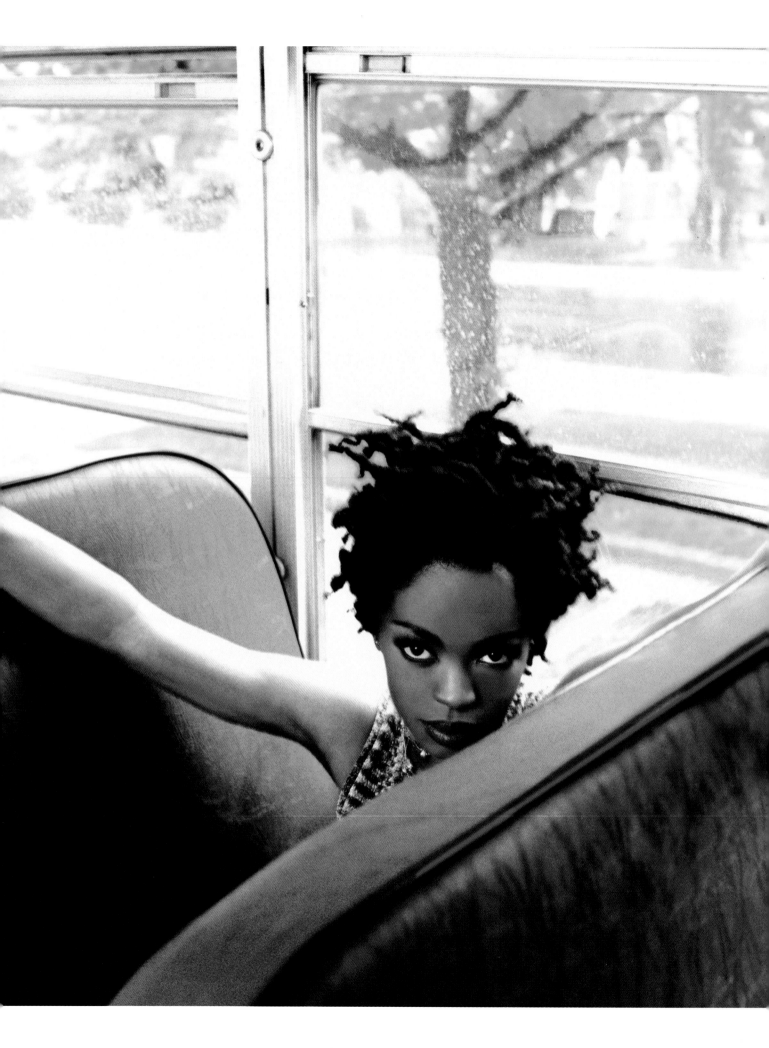

Before Salt-n-Pepa crashed the party in the mid-80s, there had been two major female MCs—and they were both called Roxanne. Sparky D and Pebbly Poo, the lone female members of two separate groups, ruled before music video budgets were even a dream. They never had a chance to truly shine beyond those early playground years, as Salt-n-Pepa did. With their initials set in Superman's logo on colorful leather jackets, spandex unitards, gold doorknocker earrings, fat gold cable necklaces and bright-red riding boots, Salt-n-Pepa's wardrobe for their high-performance video "Push It" introduced b-girl glamour to the world. Previously, Roxanne Shante had donned a floor-length white mink in her video clip, but she looked like she was trying on someone else's coat.

Salt-n-Pepa, along with their DJ Spinderella, launched their attack on the all-male world of hip-hop. Salt-n-Pepa were in control of their sexuality. They retained their power, an absolutely necessary accessory for any MC, because they seemed to be performing for each other in the video, not the screaming thousands in the audience who remain off screen.

Like b-girls before them, their outfits were as coordinated as their choreography. Onstage they look like a unit. On the microphone, Salt and Pepa, real-life best friends, complete each other's rhymes just as they complement each other's look.

Their fashion sense was an exercise in appropriation; they took looks that in any other context may have seemed preppy or biker. They wore black leather jackets with polo shirts or ripped jeans; spandex mixed with fur and gold, and diamonds with an air-brushed tee, but the clothes would always be revealing, always announce their sexuality. This would become Salt-n-Pepa's trendsetting signature style, ultra femme get ups, inventive ways of interpreting designer looks and synchronicity. Their fans, young girls across the country who preferred them to Madonna, copied them religiously.

A distant cousin to the girl groups of the Motown era, Salt-n-Pepa kept the glamour and tossed the perfect posture and hand gestures, instead opting for a backbend here and an exaggerated b-boy stance there. But just as important as the glamour, what Salt-n-Pepa brought to hip-hop was the mere fact that they were and remain an all-girl hip-hop group.

Roxanne Shante, the lone female MC from the all-male Juice Crew, answered UTFO's hit record, "Roxanne, Roxanne" with her own "Roxanne's Revenge." But it was nothing new. She was doing what women walking down the street have been doing forever—answering a cat call with her own acidic, biting, wit. Capitalizing on the frenzy, UTFO wheeled out the "Real Roxanne" and turned what might've been an inter-gender battle of words into a catfight. The Real Roxanne rhymed about her light complexion and long hair, and Shante spit back with promises of a blackened eye. Salt-n-Pepa, so named because Salt is light and Pepa is brown became cheerleaders for girl power and more importantly, unity. (Afterall, who were you gonna double-dutch with if you were

busy isolating your homegirls left and right?)

In high schools and middle schools across Black America in the late eighties, girls were storming the hallways in matching outfits five days a week, á la Salt-n-Pepa. When Salt dyed her hair blond or Pepa sheared her asymmetrical bob down to a virtual Mohawk, tenth-graders did the same. When the duo took razor blades to Guess jeans or pulled on a loud red pair of Gucci boots, the look showed up at roller-skating rinks.

While the mid-eighties have come to be known as The Golden Era in hip-hop, a time before the market for the music began to mandate its content and presentation, rap's lyricists really began to blossom in the late eighties and early nineties. Emphasis on lyrical speed, authority, and style became more important than high-energy, chant-driven party rhymes. Live shows were stripped down. The requisite dancers who'd supported artist such as Big Daddy Kane, Heavy D., and Chubb Rock (often in three-piece suits) were considered passe. Fashion became uniform and decidedly "street:" oversized jeans and Timberland boots took little away from the point—the mic in the MC's hand.

MC Lyte, a female MC respected for her way with words, may have thrown on a pair of bamboo earrings; but in every other way, her gender was muted. Her sound, a strong alto with depth and texture, often led listeners to believe they were listening to a guy. And that was fine with Lyte, who wanted to compete with the boys on their own terms. She rarely danced, wore Timberland boots and plain white T-shirts. And she was regularly cited as a favorite by her peers, other male MCs.

The early nineties were a time, in New York at least, when an industry began to form around the music. Major labels would devote staff in their Black Music departments to the increasingly buoyant sale of rap music. Independent labels, whose foundation was hip-hop, like Def Jam and Tommy Boy, became a major presence. Industry showcases and record release parties became gathering grounds for devotees of the culture. In a sea of men, there may have been, at any given event, a dozen girls at these parties. To blend in many women adopted the trans-gender look of MC Lyte: baggy Girbaud jeans, Timberland boots and hooded sweatshirts were worn with simple bandannas or ponytails. What would become gangsta rap, West Coast hip-hop that featured violent narratives full of vehement misogyny, had found its way across the country. But Queen Latifah another superior MC at the time, resisted sexual objectification by opting for African attire and regal crowns. She later abandoned the pageantry, rightly reasoning that her look made her less accessible, but she never dropped the royal title.

Women, like everyone else in the audience during this time, were present to witness the rapid evolution that was happening among hip-hop lyricists. Content was king and everything surrounding hip-hop had gone minimalist.

Da Brat, the first female MC to sell more than one million records, mixed tomboy, glamour and materialism. The Chicago native, who'd become an important partner to super producer Jermaine Dupri, released her platinum album *Funkafied* just as the

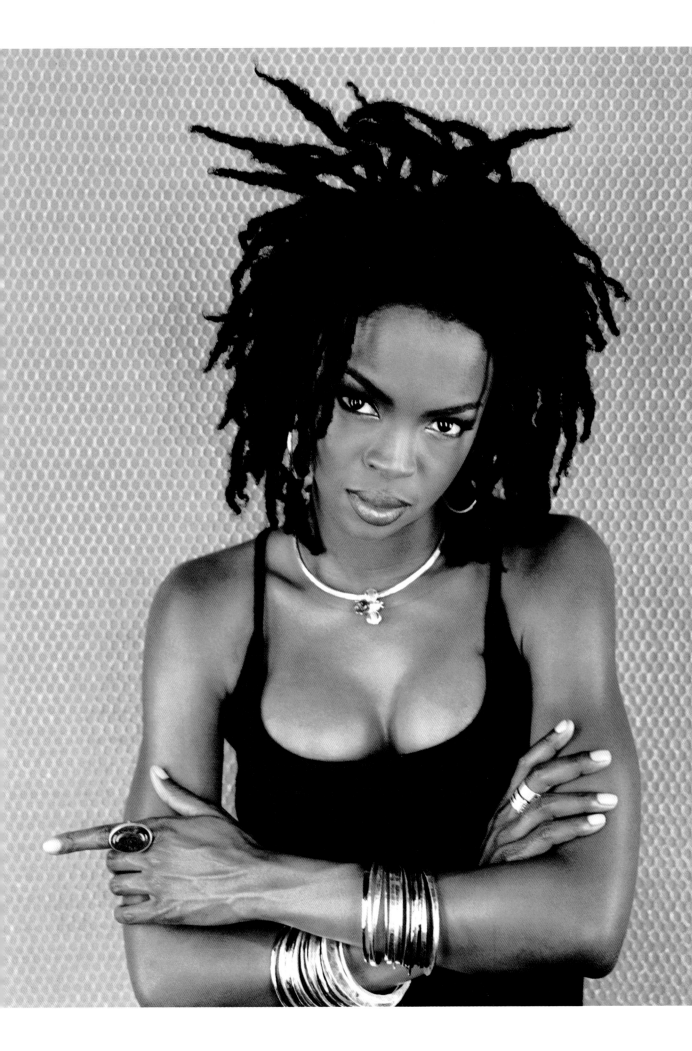

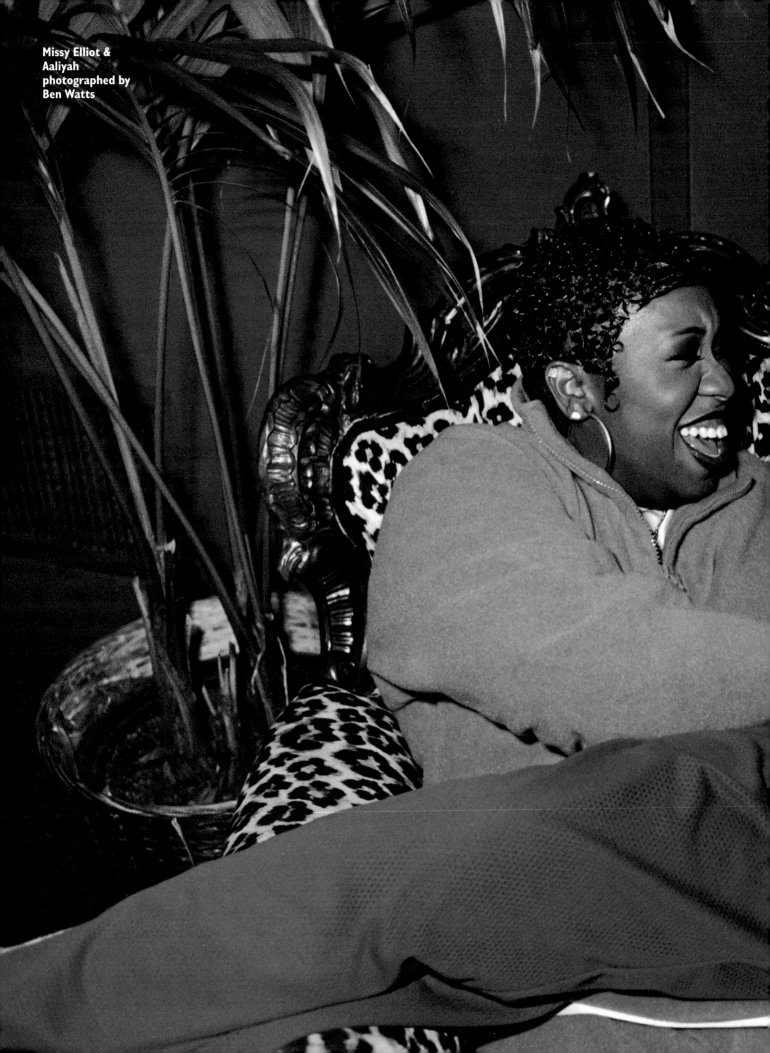

Missy Elliot &
Aaliyah
photographed by
Ben Watts

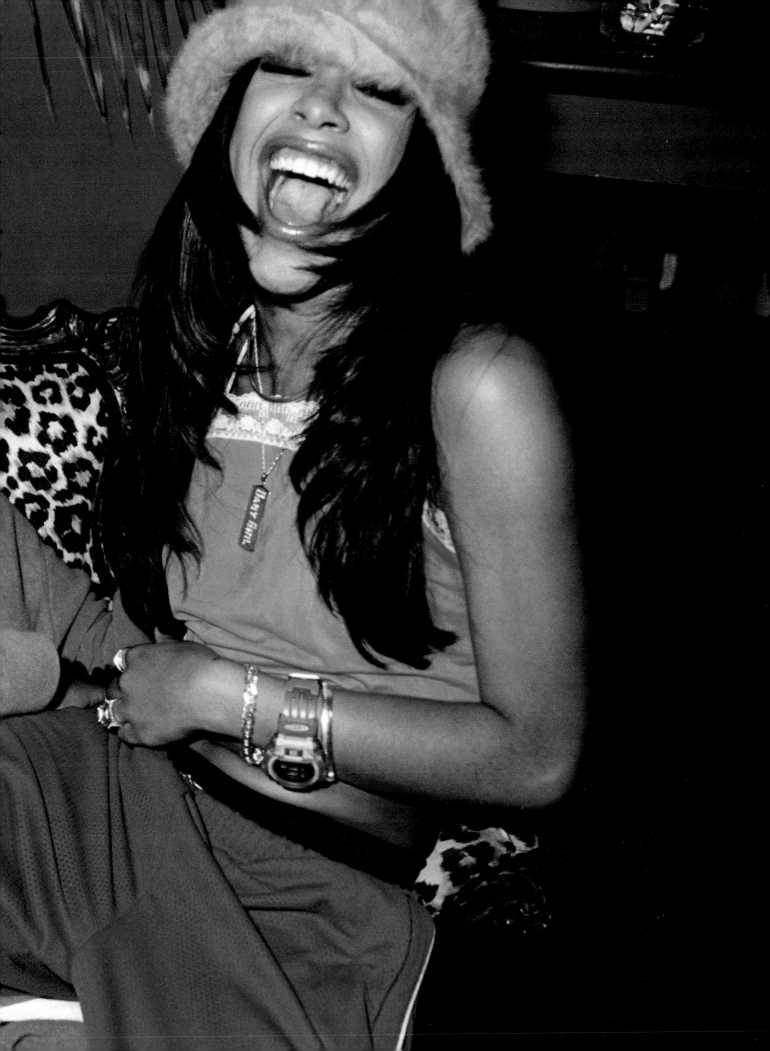

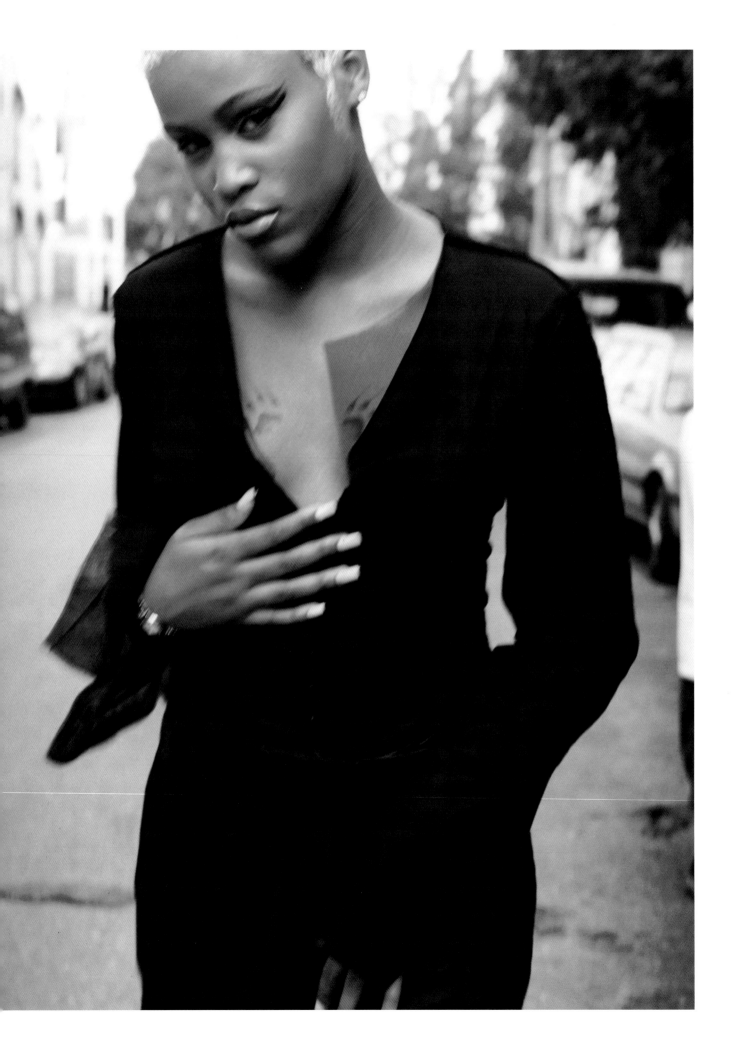

emphasis in hip-hop shifted to success in sales. Two factors contributed to the increasingly hyper-materialistic mood of hip-hop. One was the mega sales generated by gangsta rap. The other, more important factor, were the principles transplanted to hip-hop by the billion-dollar crack industry that had by the mid-nineties, been as much a part of the audiences' formative adolescent years as hip-hop. In the drug game, money was liquid and was spent as quickly as it was earned, preferably on items—Benzes, diamonds, and platinum—that belied the dealers' status. When Brat went platinum, she bought platinum. But beyond her jewelry, her look—baggy jeans, Timberlands and braids (minus the barrettes)—were as male-identified as her rhymes. Like Lyte before her, Brat rhymed about the same things as her male counterparts; only the boys no longer rhymed about their incomparable lyrical ability, but their semi-automatic weapons and offshore banking accounts.

Released little more than a year later, Lil' Kim and Foxxy Brown were marketed

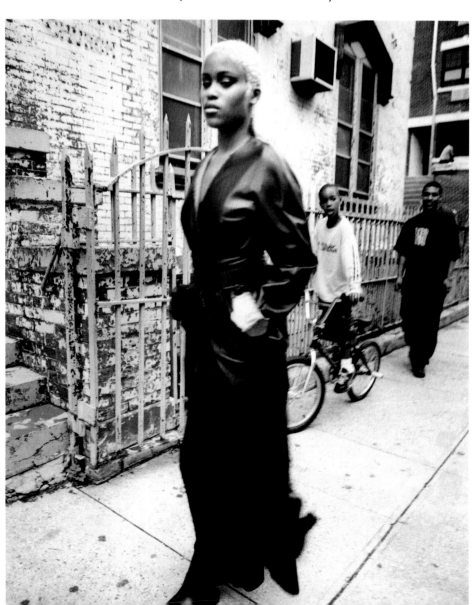

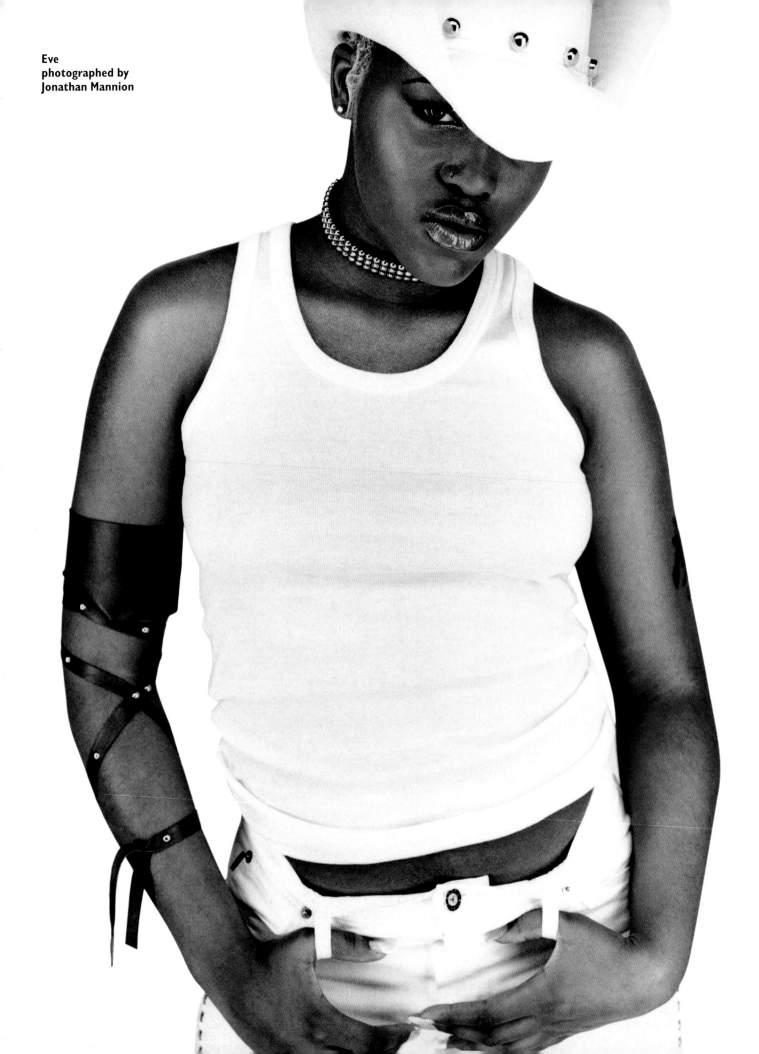
Eve
photographed by
Jonathan Mannion

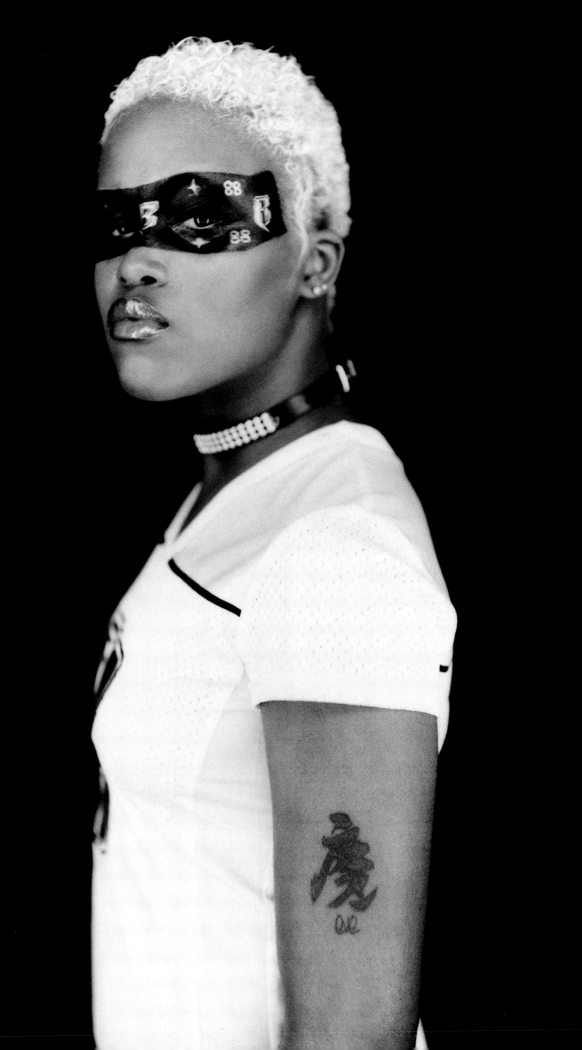

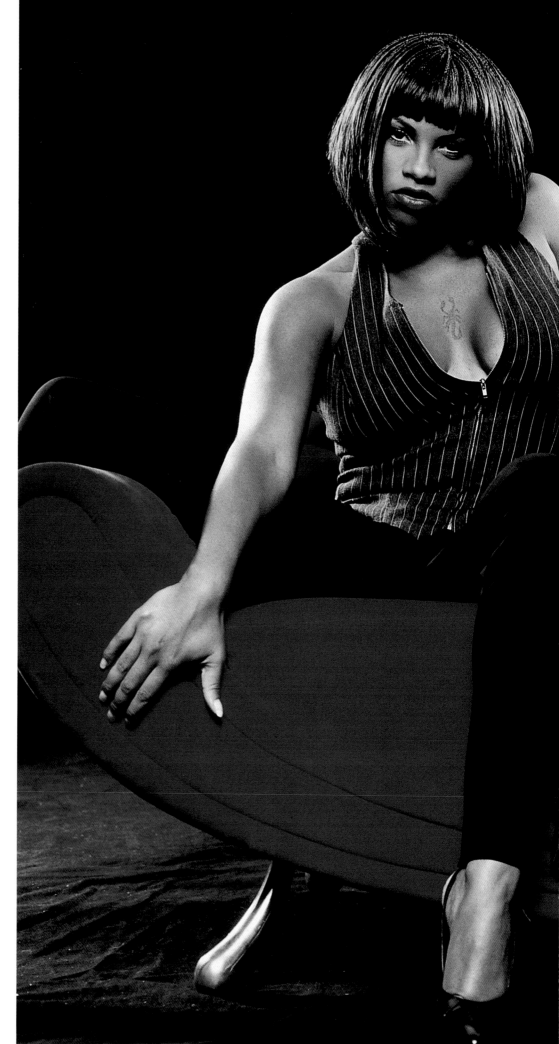

Salt N Pepa
photographed by
Guy Aroch

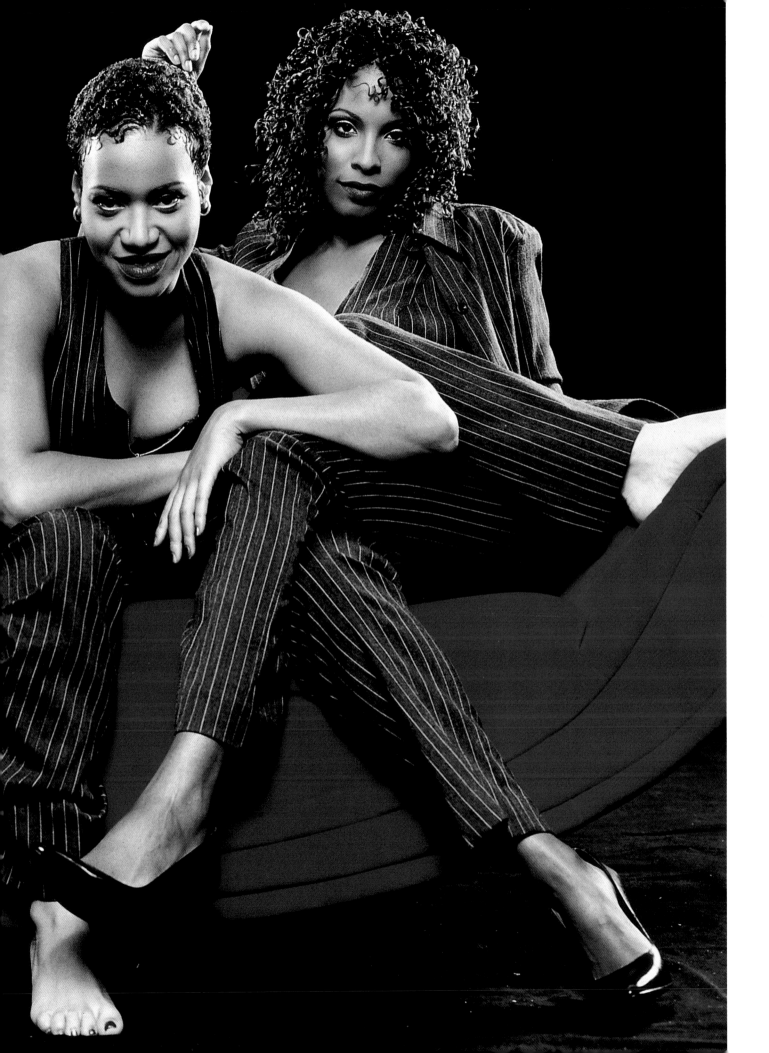

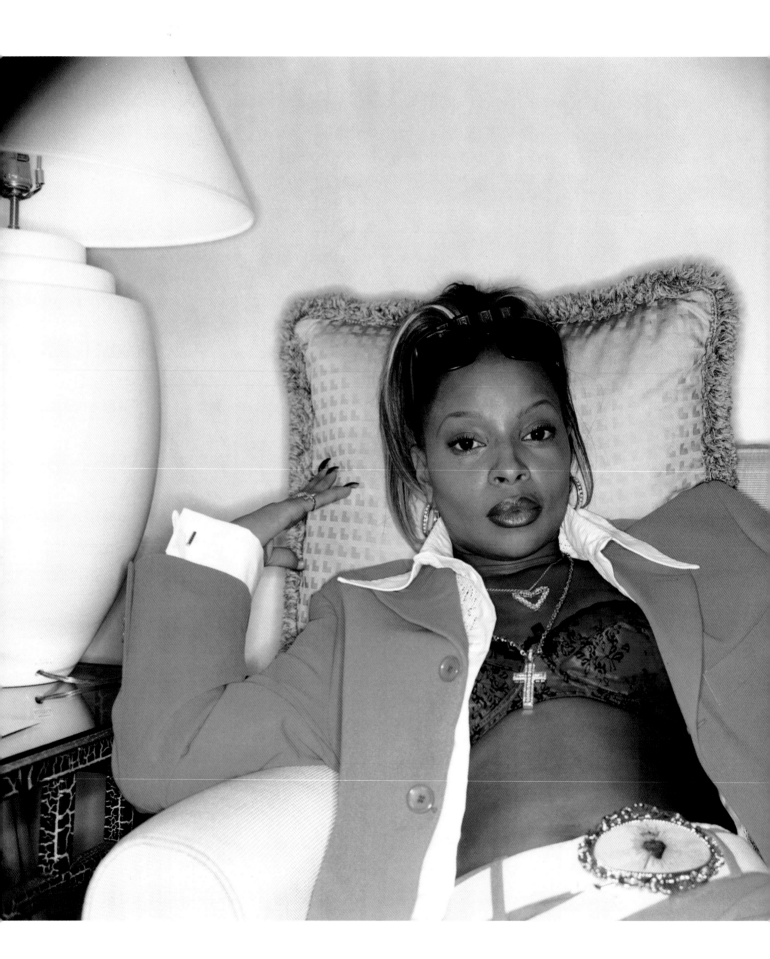

Mary J. Blige
photographed by
Jamil GS

as diametric opposites to Da Brat. Their hyper-sexualized images (both rappers launched their careers photographed semi-nude) were a direct contrast to the transgender look that had been relied on to gain respect within the genre. Kim in particular wore her sexuality like a costume, a prop that revealed the highly libidinous character she'd created. Giving a nod to the legacy of glamour pioneers Salt-n-Pepa (in a direct allusion, Kim featured the trio in her video clip for the single "Get Money") Foxxy and Kim reintroduced sex and glamour to hip-hop, only without the sisterhood. They delivered their rhymes perched on three-inch Manola Blahnik stilettos. They rhymed about sex, money, and the inter-gender politics created by the drug game. They surrounded themselves with their all-male crews, lest some eager fan become overcome with fantasy. Sometimes though, even the glamour, like the sex, seemed a cartoonish parody of itself. Decked out in high-end designers from head to toe, Kim and Foxxy often looked like two girls who'd won a shopping spree at Bergdorf Goodman's. The expensive clothes simultaneously consumed the girls and spoke to the consumerism and hyper-materialism that marked the hip-hop generation. Kim, in particular, became something of an icon for designers who declared at the end of the millennium, that luxury was back. Fashion media anointed Kim the very personification of excess. And designers who'd always copied but largely ignored the influence of hip-hop on their process, began inviting her into their world, having her photographed in the front row of their shows. She'd not released an album in years, but she was forced to creatively reinvent her already-shocking image every time she made an appearance. Ghetto fabulous, a term created by record executive Andre Harrell to describe the rich, designer-mad look of the drug dealer, had transmuted in ways that never could have been anticipated. In some ways Kim and Foxxy opened up the notion of sex as a marketing device—foregone conclusion for women in any segment of the entertainment industry—to men. In the wake of Kim and Foxxy's success, male rappers like DMX and R&B singer Tyrese began using their bodies as selling points. Shirtless and well-toned torsos became common in ads selling hip-hop albums. Sticky Fingaz from the group Onyx even released a beefcake nude twelve-month poster.

While their sexual bravado may have opened things up for men they did little to liberate Black girls from oppressive notions of beauty. Foxxy may have been proudly flaunting her "cocoa skin" but she never left home without her weave. And Kim, who began her video career wearing a short curly natural, graduated to a three-foot long Crayola yellow mermaid wigs and blue contacts. In interviews Kim, in particular, would speak to the inferior way in which she viewed her own beauty. "I'm no Halle Berry or Jada Pinkett," she would say. And it was painful to read. Hip-hop had exploded notions of what was acceptable and beautiful among men—Biggie Smalls, her 360-pound mentor was considered sexy. Kim's notion of glamour, once unburied from her costume, still lie

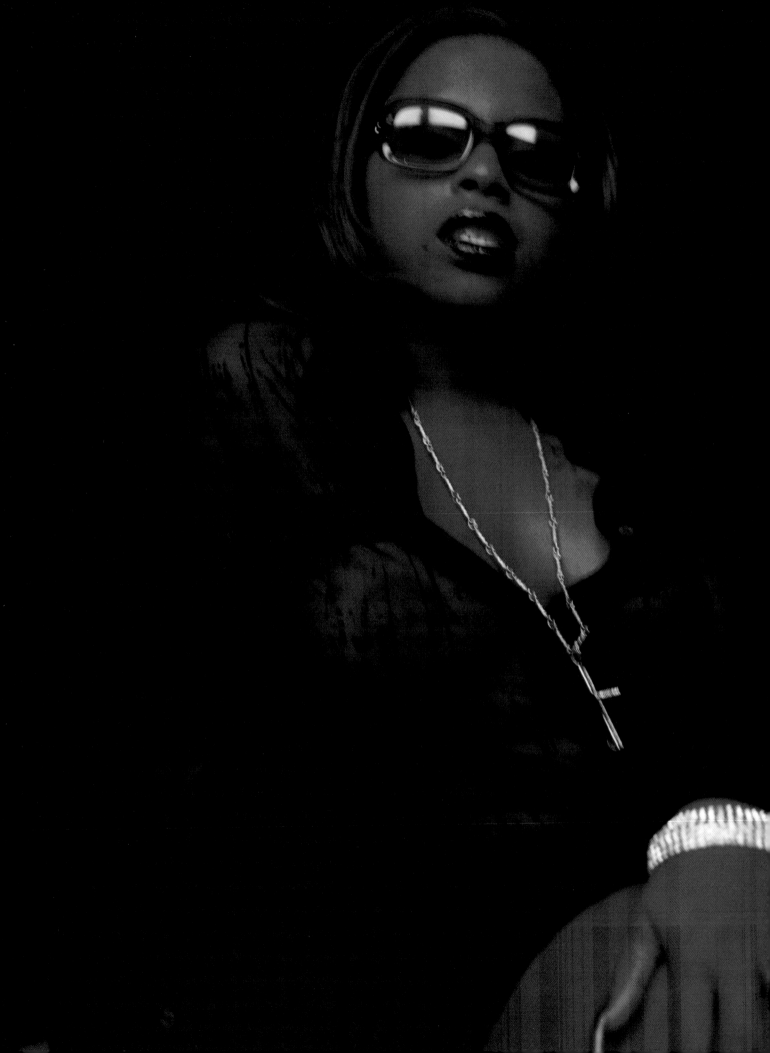

Foxy Brown
photographed by
Jamil GS

firmly in an age-old notion that lighter women, preferably with less ethnic features were the "real" beauties.

With rhymes that condemned "hair weaves by Europeans and fake nails by Koreans," Lauryn Hill offered herself as a remedy to the openly sexual, ruthless materialism of Foxxy and Kim. Lauryn Hill definitely owed some of her regal posture to Queen Latifah and her lyrical dominance to Lyte (with a similar throaty alto), but she is in every way her own creation. There is simply no reference for her in the history of stylish Black women. Diana Ross may have shown us what perfection should look like beneath a floodlight, but she was also always beneath a wig, compromising her culture as she made it accessible. Aretha, with her towering galees was a powerful symbol for the Civil Rights Movement (and a precursor to Erykah Badu) and certainly provided, on an iconic level, an image of Black beauty that was alternative at the time. But what is unique about Lauryn is that, thanks to these early divas, her style comes across as completely effortless. Her dreadlocks have never seemed like a contradiction to her four-carat studs or even her tight short shorts. She certainly didn't exist in a vacuum, New York hip-hop girls had been rocking the same hybrid look—glamour and roots—for years, but they'd not been onstage. With her elegant composure and forceful turns on the mic, Lauryn seems as accessible as she does celestial.

By the time Eve, the sole female member of DMX's Ruff Ryders clique, came along, she was embraced wholeheartedly as equal parts thug girl and high fashion. She keeps her hair cropped and natural, and though she dyes it platinum it never screams victim the way Kim's long blond wigs often do. She is always impeccably groomed, whether she's rocking jeans and a motorcycle jacket or a Fendi fur. She writes songs that condemn domestic violence and others about loving a thug. She is young enough, barely in her twenties, that there was never a time when hip-hop didn't dictate style and fashion. She, like most female MCs since Salt-n-Pepa, is part of a larger all-male rhyme crew and respected for holding her own. She's been forthcoming in interviews about her past as a teenage stripper, but she is also a role model to teenage girls who see her as a fiercely independent model of the possibility of transformation.

For the hip-hop generation, style is not just something we work, it's something that works for us, to debunk the many myths that would strip us of our humanity. When we are excessive, even gaudy, it is only to say "I am here:" "Me and this chinchilla have crashed your party and we won't be erased with some dismissive once over." You will look upon us and be blinded by fabulous-ness. When we drape our sexuality in so many oversized pieces of boy's clothing, we announce that we've come to participate, on a level playing field, that we won't be objectified or groped—not tonight. There are rhymes to be heard, so listen up. When we descend in all our glory, white Yohji Yommamoto flowing along with locks, it is only to remind the world that true goddesses live and breathe among us, They are called Black Girls. —*dream hampton*

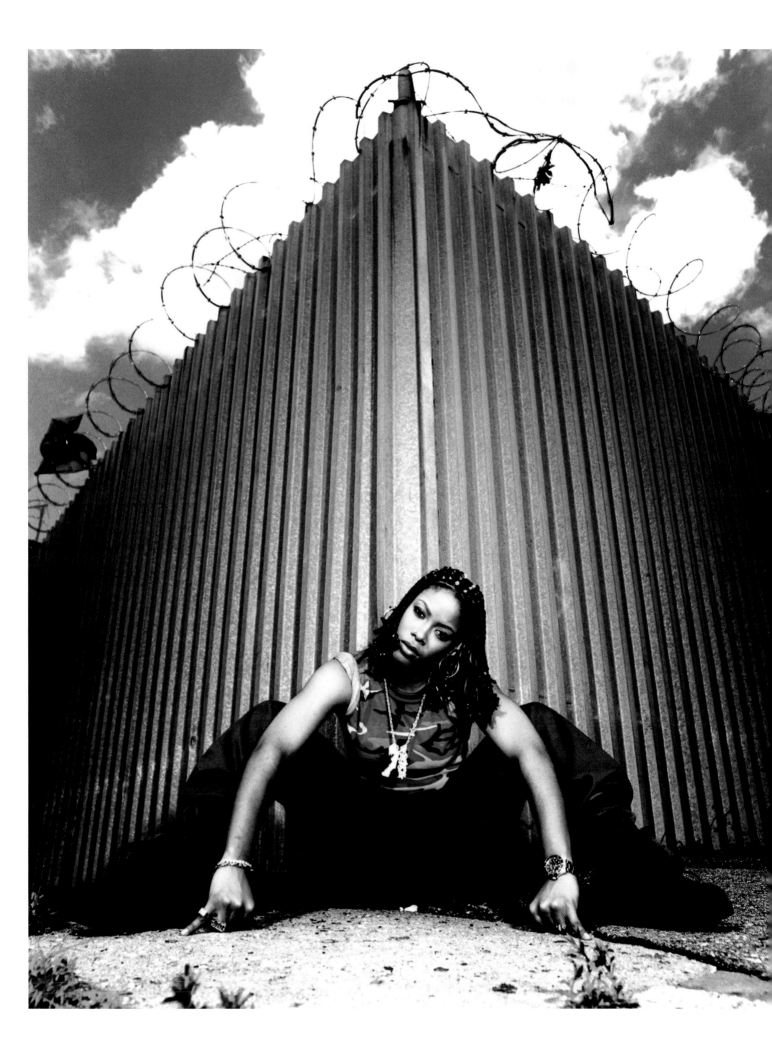

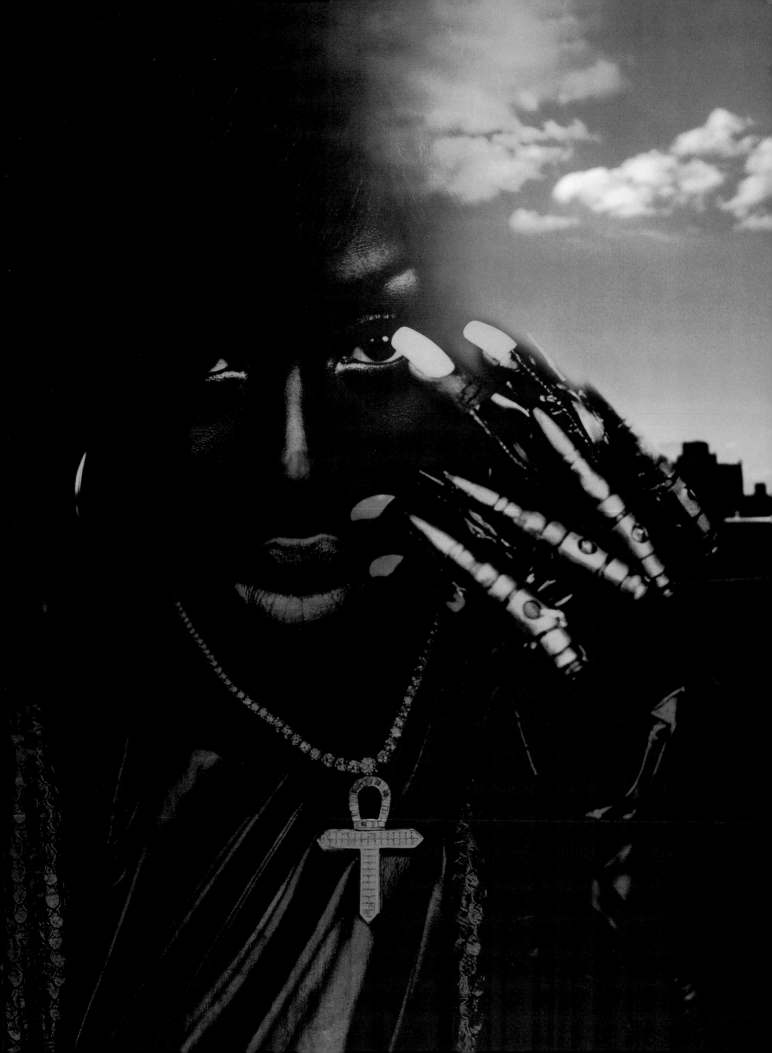

Singu larst yle

**Kelis
photographed by
Jonathan Mannion**

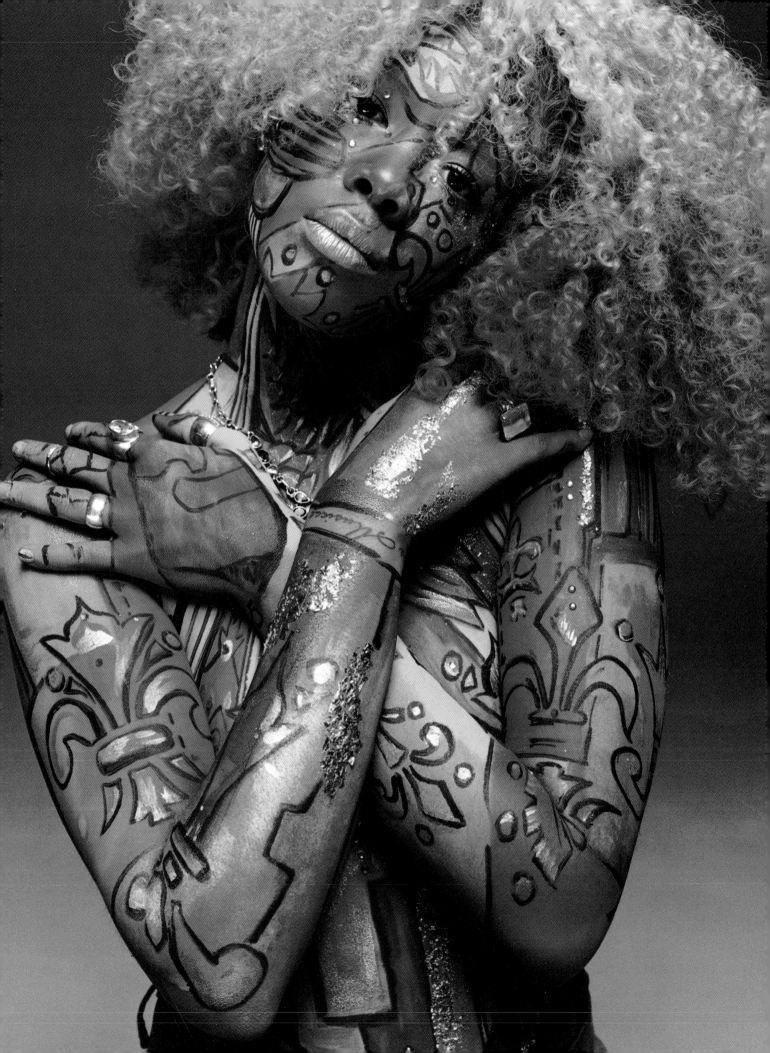

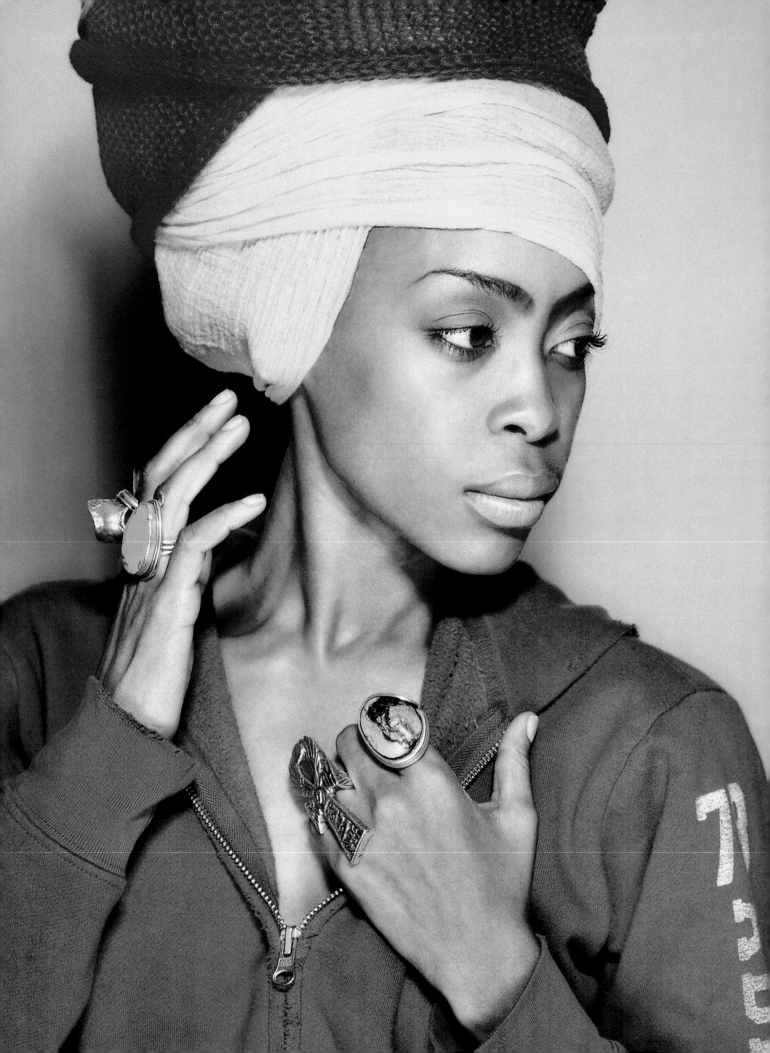

ow many times have you seen a traffic-stopping, style-serving bronzina walking down the streets of Harlem or Holland, New Orleans or New Zealand—her hips sashaying, duster flapping in the wind, and spiked heels clicking on the asphalt cement to their own beat. You turn around and say to yourself, "Now there's a girl with her own groove."

Unique Black women are indeed unforgettable—whether they fashion a look that says, "drop dead diva," "bohemian Black girl," or "neo–soul sister"—simply by letting their locks sprout and shout—they've left their stylistic mark on every era in modern history. Indeed, with the dawn of each new decade, a new breed of unique Black women bring on the noize with an eclectic sense of fashion, beauty, and attitude that cannot be simply defined.

THE DRAMA QUEENS Ever since La Baker strolled down the Champ d'Elysees in Paris wearing more spots than her pet leopard on a leash, supreme-stylin' sisterellas have been forging their own brand of bold, brazen style. We call them "drama queens"— those inventive icons who defy style counsel, fashion skirts out of Chiquita bananas, and snare prey into their hypnotic style trance with nothing more than their flashy pearly whites, and maybe a hair extension or two. When a drama queen walks into a room, there is bound to be kinetic excitement, bizarre anecdotes to share for years to come, and, at the very least, a night full of memorable fun.

I remember the first time I saw Grace Jones in the flesh. The year was 1980. I walked into the bathroom of a Paris discotheque and almost stumbled into the woman who happened to be the most famous and sizzling drama queen on the New York–Paris–Milan scene at the time. *Quel* fun! She with that smoky voice, and ebony-dark skin

stood right before me. That night Grace prowled the darkness in tight black leather pants and motorcyle jacket—topped by a motorcycle hat that dipped low over her right eye. She was the poster girl for the disco era: big smoky eyes, wide nose, killer cheekbones, and most important, lips so alarmingly luscious, white women would run to plastic surgeons for years to come, desperately seeking to copy the shape of her startling Cupid's bow. But as time would show, there would never be another Grace Jones.

Looking at Grace Jones was deliciously wicked, kind of like a scene out of the film noir, *The Night Porter*. Sometimes Grace even wore suspenders sans shirt the way Charlotte Rampling's masochistic character did in the infamous Caviani film. Going bare-breasted was a Grace Jones signature, probably a throwback, no doubt, to the days of Josephine and her bare-breasted antics. Her style counterparts of the moment certainly couldn't do it without getting arrested: Toukie Smith, Bianca Jagger, and Iman were shaped too womanly. Those girls were the talk of Paris too, but it was Grace who had the most definitive style—a raw, wicked, androgynous she-man style that is copied to this day. At that time in Paris, Grace Jones and her lover, the infamous photographer Jean Paul Goode, would create a style movement that would later become known as "New Wave." His photographs and rock videos of Grace and her music from the mega-successful album, *Warm Leatherette*, were just about everywhere. Everyone loved Grace. They couldn't get enough of those lithe limbs sometimes wrapped in a suede loincloth or satin boxing shorts with that infamous Cupid's bow drenched in fushia lip gloss. And, of course, there was her hairstyle. Grace Jones defined the fade: hers was angular to the point of no return.

Prior to our chance meeting at Le Palace discotheque in Paris she had already reigned for the better part of the seventies as a runway model before she became a singer. Back then, she was an *enfant terrible* model for prestigious French designers from Issey Miyake to Jean Paul Gaultier. But Grace had just released her first album, *Portfolio*, and it was already becoming the disco album of the decade. The hit single, "I Need a Man," defined women's new brazen attitude: ask for what you want, and flaunt what you have to get it. By the time Grace debuted in the late 1980s James Bond film *A View to a Kill*, she had perfected a look for fetish fashion that teased and taunted the masses in Frederick's of Hollywood fashion.

By the early 1990s, Grace's over-the-top theatrics combined with animal magnetism lent itself fiercely to her *Boomerang* role: that of a whip-slinging tigress model, "Strangé." Her costume—a short, black vinyl raincoat with nothing underneath but a G-string—has been copied by everyone from television tigress Pamela Anderson to RuPaul.

One look at *Supermodel* recording artist RuPaul's over-the-top femme fatale façade and it's clear that this pop culture icon draws much of her drama-queen style inspiration from drama queens like Grace Jones, Diana Ross, Josephine Baker, and Tina

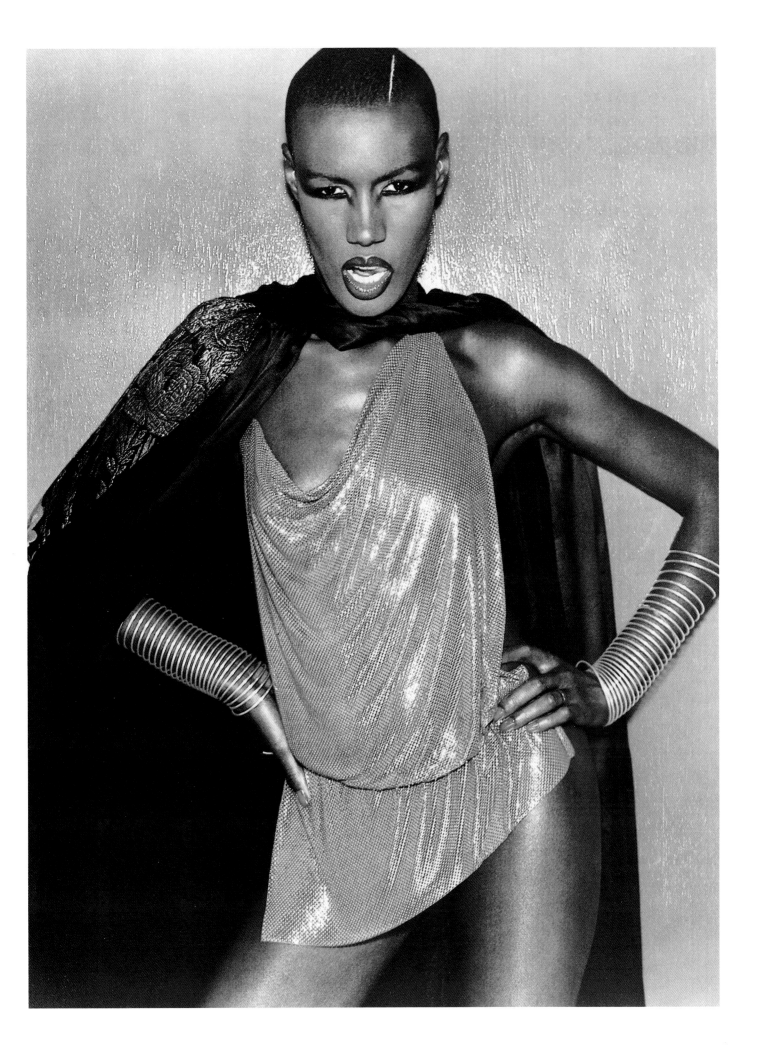

Kelis
photographed by
Jonathan Mannion

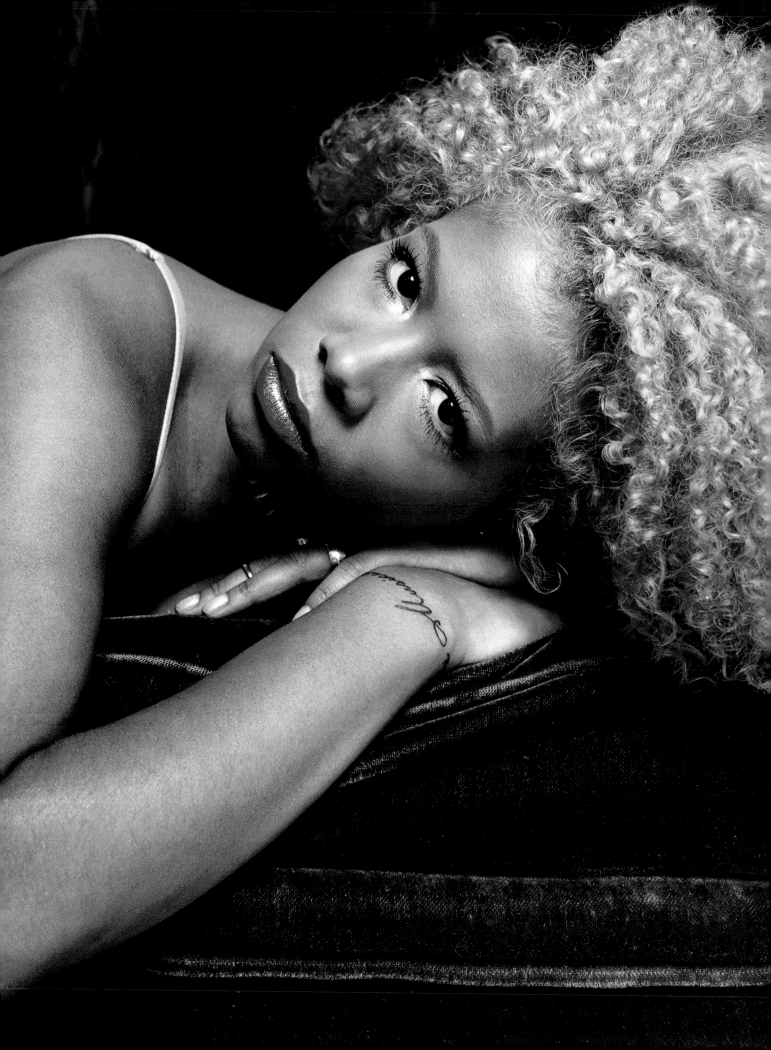

Turner. It's evident from the tip of RuPaul's platinum pussycat locks to her shocking bright and skintight satin gowns, down to her black stiletto six-inch spiked heels. Part Southern tigress, part Frederick's of Hollywood man-made creation, RuPaul arches her brows, glosses her lips, and dons elbow-length Lycra gloves covered with jeweled bracelets with a vengeance that only a true drama queen can muster. Almost by birthright, the Atlanta-raised singer uses her studied over-the-top style to make her mark in pop culture history: landing a coveted role as a MAC cosmetics spokesperson, a stint as a VH1 late-night host, and parts in feature films. Thanks to RuPaul's *Supermodel* success, a whole new crop of drag and real drama queens have cropped up ready to take up the elbow-length satin gloved gauntlet and land in pop culture history. To the next batch of drama queens around the world, we have one thing to say: "Sashay! Shante!"

THE BLACK WILD CHILD The Black diaspora has created a style fusion best decribed as a hip hybrid. Racial and cultural blending around the globe has created groovy girlies with an unleashed sense of style who draw their style inspirations from a mélange of cultural influences. These women love to sport corkscrew curly manes of hair with a sense of abandon that only an "undiva without a weava" can comfortably flaunt. She is proud of her hybrid heritage, her eclectic style, and defines her cultural identity on her own terms. The Black wild child pulls together her look in any capricious way she fashions and has the same hybrid taste in music too, always down with new grooves that cross genres. She worked it courtesy of the late 1960's hippie movement, and she reemerged with hybrid force in the late 1980s. That's when I met rapper Neneh Cherry, the Black wild child supreme. Cherry is the product of a Swedish mother and Black American jazz musician father, and she left her East Village childhood behind to set down her musical roots in London at the tender age of sixteen. At the time of our chance meeting, she was in New York to promote her hit single, "Buffalo Stance." She was shopping at a lingerie shop, and quickly snapped up a Carnival black bustier with a low-cut back and foam-filled cups. This foundation piece was at the forefront of the lingerie-worn-on-the-street movement, made popular by Madonna, who wore hers covered with gobs of chains and crosses. Neneh took the look in another direction. She had a more untamed, bohemian edge. She usually paired the bustier with combat boots, torn fishnets, and a short Lycra miniskirt. Neneh was visibly pregnant at the time, but that wasn't stopping her promotional tour. As a matter of fact, Neneh was the first performer I remember touring while visibly pregnant and not afraid of showing it. I think that's what Neneh meant by "Buffalo Stance."

Fast-forward to the dawn of the new millennium and British-born Melanie Gulzar, known to the world as one-fifth of the girl group the Spice Girls. She proves Black wild child style still reigns, scarily supreme. Like Neneh, Scary Spice Mel B is a product

of mixed heritage, with a headful of beautiful woolly locks that have a life of their own and a caramel complexion that doesn't need the over-the-top "MAC beat" that many a diva, drama, or hip-hop queen prefers. During her short-lived but off-the-chain lucrative (she's valued at £20 million—approximately $36 million in Americana speak) career as a Spice Girl, Melanie Gulzar never wavered from her wild child roots. There were no last-minute hair color additions for *Saturday Night Live* guest appearances, or wavering showbiz jitters that prompted her to get "wannabe" weave extensions that would render her corkscrew curls straight and lifeless. Not even the move into her tony mansion or motherhood have tempted the pop star icon to shed her wild child roots or cover her belly button.

Four other performers from different ends of the music and showbiz spectrum—R&B pouter Kelis, old-school soulstress Macy Gray, actress Lisa Bonet, and actress-singer Cree Summer—have also rekindled the Black wild child flavor with a bohemian blend clearly defined on their own style turf. Releasing an album heavily influenced by her longtime friend Lenny Kravitz, singer Cree Summer revels in her free-spirit style both musically and personally. In a time when slinky Lycra-clad divas with straight weaves reign supreme, Cree Summer opts for her own kinky spiral curls while fashioning her look with cropped crochet tops, low-slung baggy blue jeans, or bulky sweaters worn with long, flowery skirts and clunky boots. The Street Faerie singer epitomizes the multicultural style that has been foisted upon the masses as of late. At the onset of the year 2000, ethnic wild child looks were running wild, built on ropes of Moroccan beads worn around the neck, embroidered pashmina shawls, and cotton pullover tops made in India, American Indian turquoise bracelets, long flowing paisley skirts worn with clunky leather knee-hi boots. Cree Summer's look is clearly as eclectic as her heritage. She was raised on a Plains Cree reserve in Saskatchewan, Canada, by a jazz musician father and dancer mother, as much a part of her self-expression as her eclectic genre of music.

Another Black bohemian on the music scene is Grammy-nominated singer Macy Gray. While Macy Gray's raspy vocal style can be traced back to legendary yet little-known singers such as Abbey Lincoln or Karen Dalton, her style is unmistakably her own. The recording artist who was nominated for Best New Artist in 1999 for her debut album, *On How Life Is*, sports kinky locks that seem to sprout from a wellspring of lush creativity deep within. Propped up by her plump Mongolian lamb or faux fur-collared coats and dusters paired over groovy bell-bottoms, Macy Gray gives us style that is funky, yet hip enough for the new century.

The first thing you notice about R&B/hip-hop fusion singer Kelis is her out-of-control curly mane. Sometimes it's even funkadfied by pink, violet, and cotton-candy hair color. The Harlem firecracker even dyes her eyebrows to match. Suffice it to say, Kelis's look, like the name of her debut album, *Kaleidoscope*, screams for attention on

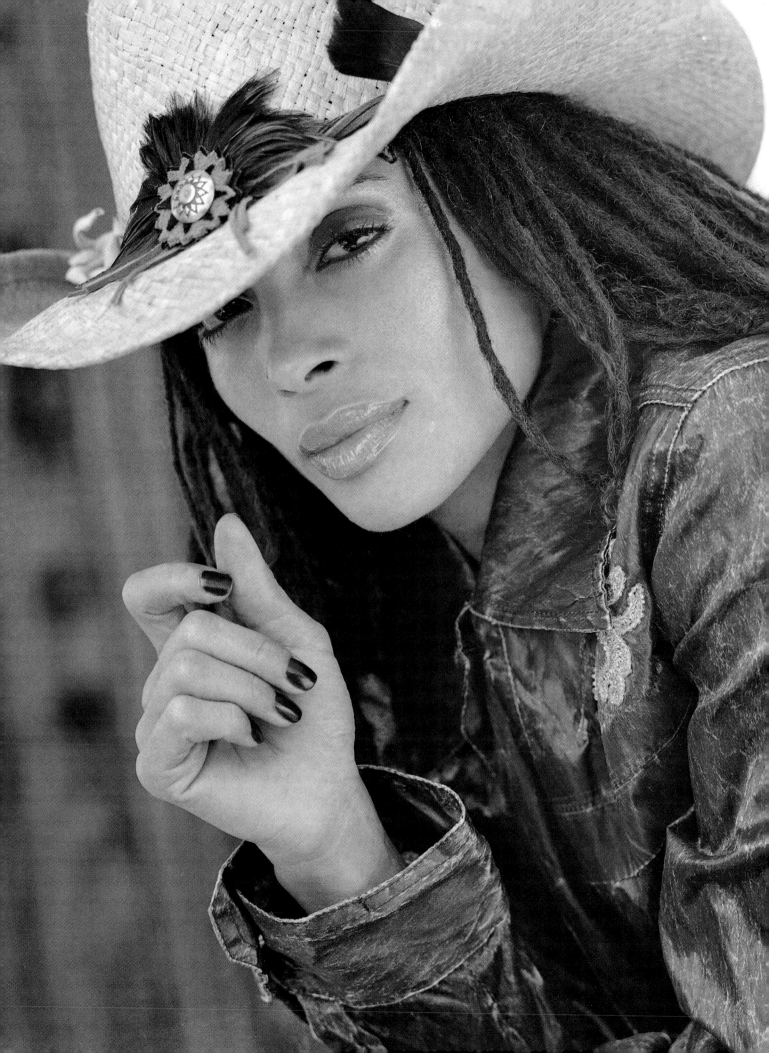

RuPaul
photographed by
Mathu Andersen

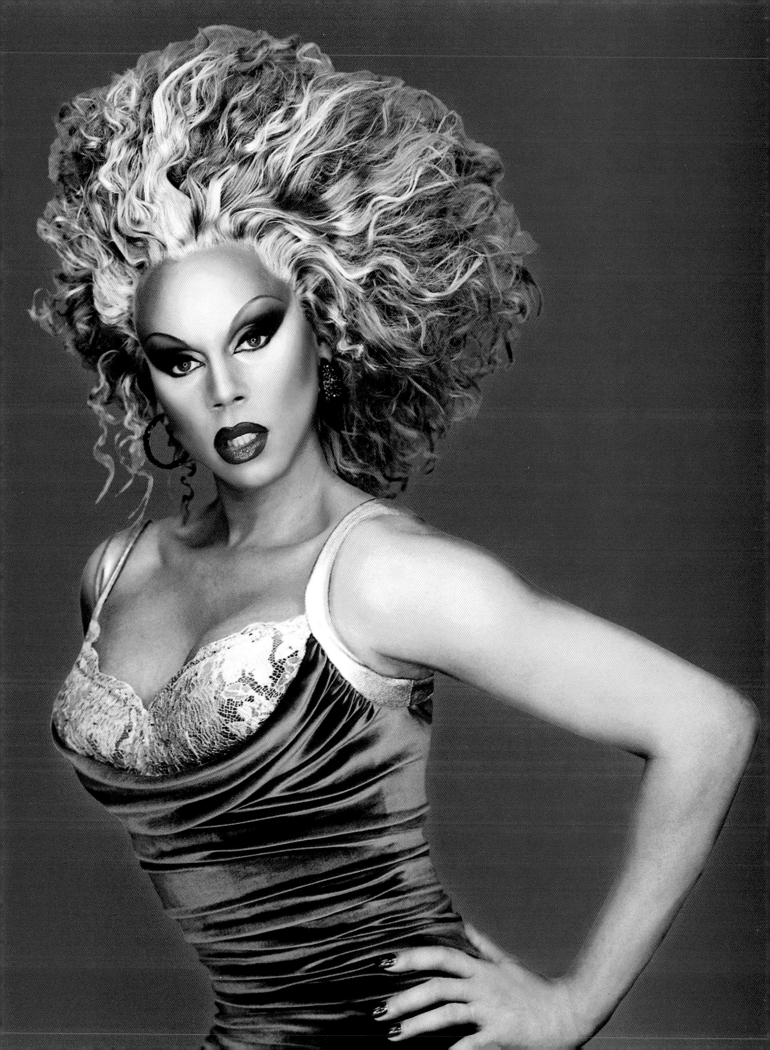

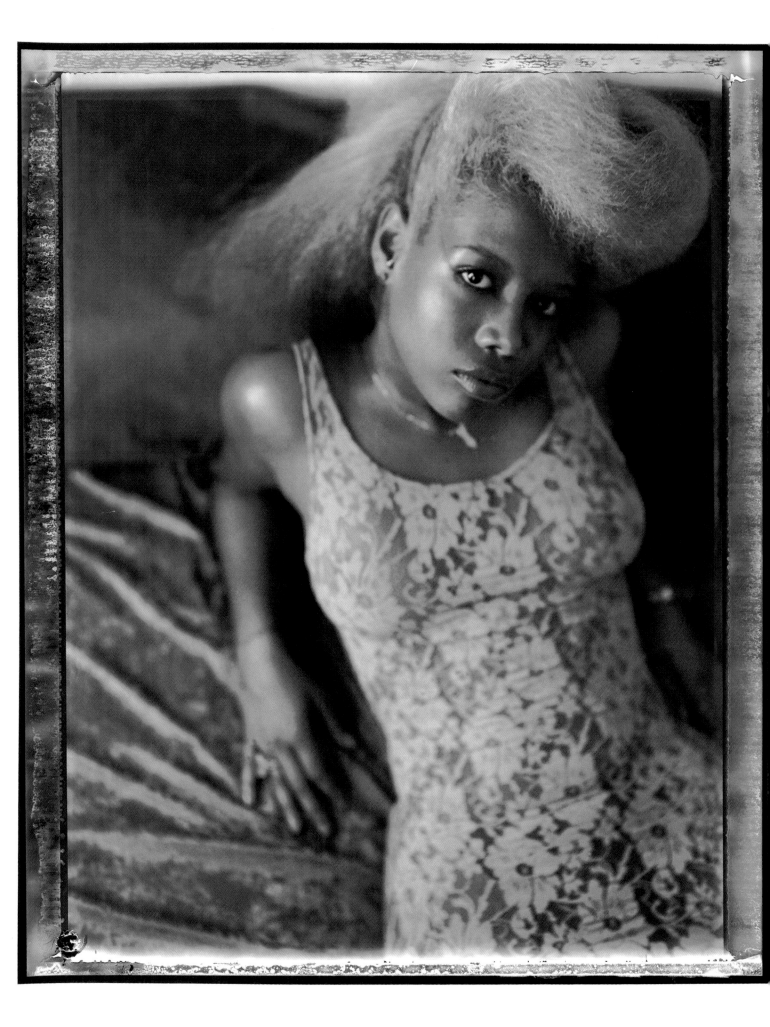

her own terms. Her album cover image gives the biggest nod to the psychedelic mania of the 1960s. Completely covered in psychedelic body paint, Kelis is obviously poising herself to become the multigenre artist for the new millennium.

Hybrid is as hybrid does, and many sisters use their unique "masala," or blend, to create their wild child style as they please. A case in point is actress and former Lenny Kravitz love, Lisa Bonet. As an almost-child actress on the institutional sitcom, *The Cosby Show*, she kept her curly mane under control, sporting hippie chic and professing her love for Lenny with flower-power vengeance. Post *Cosby*, the lovely biracial beauty re-created herself for the controversial film, *Angel Heart*. Audiences did not respond, and her film career went almost stillborn. But Bonet moved on, raising the child she had with Kravitz, until she returned on the scene in the late 1990s. Sporting a long mane of dreadlocks and wearing a nose ring, she found the perfect role, playing the rebel lawyer activist and former college love to Will Smith's straight-laced character in the 1998 film, *Enemy of the State*. The film was a blockbuster hit and again Bonet became the talk of tinseltown: "Did you see her dreadlocks?" "She still looks good." "What about that nose ring?" Like most bohemian spirits, Bonet doesn't seem to mind much if you don't get her style trip. Her movie role in the romantic comedy, *High Fidelity,* was proof. Wearing thrift-store retro garb, Bonet flings her long dreadlocks and flaunts her nose ring like proud symbols of her Black wild child status.

THE CUTURAL GROOVE In the sixties, Black-pride stylers wore Afros and caftans glamorized by foot-long eyelashes and white frosted lips and tips. Fast-forward to the nineties and many of our pop culture icons have reinvented the cultural groove. From comedian Whoopi Goldberg to Jamaican reggae singer Patra, funky singers Angie Stone to Me'shell Ndégeocello, to conscious performers Les Nubians and Erykah Badu, there are a slew of soulful performers intent on carrying on the Black Power style tradition. Singer Erykah Badu burst onto the music scene in 1997 with her unique brand of "Baduizm,'" and it was clear that her style cipher begins with the right frame of mind. I interviewed the star that year when her cultural comet first started rising. This unknown singer named Erykah Badu sat before me—carefully lighting three sticks of incense and forming a cipher with her bangled wrists before speaking about the vibrancy of the Black artistic scene in Dallas that gave birth to her brand of deep-gut singing and philosophizing on the mike. For Erykah it's all about 360 degrees of inner poetic peace—and wrapping herself in garbs of brilliant-colored fabrics that soothe the body, spirit, and mind from head to toe. There's no doubt that Erykah is a Southern girl who is inspired by our connection to the Motherland. I was present at Erykah Badu's first promotional performance for her yet-to-be released album *Baduizm*, which would ignite the Badu groove and the music and fashion worlds. Beneath her traditional African brightly colored headwrap and outstretched henna-tattooed hands, I could see a

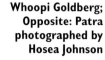

supremely focused trailblazer burning bright—and fiercely determined to challenge the cult of scantily clad video hoochies with her brand of beauty, determined to baptize the world with a new generation of cultural style and funk. She went on to parlay her Afrocentric, Nefertiti attention-getting garb and groove into an acting career, landing roles in *Blues Brothers II* and the Academy Award-winning film, *Cider House Rules*. For the latter, Erykah Badu landed a coveted slot as a presenter on the Academy Awards presentation for 1999 winners. While other stars were scurrying to secure gowns from top designers such as Randolph Duke, Christian Dior, and Versace, Badu was brazen enough to draw upon her cultural roots and present wearing one of her own emerald green wrap creations.

I knew that singer-songwriter Angie Stone's time and place would also come. The time is now and the period can best be described as "neosoul"—with newcomer Macy Gray and old-school diva Angie Stone at the forefront of it. At last, the "Black Diamond" in Angie Stone is sparkling. Chocolate, voluptuous, and earth mother-ish (having given birth to a love child from her soulful musical counterpart, D'Angelo) Angie Stone is free at last to be full-lipped and acrylic-tipped to the Motherlode max. After two decades of struggling in the music biz, Angie Stone is finally "set free": her curls are quasi kinky, quasi freestyle, framing a face with ancestral features in full bloom. She favors big silver hoop earrings and long, squared-off acrylic-tipped fingernails painted in startling shades of white that create that startling contrast against her skin. It's a sister thing that started in the late 1960s in nail parlors from Oakland to Baton Rouge. Other sisters take the ornamental tradition a step further and add decorative decals or delicately placed rhinestones. Decades later, Angie Stone tips her hand to Afrocentric style. One hundred percent funkdafied and proud, her arms are always adorned with massive bangles or bracelets, her voluptuous cleavage frequently inviting one to dip into her well of electric soul poetry without remorse.

In the 1990s, one genre of music that spawed a generation of funky neosoul style is conscious rap. From Arrested Development to Digable Planets, Afrocentric style—bald heads, elaborate braids, cowrie shells, and wraps—have been thrust to center-stage. Leap across the Atlantic to Bordeaux, France, and you'll find two sisters in full regalia: conscious rappers Les Nubians pay homage to Black style by imbibing it with their own cultural sensibilities. With the release of their debut album, *Princesses Nubiennes,* in

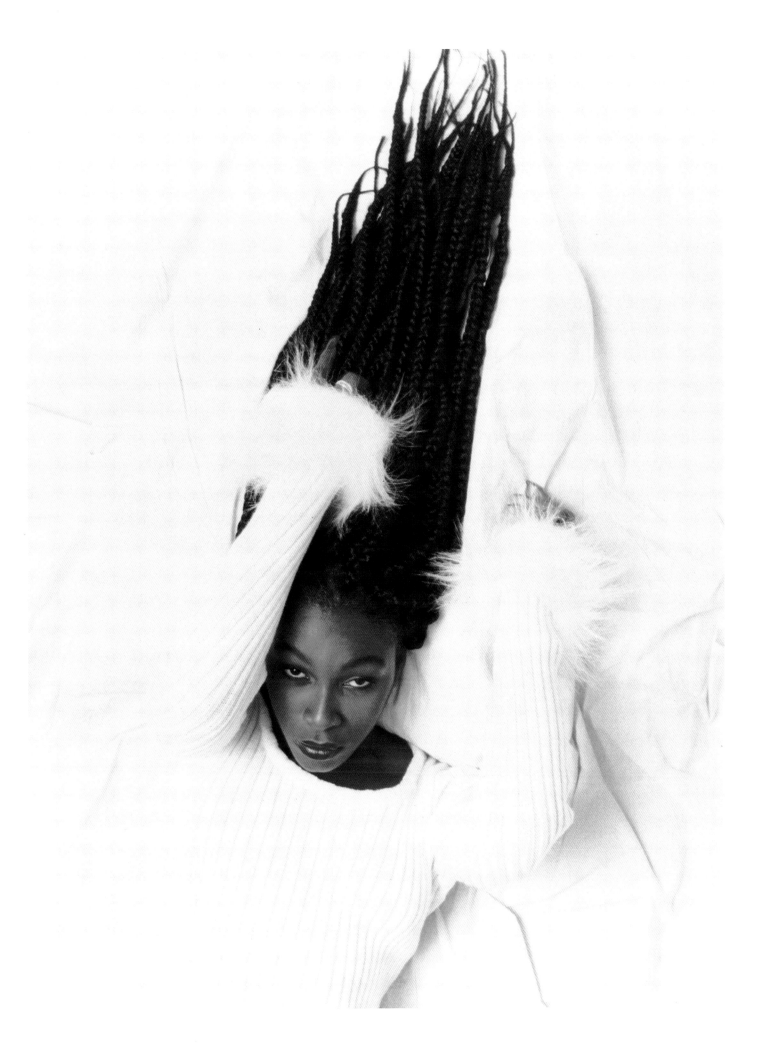

1998, sister singers Helen and Celia Faussart showcase their unique blend of Cameroonian funk and French cool, unleashing a new brand of Black global style that clearly draws its roots from ancestral African accents yet stands on its own.

While many of her Jamaican counterparts sport dreads, stunning reggae singer Patra "pulled up to the bumper" sporting slick braids, cut-off jeans, and natural tigress attitude. It's probably no coincidence that she remade the song—spicing up the cut with a lowdown reggae groove—that also propelled her pop culture icon counterpart, Grace Jones, to the top of the charts and style. Like Grace Jones, Patra possesses the same aura that leaves crowds salivating and panting for more. As her popularity rose, however, the image-makers behind Patra relied less on her natural assets and more on glam. For the release of her second album, Patra turned to the glistening glam of black vinyl. There she stood at her record release party in a catsuit and thigh-high black vinyl boots. It was a pure Patra moment with a little help from her ancestral predecessors.

When did wearing dreadlocks become downright cool for sisters? I think it all started with the rise of comedian Whoopi Goldberg.

In 1985, this dreadlocked comedian in baggy jeans and workshirt stood on an almost bare stage on Broadway and put a white shirt on her head and cooed about her "long and lovely locks." Of course, the character Whoopi was portraying was an eight-year-old girl who secretly yearned to have "white girl hair." It was a monologue that spoke volumes about Black women's struggle to accept their kinky locks. When she took a bow on that Broadway stage back in 1985, her real dreadlocks flowing freely, it was clear a star was born: a star who was "happy to be nappy" at that.

Of course, she wasn't born Whoopi Goldberg. Little ol' Caryn Johnson from the projects reinvented herself by choosing a name and hairstyle that suited her best and left her free for the show business of just being Whoopi. Some thirty-five films later—including the blockbuster 1992 film, *Sister Act,* which catapulted her into the $10 million per pic status, making her one of two Black female icons (the other is Whitney Houston) who can command such a hefty paycheck in Hollywood—Goldberg's cultural stance seems to be working. Of course, there were the naysayers along the way; those naysayers who called her an unlikely star—skin too dark, hair too nappy, looks too unconventional, and wardrobe too manly—those trademark loose sweaters, loose pants, loose shoes, and flowing dusters seem too downright dowdy for a pop culture icon, which is exactly what Whoopi Goldberg has become despite their negative predictions.

But, thanks to Whoopi and all the other courageous and uniquely Afrocentric pop culture icons who go beyond the stereotype of mainstream beauty, such as Howard Stern's sidekick Robin Quivers and singer Tracy Chapman, Black women around the globe can proudly wear their close-cut crops, fades, dreadlocks, and braids without fear of falling off the corporate ladder or getting shafted by mainstream society. —*Deborah Gregory*

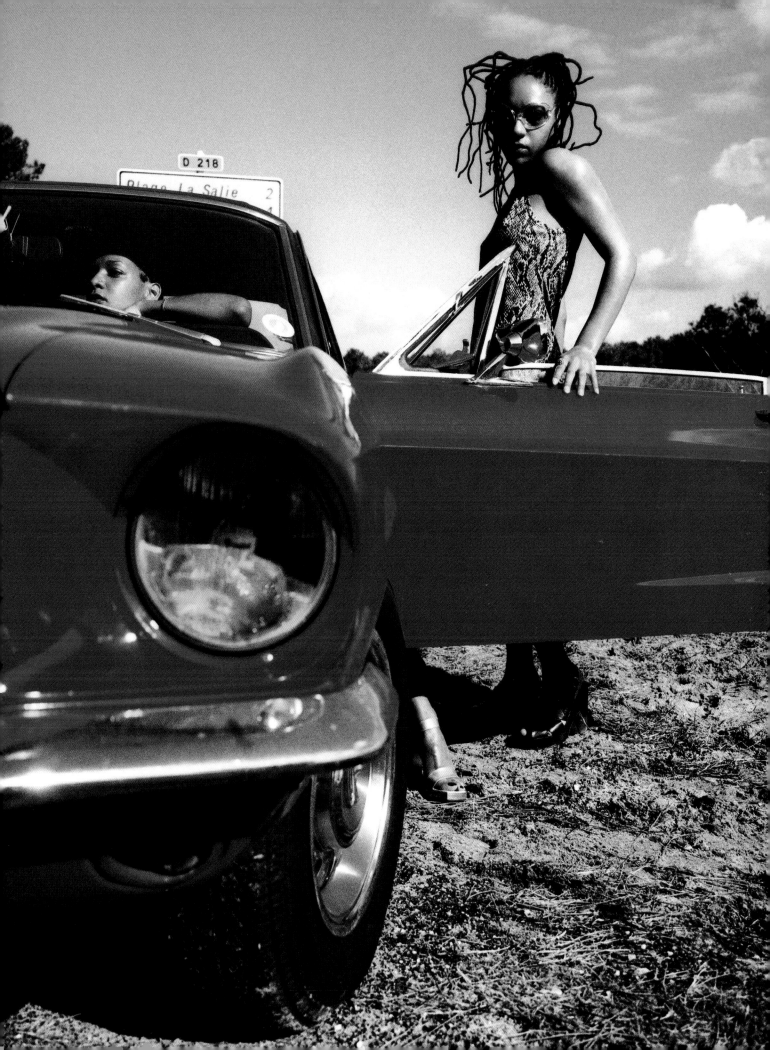

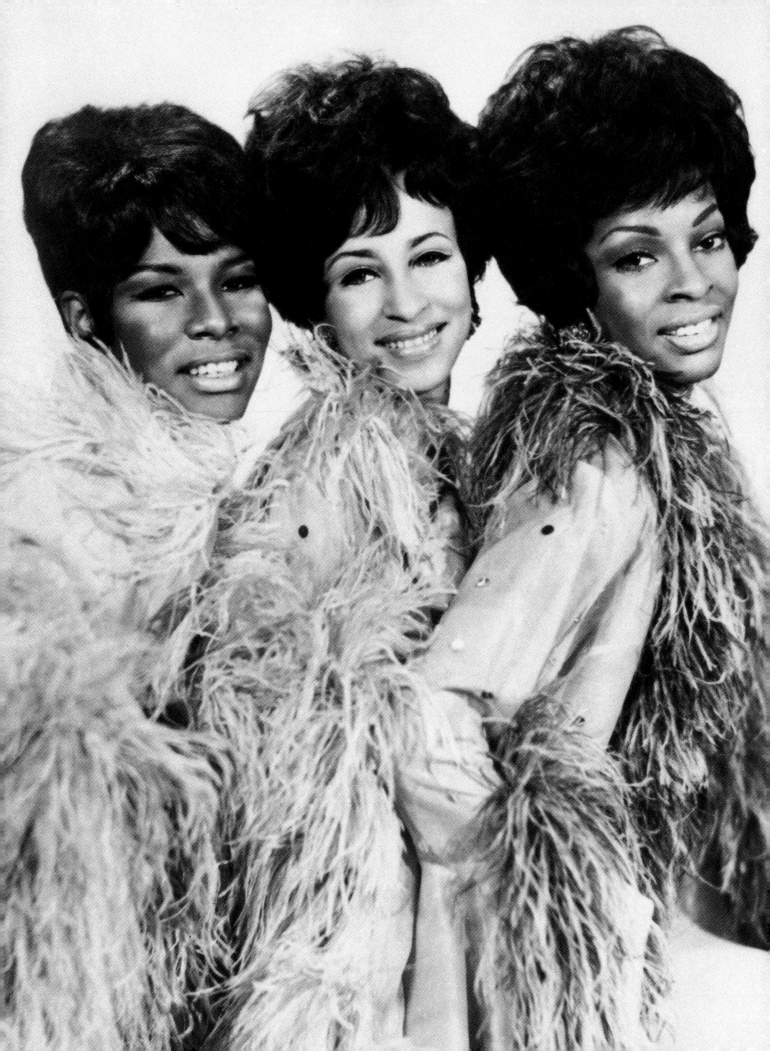

sixties

Martha and
the Vandellas

One of the most tumultuous decades in the twentieth century was the sixties. These years ushered in political and social changes that would alter the lives of all Americans, Black folks in particular. In the early part of the decade, Civil Rights Movement leaders led peaceful protests: freedom marches, bus boycotts, and sit-ins across the South in an effort to end segregation. With the pressure on, there was a sweeping optimism that the deep-rooted problems in America, poverty, racism, inadequate housing, and poor education, would somehow improve. A change was gonna come.

That optimism infused the music and fashion of the sixties. "Race music," rhythm 'n' blues of the late fifties that was marketed solely to Blacks, was replaced by a new pop-and-soul hybrid that would appeal to both Blacks and whites. Along with the new sound came a change in styles—from conservative tweed suits that featured knee-length skirts and jackets with three-quarter-length sleeves to scandalously high miniskirts worn with go-go boots that kissed the knees or thighs. The more emboldened girl teetered sexily in towering stilettos and was often clad in knitted stretch pants with narrow legs, a pencil or A-line skirt, boxy sleeveless blouses, or turtlenecks. Sixties fashion was a celebration of youthful independence.

Nothing epitomized the look of the sixties more than the superstylized all-girl groups. The Shirelles ("Will You Still Love Me Tomorrow" "Soldier Boy," and "Dedicated to the One I Love") was one of the most successful. The four teens, lead singer Shirley Owens, Addie Micki Harris, Doris Kenner, and Beverly Lee, formed their group in 1958. The hit-making sirens remained successful through the early sixties.

Besides gaining celebrity for their chart-topping love songs, the Shirelles also set the style that all groups would imitate and improve upon over time. The members of

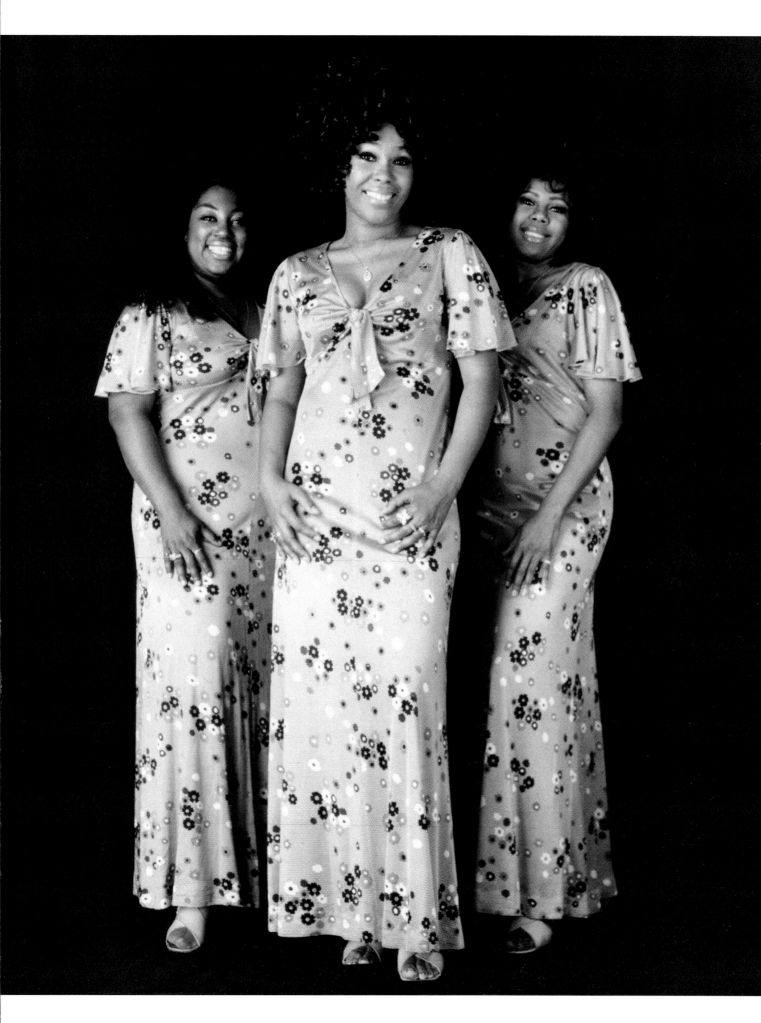

the group dressed alike, wearing colorful cocktail and party dresses, high heels, and big wigs. The Shirelles' crossover appeal and success opened the door for many girl groups.

On the flip side were the Ronettes. The trio—Veronica "Ronnie" Bennett, her sister Estelle, and their cousin Nedra Talley—began singing in high school. Their harmonized vocals were tinged with R&B and rock.

Born in Spanish Harlem and raised in Harlem, these biracial girls didn't look like any other girl group of the day. The style that the Ronettes became known for was developed partly out of necessity. The underaged girls had been hired to perform at the Peppermint Lounge in New York City, the "it" club of the sixties. To make them appear older, they learned makeup techniques and enhanced their figures by stuffing their bras with Kleenex.

While waiting their turn to perform at different gigs around the country, the group would sit backstage and experiment with their look; with thick mascara and heavily drawn eyebrows, the Ronettes exaggerated their makeup. The group said they modeled their look after the Latina girls they'd see walking down the street in Spanish Harlem.

The girls coopted a tough street image, which was totally opposite of the Shirelles. "We weren't afraid to be hot," says Ronnie Spector in her autobiography *Be My Baby*. "That was our gimmick. When we saw the Shirelles walk out onstage with their wide party dresses, we went in the opposite direction and squeezed our bodies into the tightest skirts we could find."

While the Ronettes were shaking it up in the East, another bad-girl act was getting into the groove. The Ike and Tina Turner Revue, a rock, gospel, and blues band, caused quite a sensation. Turner and her crew of Ikettes—a trio of pretty backup vocalists and dancers—twisted, shook, and shimmied their hips all over the stage in a frenzy.

The band's sound and style were distinctive. The birth of Tina's signature look can be traced back to a mishap at a beauty parlor, where she had had her hair bleached. "That was a trendy look at the time," she explains in her autobiography, *I, Tina*. But when her hair fell out from the process she started wearing wigs. "I got to like wearing wigs. Because I loved the movement, especially onstage, and I had this image of myself and the Ikettes singing and dancing, and all of our hair constantly moving, swaying to the music. So pretty soon we had the Ikettes in wigs, too, and that was the beginning of 'the look.'"

In the early sixties, Tina and her Ikettes wore knee-length cocktail and party dresses, but that quickly changed. As the years progressed, the lyrics became more raunchy, and the group dressed the part. The outfits became flashier and shorter. Their thigh-high or crotch-level mini dresses in silver, green, or blue, studded with sequins and flanked with fringes, frantically swirled as they danced. It was all about movement for Tina.

When Tina wasn't strutting in her brief outfits on stage, the long-legged diva flexed in slim cigarette pants, clingy jersey, knit dresses, or pantsuits. At one point, Tina owned seven mink coats. Designer shoes and clothes filled her closets, and she knew how to work a pair of hot pants.

In Detroit, Michigan, Motown Records owner Berry Gordy had also realized the commerical potential of female pop-soul singers and girl groups. Detroit-born Mary Wells was Motown's first female act in 1960. Originally a songwriter, Gordy pushed the raspy-voiced Wells into a singing career. At the time, Wells was the biggest artist at Motown. When "My Guy" hit the charts in 1964, she became the queen of the label.

Wells was ahead of her time when it came to style. She was funky, modern, and a bit of a fashion trailblazer. The gospel-trained singer set the style trend that all Motown female acts would follow. She was the first artist to perform concerts in elegant form-fitting gowns. She was partial to the type that flared out at the knees. And she had a collection of wigs that she favored from Detroit's Dynel House of Beauty.

In 1961, Motown signed the Marvelettes, Martha and the Vandellas, and the ultimate girl group, the Supremes. These teenagers would not only help put Motown on the map, they would also become the pioneers of a sophisticated and elegant look that

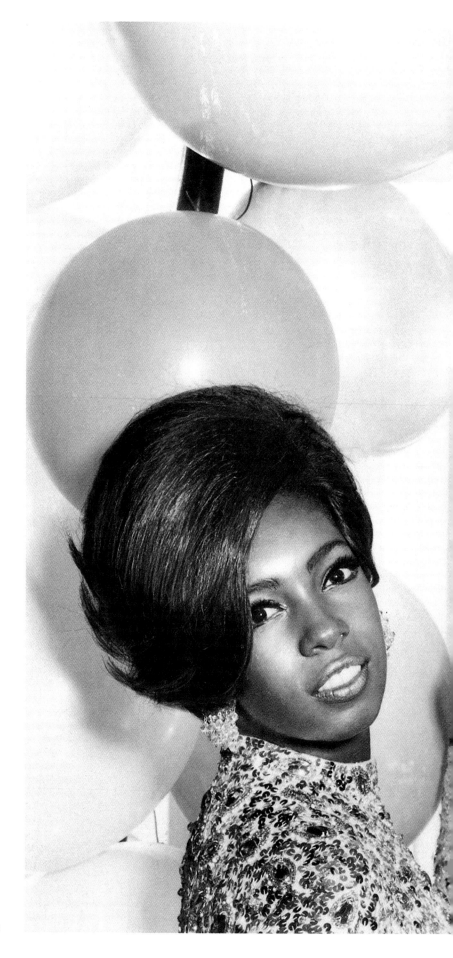

The Supremes

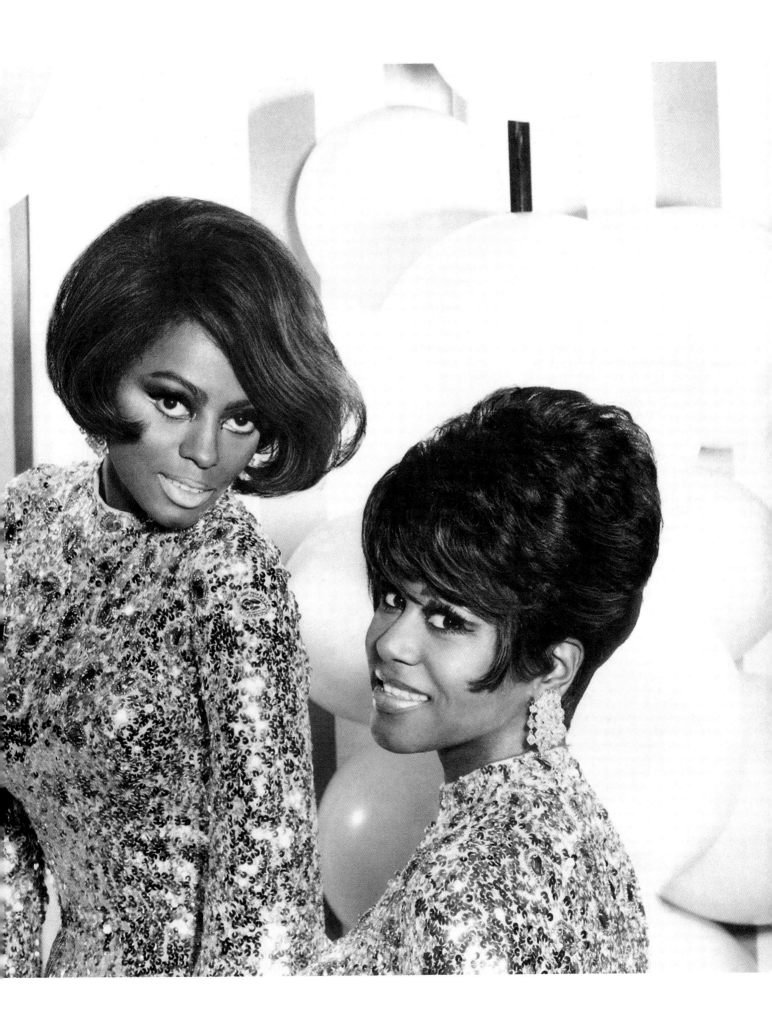

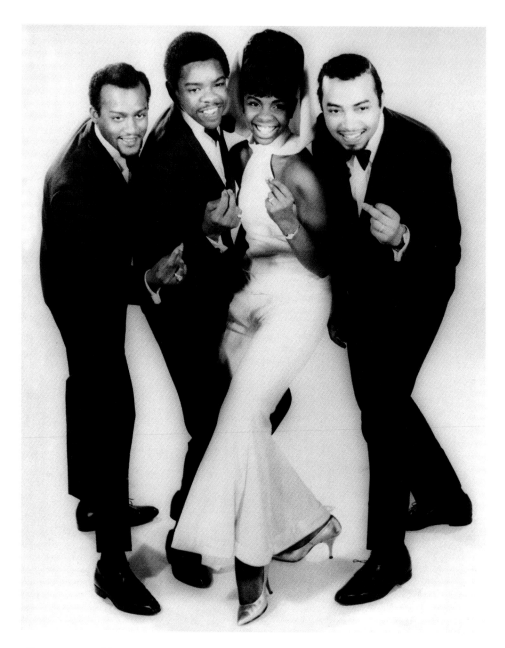

all women would want to emulate. Under the label's careful guidance, the young ladies were transformed into divas, poised, charming, and glamorous on stage and off.

When the Marvelettes—Gladys Horton, Wanda Young, Geogeanna Tillman, Katherine Anderson, and Juanita Cowart—joined Motown, they were inexperienced about clothes and makeup. By the time Motown's first female group hit it big with their 1961 chart topper "Please Mr. Postman," they were wearing custom-made dresses, high heels, and wigs styled into high, stiffly lacquered bouffants.

The Supremes—Mary Wilson, Florence Ballard, and Diane Ross (who later changed her name to Diana)—were different. Ross, who'd had a keen interest in fashion since she was a child, graduated from high school with awards for costume design and illustration. The girls pored over *Vogue* and other fashion magazines, pooled their money to buy fabrics, and Diana designed and hand-sewed simple but stylish dresses for the trio.

In the early years the stage costumes for the acts were dramatic, but not flashy. Maxine Powell, a former model who owned a finishing and modeling school, was Motown's image maker for many of the group acts, including Martha and the Vandellas (Martha Reeves, Rosaland Ashford, Annette Sterling). Powell's job was to "finish" the

girls, teach them how to walk and talk and hold a fork.

"I was a little rough," said Martha Reeves in the *Smithsonian*, "a little loud and a little undone. She taught us class and how to walk with the grace and charm of queens."

Powell was also Motown's costume designer and wardrobe mistress. Armed with a paltry costume budget, Powell used her ingenuity and creativity to fashion outstanding dresses. "I bought marked-down dresses a few sizes too big from local department stores like Hudson's," says Powell, "then they were altered to custom fit each girl." Under Powell's direction, a dressmaker would add gems, beads, or spangles to make the outfits pop. Inexpensive white shoes were tinted with shoe polish to match their outfits. Money for the groups' costume budgets flowed more freely when the groups began to consistently top the charts. Each band developed their own style, dressing in elaborate gowns. That trend was followed by other pop-soul-blues singers, such as Dionne Warwick and Gladys Knight.

But only the Supremes would become internationally lauded for their signature style: floor-sweeping feather boas, form-fitting custom-made gowns in every color of the rainbow splashed with sequins or rhinestones, jazzed up with swingy fringe, or trimmed at the hem in fur. High heels that complemented their dresses finished the look. The addition of false eyelashes, blackened with mascara, coal liner heavily rimming the eyes, and a slick of frosty lipstick added to the glamour. And then there were the fabulous wigs.

In those days a girl wouldn't be caught dead without her wig. At one point, the Supremes owned three hundred between them. "I couldn't control everything the girls wore," admits Powell. "I didn't like the wigs, but the girls wore them because we didn't have time to go to beauty salons. I also thought the wigs made their heads look too big." Even so, women in the sixties loved wigs because they could be easily altered to create any image. It wasn't just a beauty accessory: it was also practical. When your press and curl sweated out, you could hide whatever sins lay underneath.

While the better-made and expensive human hair wigs were the choice for women of means, there were affordable styles. Anyone could achieve the "Motown look." Full wigs were often cut and styled by a hairdresser, back-combed into a bouffant, bobbed, or flipped under or over, then lacquered with generous amounts of hairspray. But they weren't very comfortable, and they almost never looked natural. "I didn't know what to do with a wig when I first got it," confesses Martha Reeves in *The History of Motown*. "But it was part of the costume. Under the lights those wigs could poach your brains."

Store-bought hair wasn't the only coveted accessory of the sixties. The decade was an era of artifice. If you weren't born with it, you bought it. There were a variety of illusions to choose from: false eyelashes, nail tips, and various paddings for bras, hips, and derriere. The Motown girls routinely wore them. "Diane and I, still being beanpoles,

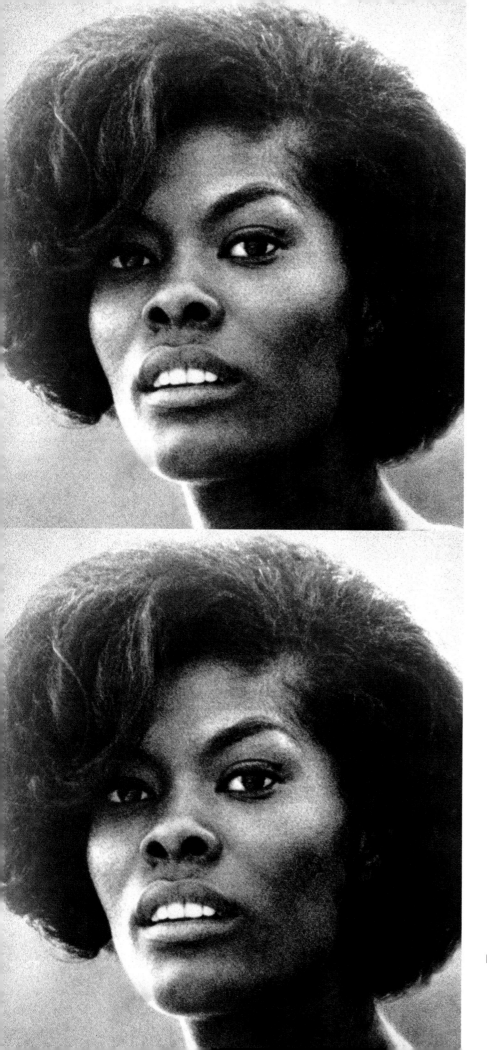

Dionne Warwick

used anything we could," says Mary Wilson in her autobiography *Dreamgirl*. "Diana added hip pads and I padded my backside."

When the Supremes and other Motown groups weren't touring, they were often out on the town shopping. Always dressed to the nines, the girls stepped out in knit pencil pants, swing coats, and collarless tweed or mohair suits, with hats and gloves to match. They flossed thigh-high minis, tights, and go-go boots in white or black patent leather or leather that fitted over the knee or grasped the thigh—a look adopted from the mods (short for moderns), a youthful style of fashion that originated in London. And, of course, the girls loved their furs: rabbit, mink, or fox coats and jackets, and ermine wraps; or cloth coats jazzed up with fur-trimmed collars, sleeves, and hems. These looks had great impact on women of all ages and colors. Though many women may not have been able to afford a mink, they could certainly adopt the Supremes smooth and polished street style.

While the sophisticated and glamorous images of the girl groups will never be forgotten, the political and social changes in the country quickly diminished their influence.

By the latter half of the sixties, America was becoming more turbulent. Nonviolent demands for better job opportunities and housing and education had fallen on deaf ears. Blacks were no longer in the mood for syrupy songs about love. They sought lyrics and images reflecting social injustices in Black communities around the country. Weary of passively waiting for change, Blacks took their frustrations into the streets. Devastating riots in Chicago, Los Angeles, and many other cities rocked the country. Organizations devoted to social and political change sprouted all over the nation. Cultural leaders like Malcolm X encouraged Blacks to have pride in their African heritage. Black men and women now addressed each other as Sister and Brother. The Black Movement had arrived.

The revolution was defined as much by the fashion of the times as the politics. Women adopted garments that symbolized their connection to Africa and showed their political awareness. The looks varied. Some women sported long, flowing caftans in colorful African prints—such as batik, mud, or kente cloths. Others wore solid-colored caftans enhanced by intricate and beautiful embroidery at the collars and hems. The dashikis, collarless African-print shirts with wide sleeves, were another option. They were worn with bell-bottom jeans, pants, or long loose skirts; sandals were often the footwear of choice to complete this casual Afrocentric look. To complement this style, women accessorized with African-inspired jewelry. Chokers, bracelets, rings, amulets, and beads made of ivory, ebony, or bone adorned necks, arms, and fingers. On the ears were large or small hoops of gold or silver, or earrings that featured cowrie shells and beads that dangled mid-neck.

Beauty trends changed. Young women tossed out their wigs and chemical hair straighteners. They put away their hot combs and wore their hair natural. The Afro was

the hairstyle of the revolution. Textured curls—full, even all around, and bushy—were shaped neatly with an Afro pick.

In 1966, in Oakland, California, the Black Panther Party formed—a band of armed young men and women who fought for equality and justice. The party's platform stressed empowerment; it was the pinnacle of what was now called the Black Movement. Women like Angela Davis, Assata Shakur, Elaine Brown, and Kathleen Cleaver played a vital role in the party as they battled against the white establishment to change the system.

The modern revolutionists strutted confidently, cloaked in the uniform of the party: black leather jackets, black berets cocked on their heads, and rifles slung casually over their shoulders. The Panthers pumped their fists in the air, shouting "Black Power"—the party anthem. Black urban teens and disenfranchised adults quickly copped to the party's look and attitude. The mainstream also hooked into it. Wig retailers added Afros of every color to their lines, designers coopted "ethnic looks," a term white designers baptized fashion inspired by Blacks and other people of color, and turned out African-inspired creations of their own. Long-haired hippies, young whites who protested compulsory military service and Western materialism, were especially fond of "ethnic" dress.

Black pop and soul stars also lead fashion trends. Performers dropped the straight wigs that were once popular in the early to mid-sixties and returned to their roots. When a struggling young Aretha Franklin began her career as a jazz and blues singer in 1960, she donned elegant wigs styled in bouffants or piled high on her head. Self-conscious about her weight, Franklin usually performed in floor-length sequined gowns that billowed around her. In the latter part of the decade, Franklin favored sophisticated dresses and gowns trimmed with ostrich feathers. Sometimes she played the drama queen by flinging capes over her showstopping gowns. Aretha's look and sound earned her the monikers "Lady Soul" and "Queen of Soul."

By 1967, Aretha, by singing "Natural Woman," "Respect," "I Never Loved a Man (the Way I Love You)," had become a success, and emerged as America's number-one soul sister. She was the epitome of a Black woman of the late sixties. Wearing her hair in a natural, Aretha belted out insightful songs about heartbreak and pain in her powerful gospel-trained voice. Anthems to women everywhere, the songs were also close to Aretha's heart: "If a song's about something I've experienced or that could've happened to me it's good. But if it's alien to me, I couldn't lend anything to it. Because that's what soul's all about."

Aretha continued to carry her brand of soul and ever-changing style into the seventies. And as the social and political climate in America continued to change, we knew that we could rely on our fashion heroines to lead us into the new decade in style.
—Lynda Jones

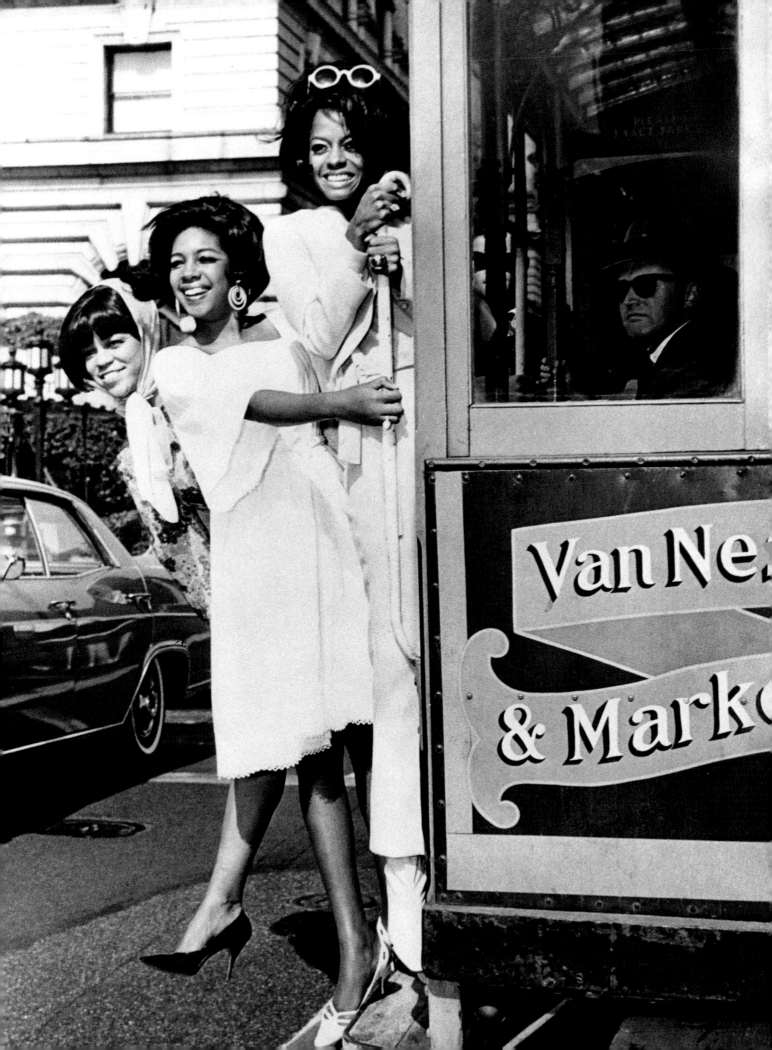

Seventies

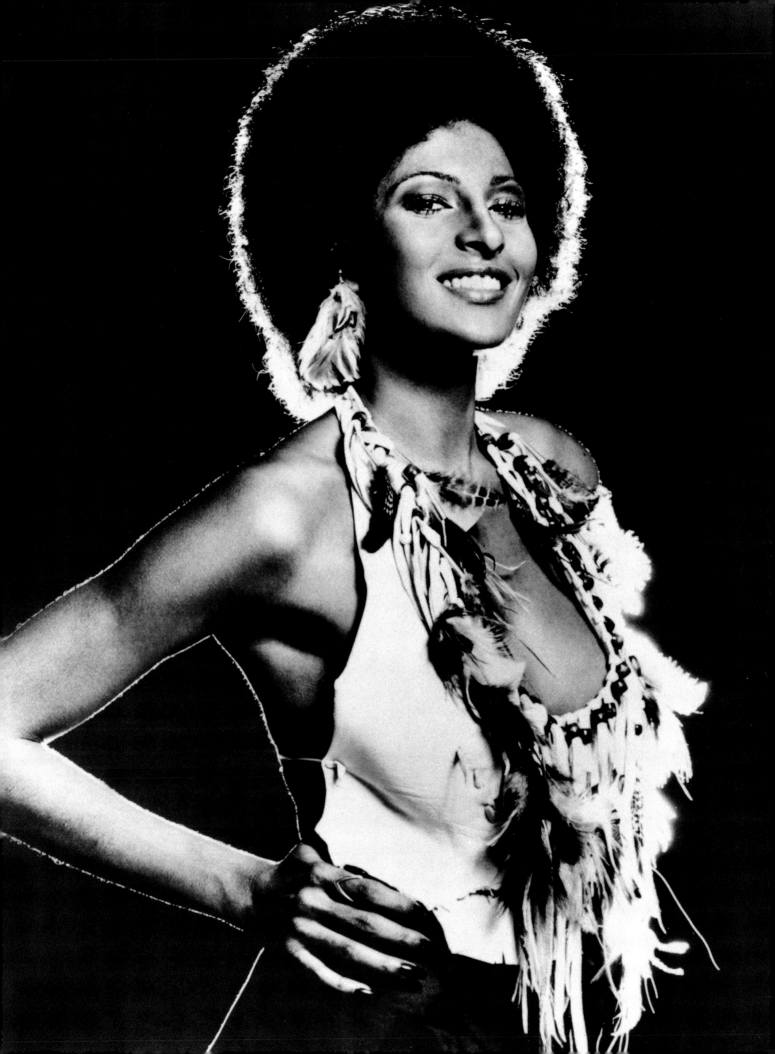

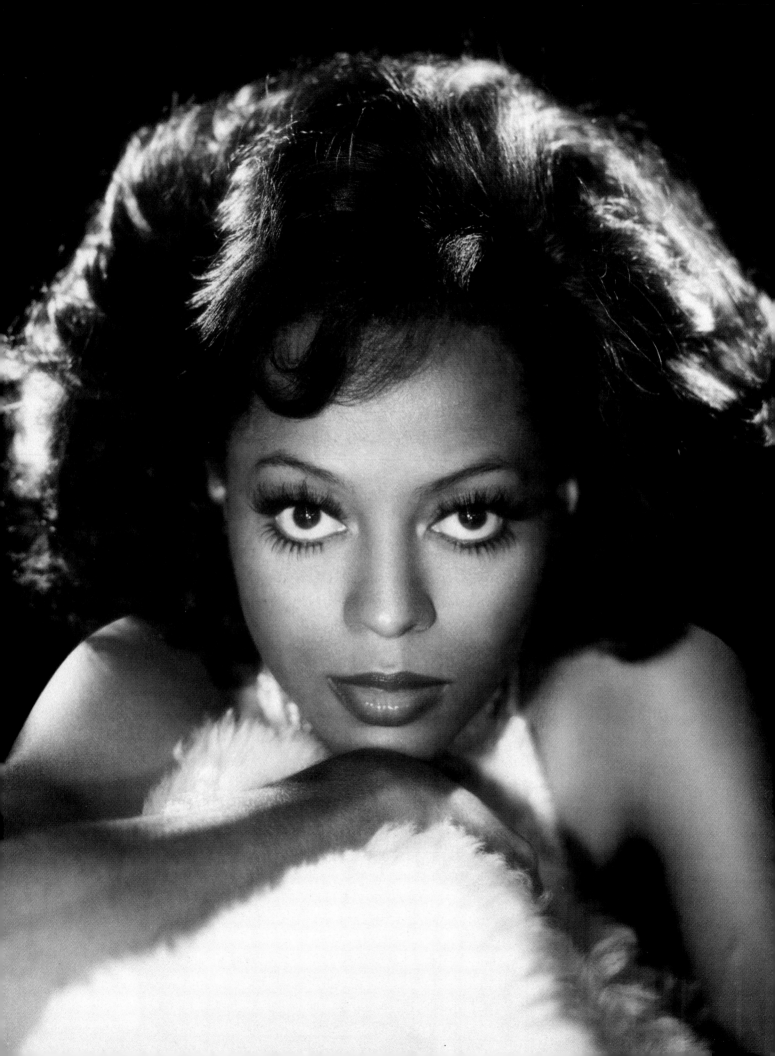

Apowerful turning point for Black women occurred in the United States in the 1970s. The era marked a milestones for social change, gender equality, and political activism in America. For the first time networks recognized the female work force and utilized the female executive in its advertising images. Suddenly the demure persona was passé. In its stead were the *Enjoli* perfume women donning two-piece suits, fanning a bankroll of twenties and singing triumphantly "I can bring home the bacon, fry it up in the pan and never ever let you forget you're a man—'cause I'm a woman!"

As they sung, college students were protesting against the Vietnam War. All this, before the Civil Rights Movement, which was at a peak. Martin Luther King had been assassinated, and in the shadows of his legacy lied the presence of an emerging active resistance. Unlike Dr. King's passive resistance doctrines, the Black Panther movement, Malcolm X, and the Nation of Islam became icons of Black consciousness. They emphasized self realization, economic independence, and cultural identity with "Mother Africa." The colloquial term "Oreo," redefined what had been the supposed dream for assimilation into mainstream America. No one cared about fitting in anymore. African dress, cornrows, Senegalese twists, Afros and the symbolic clinched fist, defined the mood of the African American community.

Black women from all walks of life stopped following European fashion trends. For the first time in the stormy tale of race relations in America, they began to wear styles reflective of a culture empowering ideology: Black is Beautiful. The foot-stomping, eye-bulging, lip-smacking, tar-blackened images remaining from slavery had been eradicated—by popular demand.

In 1970, *Essence* magazine premiered, and provided Blacks in fashion a platform like

never before. Soon after, Susan Taylor stepped to the forefront as fashion and beauty editor. Thirty years later, her ethereal style perseveres, affirming and inspiring the splendor of Black womanliness. A more natural Black beauty became the focus. Some Black women began to wear tall, majestic African gelees (headwraps) to distinguish themselves among peers. This style continues to influence current millinery's turban hat styles. Big gold hoop earrings, an armload of silver bangle bracelets, and chokers with hanging hieroglyphic ornaments like the ankh, which represents the Egyptian symbol of life, were must-haves. Kente print fabric emerged, filling vending stands and tables that lined the streets of the Black community. The royal fabric was used for dashikis and caftans.

That same decade a more diverse array of Black beauty emerged. The fair-skinned Jayne Kennedy, a former beauty queen, demonstrated that she was more than just a pretty face. She went on to become cohost of the *NFL Today Show*.

Seeing Lonette McKee's light skin on the silver screen in the movies *Sparkle* and *Which Way Is Up*, supported the undeniable fact that we do not represent one standard of beauty. The darker Melba Moore captivated many with her charm and powerful vocal cords. And Cicely Tyson's role in the film *Sounder*, which earned her an Academy Award nomination, brought home the legacy of the strong Black superwoman. Her choice of nonstereotypical roles and African hairstyles helped reestablish our grasp of ancestral lineage and exemplified our heritage. It reinforced that we had nothing to be shameful about. "I can't think of anyone who had more fashion sense than Cicely Tyson, because she did everything her way," recalls Audrey Smaltz, who was the well-known *Ebony* Fashion Fair commentator during the seventies. "You don't always agree with it, but girlfriend really had style."

Black beauty soon began making an astounding impact on both mainstream and Black culture. After years of Eurocentric definitions for beauty plastered across magazines, televisions, and movie screens, Black female sensuality and beauty was finally making its mark.

The incomparable Chaka Kahn made it apparent on the music scene, as a member of the pop/soul band Rufus, that it was cool to let our hair just be bushy, nappy, and free. Her alluring formula of dressing and her sassy hip gyrations and glossy lips blended a "love child" style with leather hip-huggers, suede skirts, and halter tops, expressing sexual freedom and star power uncensored. Her 1978 hit "I'm Every Woman" became an anthem for the Black woman.

It was a statement of an evolving Black female movement, one poised not simply on beauty, but defined by strength of character. Gloria Gaynor touched on it in the greatest disco tune in history, "I Will Survive." According to club and radio mixologist of the seventies DJ Ahli Love, Gaynor's sound helped usher in the "extended mix" that came to represent club music.

Activist Angela Davis, imprisoned for the cause, was highlighted on the cover of *Newsweek* magazine, becoming another quintessential figure of strength. All the while

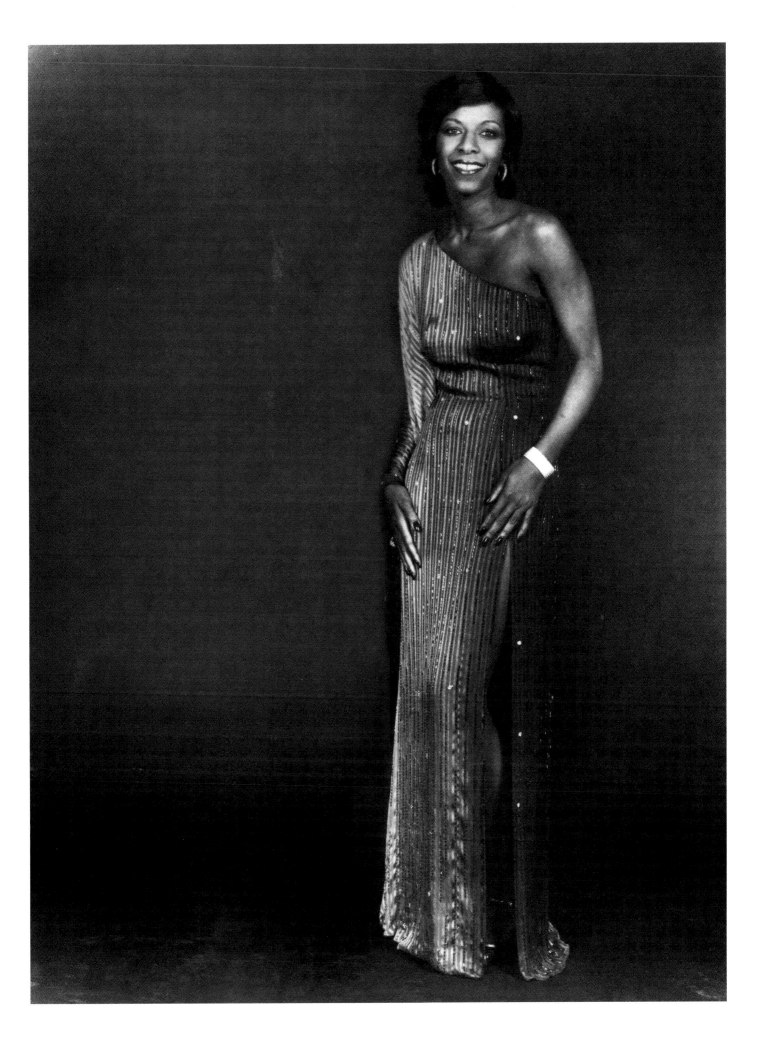

Betty Shabazz continued the legacy of her slain husband, Malcolm X, appearing before the House of Representatives in support of a bill for "Negro History and Culture."

While some Black women leaned toward Afrocentricity others modeled themselves after the over-the-top flamboyance of style icons such as Diana Ross and the queen of blaxploitation films, Pam Grier. Satin hot pants, sexy halter jumpsuits, and flashy print hip-huggers hit the fashion scene with a vengeance. Diana Ross, a style icon of the seventies, achieved super-stardom and full diva status. She sang "Someday We'll Be Together" for the last time with the Supremes in 1970. Later that year she released her first solo album, peppered with the perfect lyrics to let her do what she does best—give fans spectacular performances. Diana further demonstrated her mega-stardom by moving successfully from the stage to the silver screen. She traded in her sparkling sequins and grand tulle for a slinky white gown with white gardenias in her hair for *Lady Sings the Blues*. An Oscar nomination for best actress soon followed. From then on, Diana became the Boss. In *Mahogany*, Diana gave Afrocentric opulence by pairing an extraordinary, off-the-shoulder evening number with a matching turban and fur muff; and plaiting her hair in jumbo pretzel-like twists embellished with beautiful cording. She pranced down the yellow brick road wearing an Afro in *The Wiz*. Although her fashion tale points to designers Bob Mackie and Valentino, it doesn't end there. Pulled-back chignons, the "bob," or her signature fly-away hair, and accentuated eyelashes have left an inspiring and indelible mark on fashion.

Pam Grier was an another big trendsetter in the seventies. At the height of her career, her statuesque body didn't just appear on the silver screen in blaxploitation classics like *Foxy Brown* and *Coffy*, it descended upon you.

Pam's ultra-gorgeous looks brought to life her portrayals of tawdry, brash women who sought revenge in a streetwise culture, and decades later, both Black and white men remain in awe of her seductive on-screen persona. Her buxom shape lent power to the visuals whether she wore a black leather pantsuit, a slinky dress, big Afros or long, curly wigs. It was a part of her box office power, unlike anything Hollywood had ever shown before. Pam Grier's on-screen image represented a symbol for women's liberation, which grew out of the politicization of Black and white women during the Civil Rights Movement of the sixties. Gloria Steinem may have agreed. In 1975, Pam was the first Black woman to appear on the cover of *Ms.* magazine. Today, Pam Grier is considered the queen of blaxploitation films, and the godmother of the urban fashion trend—"ghettos fabulous."

Black women kicked butt, often starring or costarring as female heroes in action flicks that viewed like cartoon characters. Still, they were working and box offices were reporting profits.

The emergence of Tamara Dobson, Black, bold, and beautiful in *Cleopatra Jones,* affected the Afro hairstyle during the blaxploitation movie era of the 1970s. She was among

the few Black women whose screen appeal sparked many fashion trends. More than six feet tall, her physique served clothes well in films, which may be why young Black women emulate her style today. Certainly, her screen persona could be said to be a mother of hip-hop and ghetto-fabulous fashions. Wide-brimmed hats, plush furs, and flowing robes were considered characteristic of the ghetto-fabulous garb of the 1970s style.

Tamara's film character, Cleopatra Jones, was one of the original "fly girls." Although Karl Largerfeld's fall 1991 collection for Chanel was laced with urban culture, mainstream tagged the collection: Homeboy Meets Homegirl. Urban-chic fashions, heralded by Tamara's pioneering seventies flamboyance look.

It was Nona Hendryx, Sarah Dash, and Patti LaBelle of the glam-rock group LaBelle who capitalized on it best. No one would have predicted that these three clean-cut African-American women, clad in sailor-style dresses for their first appearance on *American Bandstand*, would give rise to the fashions of the disco era. Their dramatic change, from the frumpiness of the BlueBells to the avant-garde look of LaBelle, would begin a craze.

Their first release, "Lady Marmalade," topped the charts, and LaBelle's distinct style made the group a household name. "Their radical transformation brought forth something totally new that had never been done before," says Ken Reynolds, who worked as the group's road manager back then. "The idea was a combined effort. Vicki, their manager, myself, and the girls came up with the idea to dress the group in a way that expressed their own identity." According to Reynolds, Sarah was the sexy one. Nona's was every man and woman's wildest fantasy, and Patti was the mother earth type. Each had a distinct fan base.

They were notorious for wearing outlandish metallic costumes that were embellished with feathers and exaggerated padded shoulders, and flashy helmets, which gave them an almost intergalactic look—especially when Nona would appear on stage with studs on her breasts and her crotch. With their bodacious fantasy makeup, accessories, and scandalous high-heeled boots, no solo act or group was able to duplicate their style and sass with real success or dared be so bold before LaBelle made it a fashion statement. "Their style broke all kinds of molds and revolutionized the music industry" said Reynolds.

After enjoying tremendous success with LaBelle, Patti embarked on her solo career in the late 1970s. She kept the drama in her drag, didn't give up the bold jewelry, held on to some of the feathers, and always wore lots of beaded gowns, big wigs, long nails, and plenty of eye shadow—not to mention "fever pumps," shoes she's famous for kicking off on stage. By the late 1970s, she had reinvented her look into a more classic,

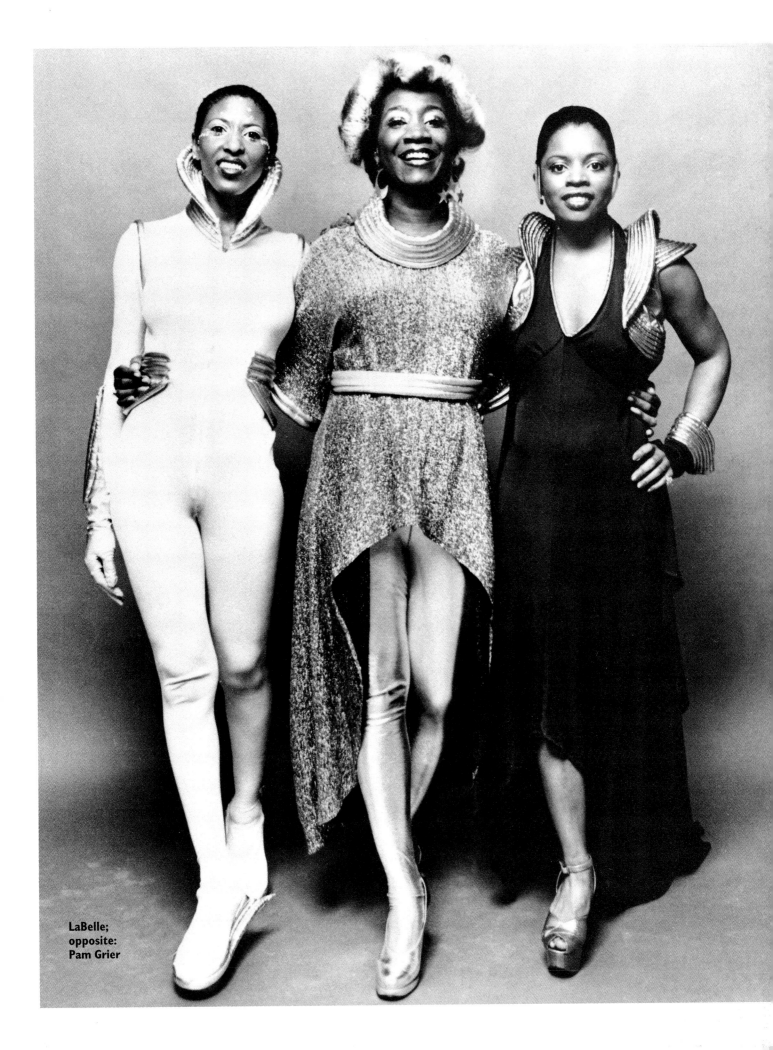

LaBelle;
opposite:
Pam Grier

modern style, which marked the transition into the down to earth, soul singing diva she is known as today. Women and female impersonators continue to carry on Patti's dynamic seventies style.

A solo Nona Hendryx exploded onto the music scene as a sultry femme fatale, clad in risqué black leather, mesmerizing audiences with hip gyrations, soul-filled ballads, and a cutting-edge signature style. Her first solo album, *Nona Hendryx*, premiered in 1977. Style became an extension of her rock-hard persona decades before fashion designers Gianni Versace and Jean Paul Gaultier even thought of meshing rock personalities with chic fashions.

Like Hendryx, Black women of the 1970s were redefining their assertiveness. They identified with the term *African queen* and evolved into true "soul sistahs." Images of these new and improved Black queens filled the movie screens. Afros and Afro-puffs were their crowns, maxi-length Blackglama fur coats were their regal robes. Fitted pantsuits and towering red, black, and white platform shoes elevated them beyond the status of a mere "little woman."

The sophistication of Phyllis Hyman—six foot one, huge doe eyes, and full lips—became the quintessential picture of statuesque beauty. The "Diva of the Blues" brought inspiration to all types of women. Phyllis carried her height with ease and grace. She donned big hats and high hair, complementing her height. "I'll give you more if you can

stand it," Hyman teased to audiences worldwide.

Natural hairstyles also had a big influence in the seventies, according to John Atchinson, owner of John Atchinson Hair Salon on Madison Avenue in New York City. Atchinson was the predominant hair stylist of the seventies—and a legend in his own right today. His list of clients reads like a Who's Who of Hollywood superstars, including: Nancy Wilson, Dionne Warwick, Candice Bergen, Jane Kennedy, Bill Cosby, Billy Dee Williams, Marilyn McCoo, Minnie Ripperton, Muhammad Ali, Cicely Tyson, along with fashion models Pat Cleveland, Iman, Billy Blair, Alva Chin, Bethann Hardison, Barbara Summers, and Pat Evans.

"I remember doing a lot of exciting braiding styles back then on Cheryl Tiegs and Beverly Johnson. But it was insulting when everybody picked up on braids after Bo Derek came out and wore them," Atchinson said. The impact Black female celebrities made on mainstream and Black culture became evident on the streets of America.

"A lot of un-kinky hair got kinky or curly," reflected Denise Nicholas, star of the ABC-TV series *Room 222*. "Black women could identify with a variety of screen images."

Nicholas earned two Golden Globe Award nominations for her role as guidance

counselor Liz McIntyre, in *Room 222*, a series that ran for four years. In retrospect Nicholas said she "had more hair styles going than I can remember including a giant Afro-wig, much to the shock of ABC and Twentieth Century Fox television."

Cornrow hairstyles and hair attachments like Afro-puffs, chignons, and pretzel plaits were fun, versatile looks that definitely attracted attention. Similarly, long-layered silky straight wigs were equally popular among Black women.

Donna Summer donned long curly wigs, split skirts, and performed with relative reserve. Still, her 1976 debut album, *Love Trilogy*, rocketed to the top of the charts, making her one of the most sought-after soloists of the era. Big hair helped to define her glamorous style. Donna parlayed a party-girl style with that of a super diva, eventually becoming the queen of the disco era. She exuded a subliminal sex appeal, transcending the rock-styled in-your-face types of the early seventies. Her magnetic appeal attracted both white and Black audiences, catapulting her to a Marilyn Monroe-type status almost overnight. She was the only Black woman to successfully portray a glamour queen in a prime time television special, focusing solely on Donna. From then on, Donna's French wet and wavy hairstyles of the seventies have impacted the look of contemporary society.

Undoubtedly, Natalie Cole, daughter of legendary singer Nat King Cole, contributed to the girl-next-door style in 1975 through 1977, with top hits "Inseparable" and "This Will Be." She first emerged as a spry, innocent, twenty-something girl. Her persona bore more of an earthy look—minimal makeup, textured Afro, and peasant/western-style dresses. She was the product of the seventies, teetering between an explosion of varying fashions. It wasn't until the end of the decade that Natalie settled into a more comfortable womanly persona: black boas, sequined gowns, and feathered hair. Whether girlish, sophisticated or worldly, she transcended category and is an evolving woman.

The trendsetting beauty images of these seventies starlets were amazing, considering that basic beauty cosmetics had not been formulated for darker-complexioned African-American women. Black women formulated their own colors by mixing whatever products were readily available. Somehow they would come up with the right shade of midnight-blue eye shadow, which was the en vogue color of that era. White eye shadow was also popular, as were fake lashes and black eyeliner. It was amazing that Black women were able to develop fascinating makeup looks, as complementary cosmetics were sparse.

Through it all, there were luminaries who titillated our senses with a certain freedom from the constraints of rules—pushing their creative boundaries to entertain our hearts. The idea of what they left behind has become universal, whether we are stargazers or not. These are women we love, indeed, and we will never forget their fabulous style impact.—*Cheryl Ann Wadlington*

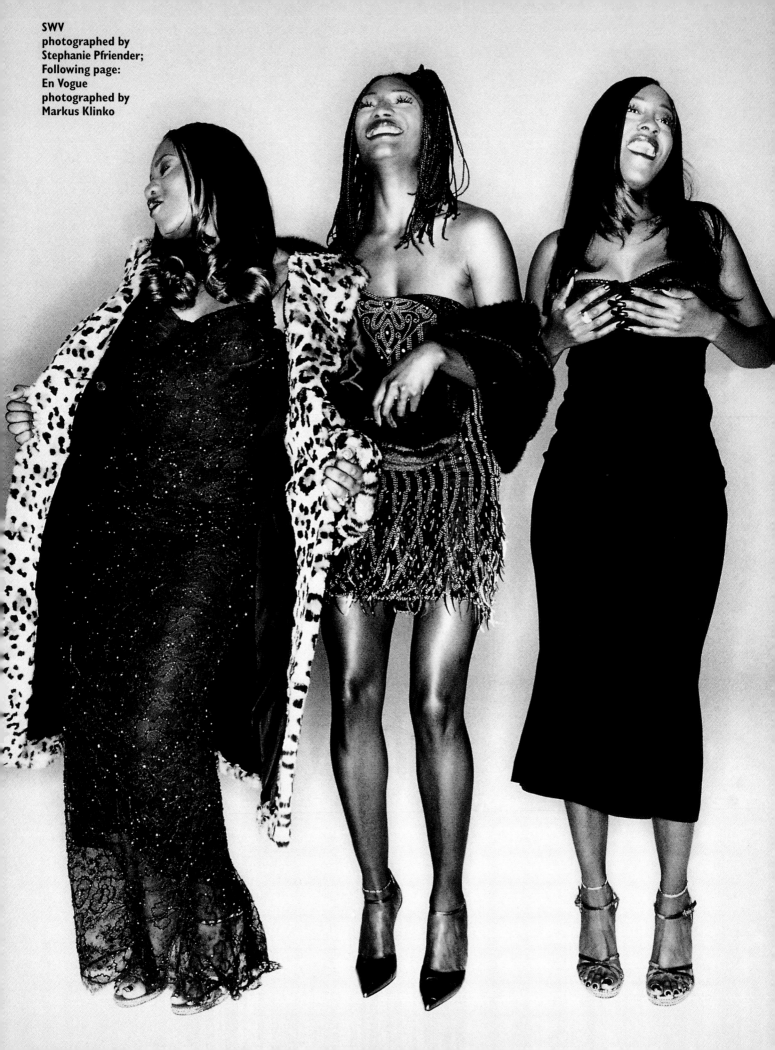

SWV
photographed by
Stephanie Pfriender;
Following page:
En Vogue
photographed by
Markus Klinko

SWV
photographed by
Stephanie Pfriender

Author/Designer DUANE THOMAS
Editor GENA PEARSON
Creative Director JULIUS POOLE
Contributing Editors LYNDA JONES, CHERYL ANN WADLINGTON

ACKNOWLEDGMENTS

Thank you Charles Miers, Bonnie Eldon, and Gena Pearson
at Universe Publishing for this time seeing the beauty in black women.

Thank you Julius Poole for your hard work and dedication.

Thank you Roy Campbell, Deborah Gregory, dream hampton,
Lynda Jones, Jenyne Raines, Barbara Summers, Cheryl Ann Wadlington,
and Constance C. R. White for your excellent essays.

Many thanks to all the photographers, editors, stylists, makeup artists, hairstylists,
subjects, and their agents without whom this book would not have been possible.

Thank you Mathu Andersen, Guy Aroch, Gilles Bensimon, Gavin Bond, Calliope, Carlton Davis,
Bob Frame, Lou Freeman, Kate Garner, Jamil GS, Pamela Hanson, George Holz, David Jensen, Eric Johnson,
Hosea Johnson, Markus Klinko, Christian Lantry, Keith Major, Jonathan Mannion, Steven Meisel, Silvia Otte,
Stephanie Pfriender, Len Prince, Pablo Ravazzani, Paolo Roversi, Piotr Sikora, Diego Uchitel, Nitin Vadukul,
Ben Watts, Kenneth Willardt, and Firooz Zahedi for your brilliant photography.

Thank you Color Edge; Jeffrey Kane and everyone at The Edge; David Joseph;
Michael Stratton for Steven Meisel; Nakiah Cherry for Gilles Bensimon; Alexis and Cary for George Holz;
Gay at Kramer + Kramer for Ben Watts; Maxine at Art House for Gavin Bond;
Philipe at Area 51 for Markus Klinko; Sydney and Charlene at Oliver Piro for Eric Johnson;
Patty Smith at Corbis Outline; Ron at Photofest; Patrick McColery and Talisen Malone at JBG;
Lynne Volkman for Whitney Houston; Karin Flores for RuPaul; Nicole Ross for Nia Long;
Claudia Mason for going the extra mile; and Dawn Bossman and Cathy Nastase at Universe Publishing.

Thank you Tom Ackeman, Omari Ali, Julio Davis, David Doty, Richard Hearns, Sharon Graham,
Tracy Graham, Cherlyn Miller Grier, Robin Jones, Emma Ladson, Vincent Lawrence, Bernice McWilliams
Richard Reid, John Stefura, and Joanne Wu for your friendship, suggestions, and support.

Julius Poole would like to thank his mother, Millie Poole Johnson, for years of support and encouragement.

PHOTO CREDITS

Whitney Houston photograph courtesy Arista
Whoopi Goldberg and Grace Jones photographs courtesy Photofest
All Len Prince, Diego Uchitel, and Firooz Zahedi photographs courtesy Janet Botaish Group
All Guy Aroch, Kate Garner, Stephanie Pfriender, and Kenneth Willardt photographs courtesy Corbis Outline
All "Seventies," "Sixties," and "Legends" photographs courtesy Photofest

PART OF THE PROCEEDS FROM THE SALE OF THIS
BOOK WILL BENEFIT THE MINORITY TASK FORCE ON AIDS.

E-mail address: SoulStyle2000@yahoo.com

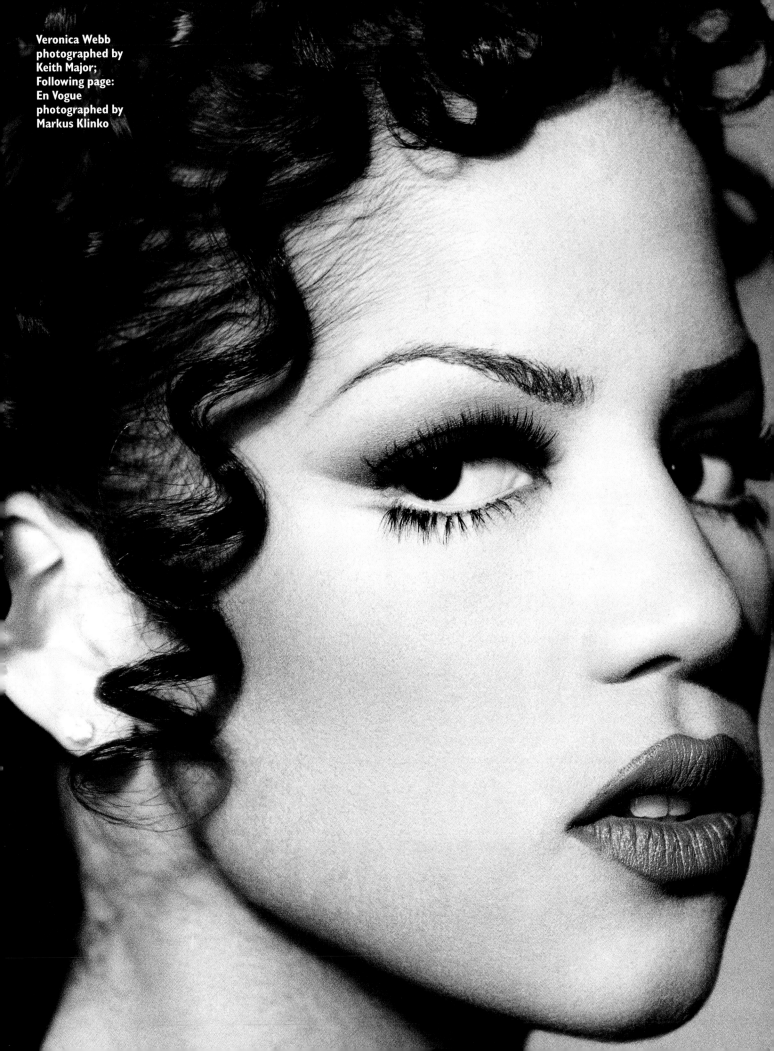